acrylic revolution

acrylic REVOLUTION

new tricks & techniques for
working with the world's
most versatile medium

Nancy Reyner

NORTH LIGHT BOOKS
CINCINNATI, OHIO
www.artistsnetwork.com

Other fine North Light Books are available from your local bookstore, art supply store or direct from the publisher.

16 15 14 13 12 11 10 9

Distributed in Canada by Fraser Direct
100 Armstrong Avenue
Georgetown, ON, Canada L7G 5S4
Tel: (905) 877-4411

Distributed in the U.K. and Europe by David & Charles
Brunel House, Newton Abbot, Devon, TQ12 4PU, England
Tel: (+44) 1626 323200, Fax: (+44) 1626 323319
Email: postmaster@davidandcharles.co.uk

Distributed in Australia by Capricorn Link
P.O. Box 704, S. Windsor NSW, 2756 Australia
Tel: (02) 4577-3555

Library of Congress Cataloging-in-Publication Data

Reyner, Nancy.
 Acrylic revolution : new tricks & techniques for working with the world's most versatile medium / Nancy Reyner.
 p. cm.
 Includes index.
 ISBN-13: 978-1-58180-804-9 (concealed wire-o : alk. paper)
 ISBN-10: 1-58180-804-6 (concealed wire-o : alk. paper)
 1. Acrylic painting--Technique. I. Title.
ND1535.R49 2007
751.4'26--dc22
 2006026035

Edited by Kelly C. Messerly
Designed by Guy Kelly
Production coordinated by Matt Wagner

About the Author

Nancy Reyner has been painting, exhibiting and teaching for more than thirty years. Nancy holds a BFA from the Rhode Island School of Design and an MFA from Columbia University. In addition to this formal art training, she credits the varied and unusual jobs she has held to contributing to her artistic and technical knowledge. While living in New York City, she created costumes and sets for Broadway and off-Broadway theater and film (including a Madonna film); coordinated public arts programs for New York's MTA for the subway, bus and train systems; directed and performed with the Ragabash Puppet Theater; held several graphic design and color technician jobs; and managed a print production facility. While living in Phoenix, Arizona, Nancy was selected for a two-year painting and drawing residency for the Phoenix Center. There she exhibited, curated shows, taught drawing and painting, and created new works. She has been a technical consultant for the acrylic paint company Golden Artist Colors, Inc. in their "Working Artist Program" for the past seven years. She was born and raised in Philadelphia, Pennsylvania, by two wonderful parents who were both dedicated school teachers. Their love for teaching has definitely rubbed off on Nancy, who now lives in Santa Fe, New Mexico, and continues to teach in the Southwest. Nancy's current artwork can be seen on her website at www.nancyreyner.com. You may contact her at nancy@nancyreyner.com.

Author photo and technical photographs by Daniel Barsotti.

Cover uses artworks by Nancy Reyner, Bonnie Teitelbaum and Declan Halpin.

Art from page 2:

You Have Been Chosen
Acrylic and mixed media on canvas
62" × 48" (158cm × 122cm)
Nancy Reyner

Metric Conversion Chart

To convert	to	multiply by
Inches	Centimeters	2.54
Centimeters	Inches	0.4
Feet	Centimeters	30.5
Centimeters	Feet	0.03
Yards	Meters	0.9
Meters	Yards	1.1
Sq. Inches	Sq. Centimeters	6.45
Sq. Centimeters	Sq. Inches	0.16
Sq. Feet	Sq. Meters	0.09
Sq. Meters	Sq. Feet	10.8
Sq. Yards	Sq. Meters	0.8
Sq. Meters	Sq. Yards	1.2

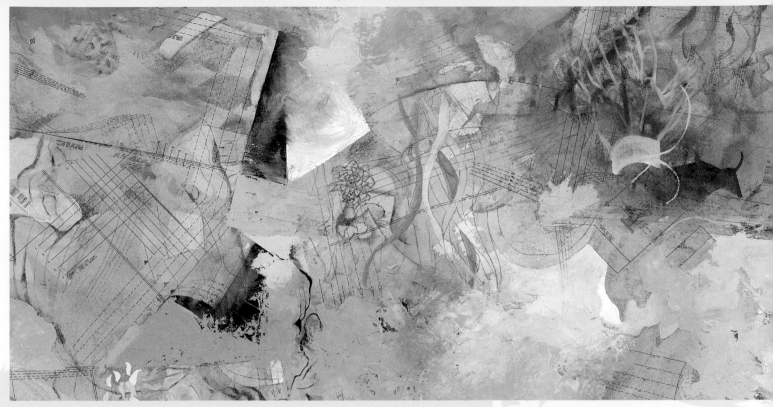

Cosmic Sea (Detail)
Acrylic and mixed media on canvas
48" × 62" (122cm × 158cm), Nancy Reyner

Acknowledgments

I have had way too much fun writing this book. The best part by far was working with so many talented people. While creating, inventing and conjuring up the variety of techniques, I was reminded of advice my brother, Dr. Peter Reyner, once gave me on baking bread. He reminded me that the yeast is alive, and showed me that if I kept this in mind while kneading the dough, the bread would rise to the occasion. I found the same principle at work with paint. Paint, too, can seem alive. I often feel a certain type of magic while painting and imagine donning a witch hat and cloak while mixing paint in my cauldron. I was especially pleased to have discovered so many fellow alchemists along the way. Sorry, no full moon ceremonies here, but hopefully this book has whipped up a few practical potions with possible side effects such as inspiration, creativity and fun.

I have learned that what makes life truly worthwhile is people. I want to thank my husband and son, Phillip and Jacob Cohen, for love, support and a never-ending sense of humor. Thanks also to my parents, Nora and Jack Reyner, who instilled in me a love for exploration, experimentation and especially teaching. A big thanks to my life sisters Tabitha and Danielle Marceau, Cleves Weber, Laura McClure, Mary Ross, Julia Santos Solomon and Marcia McCoy.

My assistant, Bonnie Teitelbaum, was a gift beyond words. I was equally blessed by having the talented photographer Daniel Barsotti shoot all the technique images.

A very big thank you to Barbara and Mark Golden, Mike Townsend, Sarah Sands, Scott Bennett and Pat Pirrone. A special thank you to Patti Brady. I could use a whole page to thank Patti. Many of the acrylic teaching tips I first learned from her, and in particular a love for acrylic paint.

Thanks to Jamie Markle and Kelly Messerly. Jamie, thanks for the fun, collaborative effort in coming up with the idea for this book. Kelly, thanks for keeping me on track with a positive attitude.

A big thanks to all my students for trying out all my ideas, which formed the seeds of this book, and to all my colleagues who submitted their artwork for the gallery section. The professionalism and variety of your work illustrates an essential point of the book—that acrylic is a professional artist's medium with a range of possibilities that goes beyond any other.

Dedication

This book is dedicated to my wonderful support team at home, Phillip and Jacob Cohen, and to our Earth and its natural resources. The beautiful materials, colored pigments and wealth of inspiration the Earth affords is a gift to all artists.

table of contents

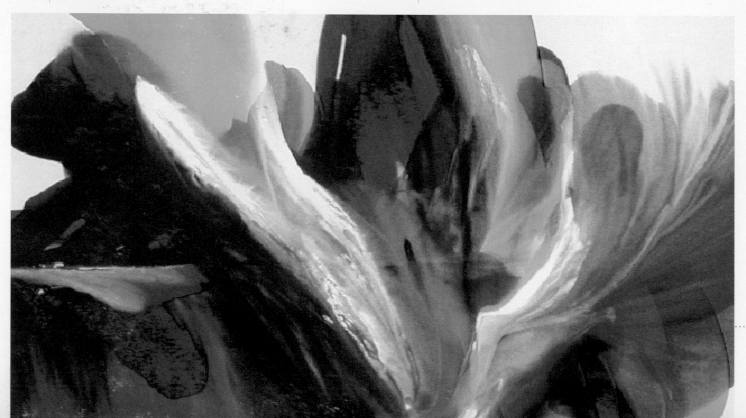

Fluid Movement
Mixed media on panel
23" × 35" (58cm × 89cm)
Aleta Pippin

The First Blush of Spring
Acrylic on linen
36" × 50" (91cm × 127cm)
Aleta Pippin

essential acrylic tips

It's important to understand some general characteristics of acrylic paint before starting. This will hopefully make painting easier, make the techniques you try more successful, expand the possibilities for each technique and possibly save you time and money.

- **Acrylic can be used in combination with other mediums.** If you like using other mediums (such as oil, gouache, pastel, or egg tempera), then try using them on top of the acrylic techniques in this book. Avoid the reverse: using acrylic over other mediums. Oil paint, for example, can be used over acrylic but not the other way around. Also avoid combining different wet mediums in the same wet blend. For example, watercolor can be used to wonderful effect on top of acrylic that is already dry, but blending the two when wet is less effective.

- **Acrylic products are compatible with each other.** You can combine any acrylic products together to create new mixtures and hybrids. For instance, you can mix paints into gels and again into mediums without decreasing their stability. Keep in mind that the characteristics of one particular paint or product will change when you mix it with another. This can work to your advantage; for example, mixing a gloss medium with a matte medium will produce an excellent semigloss. However, some specialty products, such as Golden's Clear Tar Gel, which makes the paint tar-like and stringy, will lose their special abilities when too much of another paint or product is added. Specific cautionary advice is mentioned with the techniques where such products appear. You can also use acrylic products and paints in any order on your surface. Gels can go on top of mediums and mediums on gels. Diluted paint works on undiluted paint and vice-versa. Glossy can go on top of matte, then on satin and on glossy again.

- **A few acrylic products are better used alone.**
 1. Use acrylic gesso as a primer and not as a paint. In thick applications, acrylic gesso may crack.
 2. Use a varnish as a final protective coat. Even though it can be used in the middle layers of a painting, it is meant to be removable and used as a final coat. (See technique 104.)
 3. Additives need to be used in correct proportions. There are only two additives used in this book: retarder and flow release (see techniques 5 and 74). It is always a good idea to read product labels for correct use and application information.

- **Acrylic is a glue.** Any acrylic paint or product can function very well as a glue. You can add collage elements and mixed media to acrylic while wet and it will adhere. See techniques 55 and 56 for more details on gluing.

- **Stir gently and don't shake.** The small amount of soap which remains in the acrylic products from processing may create bubbles with vigorous stirring or handling. If you need to stir a batch of paint, use a palette knife instead of a stiff bristle brush. After stirring mediums for use in pours, let the bubbles settle out overnight.

- **As you paint, keep your brushes in water until you can clean them well with soap and water.** Soap removes paint from the brush more effectively than water. If the brush in use is left out of water too long, the paint will dry on your brush and be difficult to remove later. To make cleaning easier, slightly dampen the brush bristles with water before dipping them into the acrylic paint. Damp bristles keep the paint from gripping the bristles too tightly, making the paint easier to remove. (See technique 102.)

- **In general, mix paint with a knife.** Brushes are meant to hold paint, while knives more easily release the paint. Mix a batch of paint with a knife for a clean, homogenized mixture. Use a brush to mix paint in a hodgepodge manner, for a painting technique called "dirty brushing."

- **There are two choices for thinning acrylic paint: water or acrylic medium.** Adding water will break down the acrylic binder in the paint, creating a thinner paint that appears like watercolor, with more of a matte finish. The more water you add, the more the paint will be affected by the absorbency of the painting surface. Most of the techniques in Section 3 focus on using over-watered acrylic, in particular techniques 19 and 20. Using acrylic mediums, however, will maintain the acrylic's properties, offering a rich, glossy paint.

- **Acrylic shrinks in volume while drying.** As acrylic dries, the paint layer will shrink by about a third in volume. This is more noticeable when using thick pastes and gels. Generally, apply a paint layer that is a little thicker than what you want at completion.

- **Acrylic appears lighter in color when wet.** The acrylic binder is naturally white when wet, but dries clear and glossy. With acrylic paints, the color will appear lighter when wet but will go to its natural color when dry. The more mediums and gels you add to a paint color, the greater the difference between this lighter version when wet and its natural color when dry.

- **Acrylic is naturally glossy.** Matte products such as matte mediums, matte gels and matte varnishes have matting agent (a fine white powder) added to them to create their characteristic appearance. This matting agent will slightly cloud and lighten colors underneath. The thicker the application of a matte product, the more this cloudy and lightening effect will be apparent. Techniques 31, 42 and 92 describe methods that use matte products to create interesting effects. Acrylic products labeled semigloss or satin have matting agent in them as well, just less in proportion to a matte product.

- **Acrylic has a two-part drying process.** The first part of the acrylic drying process, known as "dry to the touch," means the top layer of the paint skin has dried due to the evaporation of the water in the paint. The second part of the drying process involves the polymer or acrylic in the paint, which takes several days to several weeks to fully cure. The actual curing time is dependent on the layer's thickness and environmental factors. During this curing time, it is important to not tightly wrap or store the artwork in a closed environment and to avoid exposing it to extreme temperatures. (See technique 104.)

- **Be aware of the "tacky phase."** While the paint is still wet, it is very malleable. You can scrape it, wipe it off and rework it with ease. As you continue to work into this wet paint, however, it is already beginning to dry. Once it dries to the touch, it has a wonderfully resistant surface on which you can overlay new paints without disturbing what is underneath. It is between the wet stage and this "dry to the touch" stage when problems can occur. Between the wet and dry stages, the acrylic gets tacky, and continued working over this tacky area can create unwanted effects such as streaking or pulling as the paint sticks to your brush. Initially, acrylic paint glides smoothly and easily, but as it reaches the tacky phase, it will begin to pull and feel difficult and out of control. At this point, stop painting in that area, and move on to a dryer area of the painting. If you need to keep working in the tacky area, use a blow-dryer for a minute to dry it quickly, then resume painting. I tend to avoid blow-drying very thick layers. Also, be aware that the paint on your brush will dry quickly. Make a habit of rinsing frequently to keep the paint from getting tacky on your brush. Refer to technique 74 for ways to slow the drying process even more, or technique 75 to speed it up.

- **Do not freeze acrylic.** Oil painters sometimes freeze the excess paint on their palettes to prolong the paints' life. Do not try this with acrylic. Acrylic contains a certain amount of antifreeze, but after a few freeze/thaw cycles, the paint will no longer be stable. Acrylic paintings, even when fully cured, should not be exposed to extreme temperatures.

All Sorts of Lovers
Acrylic and graphite on aluminum
37" × 17" × 2" (94cm × 43cm × 5cm)
Declan Halpin

materials

In addition to the specific materials required for the technique demonstrations in this book, several standard items are needed for almost every acrylic painting session or technique. Whether you're a first-time user or a seasoned painter, you will find these acrylic essentials convenient to have on hand.

PAINTS

- **Acrylic paint in basic primary colors (red, yellow, blue) plus black and white.** Purchase small amounts in both thick and fluid versions. I use Pyrrole Red, Hansa Yellow Medium, Phthalo Blue (Green shade), Carbon Black and Titanium White. To have what is called a "full palette," you need both warm and cool versions of red and blue. I suggest adding Quinacridone Magenta and Ultramarine Blue to the list of colors. A full palette will enable you to mix just about any color.
- **All-purpose acrylic medium in both gloss and matte.** I use Polymer Medium (Gloss) and Matte Medium.
- **Basic gloss gel.** I prefer using Soft Gel (Gloss).
- **Acrylic gesso primer.**

application tools

Here is the regular slew of popular painting tools. A few of each category will come in handy and add some variety to your painting techniques. You'll need at least one palette knife and two or three brushes, each with a different size and/or shape.

Turn to Section 2 (page 24–33) to see a wider variety of tools for applying paint, including unusual ones such as common household items and found objects that can create different painted effects.

A Note About Paint Brands
Several brands of acrylic paint are available. I prefer using paints and products from Golden Acrylic Colors, Inc., since they are high in quality and are sold in most art stores. I refer to Golden's brand names for paints, and they appear in many of my demonstration shots. Experiment with different brands to find which one best suits your needs. If a technique needs a particular product produced only by a specific company, I have tried to identify it. Many acrylic products sold by different paint companies have similar characteristics.

BRUSHES

When selecting brushes, consider the length of the handles, the type of bristle hair, the shape of the bristle and the size. Get short-handled brushes for painting close to your canvas and long-handled ones for painting some distance from your canvas (typically while standing at an easel). Brush bristles can be synthetic or natural, soft or stiff; any of these can be used with acrylic. Soft bristles make blending easier and create smoothly painted areas, while stiff bristles add texture and visible brushstrokes to the paint. Bristles come in different shapes; the most common are designated as round, flat or filbert. The round ones come to a point and facilitate linear strokes. Flat shapes make it easier to paint large, flat areas. Filbert shapes are flat brushes that curve inward at the outside edges; they make great all-purpose brushes. Brush sizes vary as well. In general, use small brushes for smaller paintings and large ones for larger paintings. Small brushes are important for detail, while large ones make evenly painted flat areas of color possible. Start with at least one brush in each category for ease in experimentation.

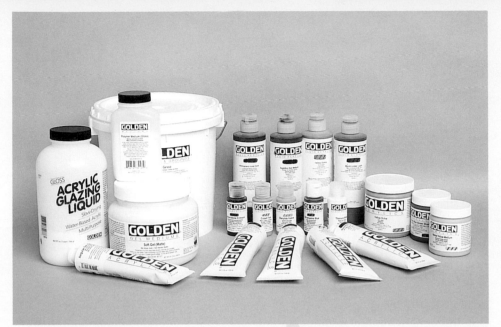

acrylic paints and painting products

The uses, characteristics and differences among the paints, gels, pastes and mediums pictured here will become clear as you experiment with the various techniques in this book. Be sure to read the labels carefully to make sure you purchase the correct product.

Make Opening Containers Easy

Here is an easy way to keep acrylic containers from getting stuck and difficult to open. When you purchase a jar of acrylic, try putting a thin coat of petroleum jelly around the top outside edge of the jar or place plastic wrap between the jar top and lid. This will make it easier to open the container later.

PALETTE KNIVES

Palette knives also come in a wide range of shapes and sizes. Knives are used for mixing paint but are also wonderful tools for applying paint in textural patterns. They can also be used to scratch through layers, carving out relief patterns. Metal knives are stronger and will last longer than plastic knives. I prefer knives with stepped handles rather than flat ones. A stepped handle puts the flat edge of the knife on a different level, so you can apply the paint without dragging your hand in it. Stepped-handled knives also have a bit more spring in them, so applications feel easier. Use smaller knives for details and smaller areas, and large knives for larger areas, bigger textural patterns and mixing larger amounts of paint.

RUBBER SHAPING TOOLS

These are relatively new tools that come in handy when working texturally with thicker pastes and gels. They can carve into wet acrylic to create lines, patterns and sculptural effects. The larger flat ones are useful for spreading paint evenly or for gluing. These are not a necessity but are fun enough to mention here.

GENERAL NECESSITIES

These items are important for any painting session.

- **A large plastic container to hold water for frequent brush rinsing.** Water is used for cleaning brushes, before changing colors and to create dilutions. Use filtered water when adding it to a paint mixture; tap water

is OK for all other applications. Your container should be wide enough to reach without having to take careful aim when you need to rinse, and short enough that you won't have to reach too far over the top. Fill the container only one-third to one-half with water to eliminate excess water rolling down the brush while you paint.

- **Paper towels or rags.** These are great for getting rid of excess paint, for cleaning up and for some painting applications.
- **A palette.** This is necessary for all your mixing needs. See page 12 for a variety of possibilities.
- **Small plastic containers with lids.** These come in handy for storing and saving unused paint and mediums. Containers with tight-fitting lids will keep the paint from drying out too quickly. Film containers work well. Commercial kitchen supply stores sell packages of containers that are used by restaurants to carry out salad dressings and sauces relatively cheap. The lids of these containers are not as tight fitting, so the paint will probably dry out after several months, but they are a good, inexpensive place to start.
- **A painting support.** This is the term I use throughout the book to refer to whatever you decide to paint on. The first section of this book is called "You Can Paint on Anything" and offers many suggestions for painting supports. Experiment with different types to find your preference.
- **Soap.** This is a necessity to fully clean your brushes. I like to use a bar of plain bath soap. For more information, see technique 102.

palette ideas

The main purpose of a palette is to hold paint in a way that will be easy for you to use. It should have ample room to mix as many colors as necessary. The most important requirement for a palette is to be nonabsorbent. An absorbent surface like paper or unsealed wood will soak up the paint so fast you won't have time to work with it. Experiment with the suggestions here to see which suit you and your working style.

WET PALETTES

A wet palette is quite popular with acrylic painters. It is a tray with a sponge in it. On top of the sponge sits a piece of wax or gloss paper. When you wet the sponge under the paper, it keeps the paint from drying out too quickly. If you do not like mixing paint on this spongy surface or find it too

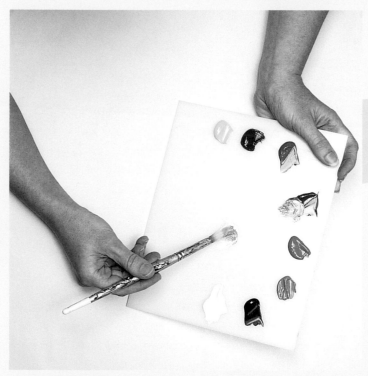

panel-sized palette
This is a ¼-inch (6mm) sheet of HDPE, purchased at a plastics store and cut to a manageable size. Have a sheet cut to the size of your work table for larger work.

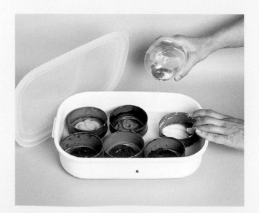

lidded tubs

delicate, select another palette idea and refer to technique 74, which offers alternatives for keeping your paint moist.

STANDARD, PANEL-TYPE PALETTES

Any sealed panel that's hard, rigid and stable will work as a palette. A piece of wood sealed with polyurethane, glass or plastic all work well. Get a piece cut to your preferred size at a hardware store, lumber yard or plastics store. Art stores have precut palettes in various easy-to-handle shapes, sometimes with a hole for your thumb. I like to use a special type of plastic called HDPE (high-density polyethylene), available at plastic specialty stores. This is the plastic used for acrylic paint jars, so acrylic will not adhere to the surface and just peels right up. You can also buy thin, flexible HDPE sheeting for drop cloths at hardware and home improvement stores.

WAXED OR COATED PAPER

Art stores carry pads of palette paper. These come in various sizes and contain precut sheets of coated paper. These convenient, throw-away palettes work well for workshops, art trips and outdoor painting. A cheaper alternative is the freezer paper you find in grocery stores. Just rip off a sheet the size you prefer and tape it to your table or to a separate piece of wood, foamcore board, cardboard or Masonite. Freezer paper holds up quite well through many painting sessions. Change the paper as necessary.

PLASTIC PICNIC PLATES

These also make great palettes. They are reusable and easy to carry to workshops and for outdoor painting trips. They are cheap and easy to find. Use the white plastic coated ones, as plain paper plates will absorb paint.

ICE CUBE TRAYS

Add colors to each compartment or use as a mixing tray. When you're working with washes or paint that is heavily diluted with water, these come in handy and keep the colors from running into each other. Store the trays in large plastic bags and they will stay wet for long periods of time. When the paint dries, just keep adding fresh paint on top. To fully clean, add water to each compartment and let it sit for an hour or so. Use a screwdriver or knife to pry the compartment clean. Ice cube trays will work only with brushes that are small enough to fit into the compartments.

LIDDED TUBS

In a plastic lidded tub, available at grocery stores, place several small tin containers such as old tuna or cat food cans. Add paint to the cans and pour about ½-inch (12mm) or more water into the tub surrounding the tins. The paint should last several months as long as the paint in the tins does not get too low. Use this setup in combination with another flat palette so you will have a place to mix the paint.

materials and equipment setup

Ventilation is another important consideration. Work with windows and doors open if possible. Even though acrylic is nontoxic, it is always good to work with circulating air, especially in a small space.

PREPARING TO PAINT

I have created a convenient setup that allows my hand and brush to follow a circular pattern. If you are right-handed, place this setup to the right of your painting support; if you are a lefty, place it to the left. The setup consists of two piles of folded paper towels placed so they form an angle or *L* shape, with the water container as the middle of the *L*. Use one set of folded towels to get rid of excess paint; use the other to blot excess water. The water container should be wide enough that you don't need to look and aim. The palette goes next to the water container completing the circular pattern. This setup allows your hand to move the brush easily through the rinsing and reloading process so that you don't have to take your eyes away from the painting. It also gives you more control over your paint's consistency because it will not get over-watered. It permits you to clean your brush faster, keep the water clean longer and minimizes the amount of paint that goes into the water system. Acrylic is nontoxic when dry and therefore harmless in landfills, but some of the pigments may be harmful when dissolved in water.

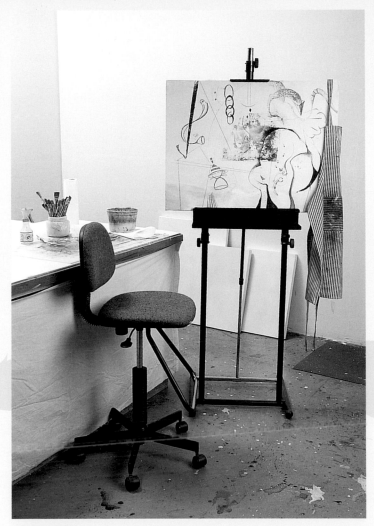

studio setup

Your painting area does not have to be large, nor do you have to purchase expensive equipment, but everything you need should be close at hand. A cozy arrangement of equipment and supplies tends to work the best.

ARRANGING EQUIPMENT

There are many ways to approach a painting setup, and much depends on how you like to work. For abstract paintings, you may want to be able to carry the painting easily from wall to table to floor. Such portability will let you take advantage of exciting drips, control the direction of a pour or easily fling or spray paint at will. Use a simple metal easel, which doesn't take several knob turnings to release the painting. If you work standing at a low table for long periods of time, adjust it accordingly to prevent back problems. Also wear comfortable shoes and consider using rubber floor mats when working standing up. A chair that can be raised to a higher height than a normal office chair will work well with an easel or a higher table height.

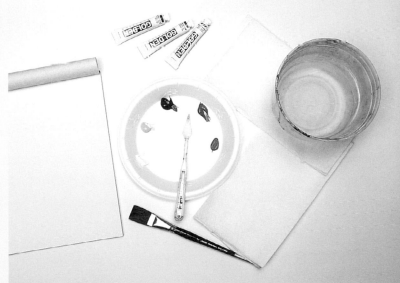

painting area

To use this circular setup, load your brush with color and paint. When you feel the paint pull, or you need to change colors, move your brush to the paper towel stack closest to you. Wipe off the excess paint on the paper towel and insert your brush into the container of water and move it around along the bottom. Remove the brush from the water, blot it dry on the other stack of paper towels, reload your brush with color from the palette, and resume painting.

glossary

Absorbent: Capable of accepting and holding moisture. Generally, smooth and glossy surfaces are less absorbent than toothy and matte surfaces.

Acid-free: Paper is considered acid-free when there is no acid in the pulp, resulting in a pH of 7.0.

Acrylic paint: Paint with a *polymer vehicle*.

Additive: A substance added to paint that alters the quality and characteristics of the basic mixture. Additives can be mixed with paint only in limited amounts.

Archival: Refers to a process, procedure, method or product that can preserve the quality or extend the life of an artwork.

Atmospheric depth: The feeling or quality of three dimensions created on a two-dimensional surface.

Binder: The main ingredient, other than *pigment*, used to create a paint. The binder is the main *vehicle* that identifies the art medium. Acrylic is the binder for acrylic paint. (See also *medium*.)

Bleed: Paint that runs into an adjoining area or up through coats of paint. A bleed can also be a halo effect or blurred edge around a brushstroke or color shape.

Brayer: A hand roller typically used to apply ink to a printing surface; brayers are often used for other tasks such as flattening a bumpy surface.

Chroma: The intensity of a color. A very bright color has a high chroma. A dull or muted color has a low chroma.

Cold press: A paper with a slight surface texture produced by pressing a finished sheet between cold cylinders.

Collage: A combination of a variety of images, shapes and materials attached together to form a new collective image.

Color field: A large area of pure color. A color-field painting is usually an abstract composition consisting of pure color with minimal attention to form, shape and imagery.

Consistency: The quality of fluidity in a mixture of paint.

Contrasting: Dramatically different or opposite. Contrasting elements in art include light vs. dark, hard vs. soft edges and geometric vs. organic form.

Deckle edge: A feathery edge that results from the natural run-off of wet pulp during the production of handmade and mouldmade paper. It can also result when a sheet of paper is torn while wet. The deckle is simulated in machine-made paper by "cutting" it with a stream of water when the sheet is still wet.

Depth: This can refer to the actual thickness of an art work, as well as to the illusion of three-dimensional space on a two-dimensional surface.

Dilute: To add water or some other solvent that breaks down the natural *binder* in paint.

Drybrush: Painting with a brush that is not heavily loaded with paint.

Embedding: The act of implanting an object into thick layers of paint.

Encaustic: A method of painting with hot wax mixed with pigment.

Fluid acrylic paints: Acrylic paint made with a minimum of thickeners so that it is fluid and pourable.

Fresco: Painting with pigments on plaster. This ancient method is still used today.

Gel: A thickened acrylic *medium* or *binder* that can be used alone or mixed with paint to create *texture* and *transparency*.

Gesso: An acrylic primer, usually white, used as a painting base to aid adhesion. Also used as a base for oil paintings to protect the painting support from the effects of the oil.

Glaze: Paint mixed with enough *medium* or clear *binder* to create an even layer with a high level of *transparency*.

Gloss: A finish with a high *sheen*.

Grisaille: The technique of underpainting with grays then applying transparent or semitransparent glazes.

HDPE: High-density polyethylene, a type of plastic that will not stick to *acrylic paint* and is useful for paint containers, *palettes* and protective sheeting.

Heavy body paints: A thicker type of *acrylic paint* with a creamy quality that facilitates brushstroke retention.

Hot press: A paper with a smooth surface produced by pressing a finished sheet between hot cylinders.

Hue: The name of a color with a position on the color wheel.

Image transfer: Duplication of an inked image by moving some of the ink from one surface to another.

Impasto: Textural painting with thick paint.

Inorganic pigments: *Pigments*, generally from natural mineral sources, that are somewhat opaque and have a matte finish. Also referred to as *mineral pigments*, they have familiar, traditional names like Burnt Sienna. (In this book, *inorganic pigments* are referred to as *mineral pigments*.)

Intensity: Another word for *chroma*.

Interference paint: Paint made with a new technology that causes it to reflect and refract light in an unusual way, producing shifts in color when the paint is viewed from different angles.

Isolation coat: A clear coat used between layers of paint to seal one surface before adding another. An isolation coat can also offer a *nonabsorbent* finish for varnishing. In addition, isolation coats can contribute refractive qualities to a painted surface.

Layer: Any combination of wet paints or other materials applied at the same time. Once this dries, it becomes one layer and anything applied on top becomes another layer.

Marbleize: A process that creates a multicolored swirling pattern resembling the natural patterns in marble.

Masstone: The full-bodied color of a pigmented paint when applied thickly.

Mat board: A sturdy piece of cardboard somewhat thicker than poster board.

Mat knife: A knife with a changeable blade used for cutting *mat board*.

Matte: A finish with little or no shine. Rough surfaces usually produce a matte finish. (See also *matting agent*.)

Matting agent: A fine white powder added to acrylic products such as *mediums*, *gels* and *varnishes* to create a *matte* finish.

Medium: The main ingredient in a particular paint, but without the colored pigment. The medium can be used straight to create a sheen in a painting or be mixed into a paint to enhance its characteristics. (See also *binder*.)

Mineral pigments: See *inorganic pigments*.

Mixed media: refers to compositions with a variety of art ymediums such as *collages* or other works that incorporate found materials.

Modern pigments: See *organic pigments*.

Nonabsorbent: Capable of repelling moisture. Generally, smooth, glossy or sealed surfaces will not allow liquid to be absorbed.

Opacity: The degree to which a paint can hide the color underneath; opposite of *transparency*.

Open time: The amount of time a paint stays wet and malleable.

Organic pigments: Pigments, usually synthetically produced, that are somewhat transparent, have a glossy finish, create very strong tinting and coloring paints, and have odd sounding names like Phthalo. Also referred to as *modern pigments*. (In this book, *organic pigments* are referred to as *modern pigments*.)

Overpaint: Applying a new paint layer over another.

Over water: Adding water to acrylic paint in a 2 to 1 ratio to break down the binder to create washes and staining effects.

Painting support: A material or substrate to paint on. (See also *painting surface*.)

Painting surface: The top layer of a painting or *painting support*.

Palette: A tool for holding and mixing paints and products used during painting.

Palette knife: A tool with a flat blade used for mixing and applying paint.

Pigment: A finely powdered coloring material used to make paint. Pigment can be obtained from natural sources or be synthetically produced.

Polymer: A long molecule made up of a chain of smaller, simpler molecules. *Acrylic paint* is made from a polymer emulsion.

Resist: A nonabsorbent material applied to a surface to keep the paint from staining or being absorbed.

Retarder: An additive used to slow down the drying time of acrylic paint.

Satin: See *semigloss*.

Scrafito: The technique of scratching line designs through a top layer to reveal the layer underneath.

Semigloss: A *sheen* somewhere between *gloss* and *matte*. Also referred to as *satin*.

Sheen: Refers to the reflective quality of a surface. Sheens are characterized as *glossy* or *semigloss/satin*. *Matte* surfaces have no sheen.

Stain: Thin, transparent, diluted paint absorbed by a surface.

Stencil: A repeatable pattern for painting designs.

Substrate: Any material such as paper, canvas or board onto which paint is applied.

Support: See *painting support*.

Surface: See *painting surface*.

Tempera: Traditionally, the use of egg and pigment to create a paint. Tempera also refers to cheaper media such as poster paint which does not use egg.

Texture: A raised relief or tactile pattern on a painting's surface often created by *impasto*. Texture can also be visually perceived as a patterning effect, even without a raised relief.

Tooth: The texture of a paper, canvas or other ground that helps hold the paint.

Transfer: See *image transfer*.

Transparency: The degree to which a paint can reveal what is underneath.

Undertone: The color of a pigmented paint when applied very thinly.

Varnish: A top coat or finish; a painting varnish. To be *archival*, a painting varnish must be removable.

Vehicle: Another word for a paint *binder* or *medium*. It usually identifies the art medium. The vehicle is combined with a colored *pigment* to create a paint. See also *binder*.

Veiling: A semitransparent paint or product applied to a surface to partially hide what lies underneath.

You Can Paint on Anything

Acrylic can be painted on just about any support. Select among the many choices in this section for convenience, longevity and aesthetics.

1

canvas

Canvas is commonly used as a painting surface and offers many advantages: it's absorbent, has a wonderful fabric texture, is lightweight and portable. Canvas supports come in three types: unstretched, stretched and commercially made canvas boards. Canvas paper also comes in pads, but canvas paper feels very slick, not at all like real canvas fabric.

Stretching it yourself takes practice. You'll need wood stretcher bars, a staple gun and stretcher pliers. Assemble the stretcher bars and square up. Wrap the canvas around the bars and tack it down in the back, pulling it tightly each time. Start from the center and work outward. Stretched canvases can be purchased in standard sizes, or custom-made by your art store or framer. Those that are mass-produced with a machine can sometimes cost about the same or less than supplies for stretching it yourself.

selecting canvas

Canvas comes in three weights: light, medium and heavy. Use lightweight for smaller works, medium-weight for medium-sized works and heavyweight for larger pieces. The quality of canvas varies depending on the weave—the tighter the weave, the more expensive. If you are painting a realistic, detailed portrait with thin applications of paint, use the tighter weave. A coarse weave can add an interesting element to a textural landscape or abstract painting. Canvas also comes pre-primed or raw. It is easier to stretch an unprimed canvas, but a pre-primed canvas allows you to skip the priming step and start painting sooner.

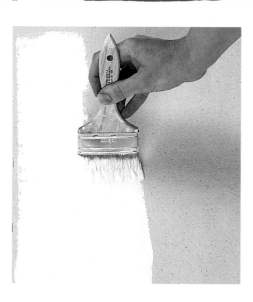

priming unstretched canvas

Unstretched canvas will shrink after priming with gesso. Secure the canvas to a wall or a board before priming. Apply one coat of diluted gesso, using a wide brush. Unless the directions on the can indicate otherwise, do not dilute the gesso for the second coat. Brush in a different direction from the first coat.

Priming Your Canvas

There are many reasons to prime your support. A primed canvas increases paint's drying time, increases paint adhesion to the surface and creates a brilliant white surface, making your colors look brighter.

priming stretched canvas

Prop the canvas up on jars or blocks of wood to lift it off the table or floor. Apply gesso to the front and sides using the same method as for applying gesso to unstretched canvas.

Fixing Dents and Bulges

If you get an indentation or bulge in the stretched canvas, thoroughly spray the entire back of the canvas with water. The canvas will then dry smooth.

paper and cardboard

Paper and cardboard are great support choices if you are a beginner or just want to experiment. Both are economical and easy to find. Both have absorbent surfaces that make washes and over-watered acrylic techniques possible. Select acid-free papers or cardboard, which are more archival and will not have impurities that might stain through into your painting.

SELECTING PAPER

Paper comes in three general categories, each of which is fine to use with acrylic: watercolor paper (for water-based mediums), printing papers (for use with inks, paint and printing presses) and bristol (for drawing). There are also acrylic paper pads available that resemble watercolor paper. Paper also comes in different weights. If you are working with thick layers of paint, use a heavier-weight paper to minimize warping or curling.

Watercolor paper comes with different surface textures. Hot-press watercolor papers are smooth, while cold-press papers are medium-textured. There is also a rough-texture available. Printing papers come in many varieties. Stonehenge is a fairly inexpensive printing paper with a wonderfully absorbent yet strong surface, and a slightly toothed texture. Bristol has two surface types: plate, which is smooth, and vellum, which is smooth to the touch but has more tooth than plate.

Before painting, tape your paper down to a stiff, portable surface such as wood or foamcore board. If the paper warps too much while you are working, gesso the back. If you haven't started painting yet, you can stretch the paper. To do so, tape the paper securely to a strong board. Spray or wipe the entire surface with water and let it dry. It will curl slightly while wet, then restretch itself flat. When you work on it again, it will remain flat.

SELECTING CARDBOARD

Cardboard comes in many forms. Art stores sell an acid-free board called museum board. Mat board is a bit cheaper. You can also buy inexpensive scraps of cardboard, sometimes called "backing boards," cut for framing. Sometimes you can get these for free at frame shops. Other great supports in this category are foamcore board or a stronger type of foamcore called Gator board. These are lightweight and absorbent, but a bit stronger than regular cardboard so they won't warp as easily.

Making the Best of Your Mistakes

A fun way to reuse failed or unfinished paintings on paper or cardboard is to tear them up into smaller pieces, then arrange these pieces onto a new surface for a collage. See technique 55 for gluing tips.

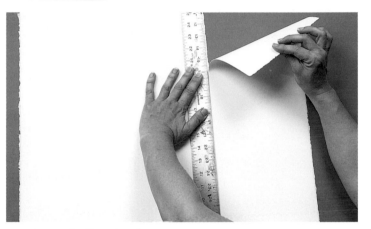

creating a deckle edge for your paper

A deckle edge is a beautifully ripped edge found on nicer sheets of paper such as Arches 140-lb. (300gsm) cold press. Hold a strong metal ruler down at the place to be ripped. As you press down on the ruler with one hand, use the other hand to tear the paper along the ruler's edge.

priming your paper or cardboard support

Priming the front of your support will change the absorbency of your surface. If you do not want this change, don't prime. Priming the back, however, will keep your support from curling while you paint. Using a wide brush, apply undiluted gesso to the back surface. Let it dry for 20 minutes, or longer if necessary.

wood and composite panels

Wood is a great support for paintings, especially for thick applications of paint and other techniques that require a rigid, sturdy support. There are many types of natural wood available, as well as composites such as Masonite, high-density fiber board (HDFB) and medium-density fiber board (MDFB). Birch makes a great thin, lightweight panel for large paintings.

Wood has many impurities, resins and other natural elements that may seep through into the paint layers, causing stains and yellow-ing. Always clean the surface first, coat it with a stain sealer, then prime before painting.

Composites are strong and have the feel of wood but don't have a natural wood grain. Another type of composite product is particleboard, which is made of pressed sawdust. Moisture will cause particleboard's surface to swell, so sand it after the first few coats of sealer and primer to smooth out the rough surface, and it should remain smooth for subsequent coats and painting.

MATERIALS

Wood or panel support
Denatured alcohol
Rag
Commercial water-based sealer
Acrylic gesso
Flat brush

reinforce the back of the panel

If the pieces of wood are ¼-inch (6mm) thick or thinner, have them braced or cradled on the back to create a wood panel. This will add support to keep it from warping and make handling easier.

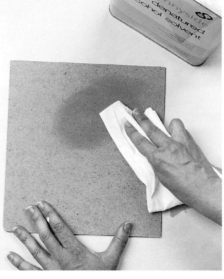

1 PREPARE AND CLEAN THE SURFACE

Clean the surface with a rag and denatured alcohol.

Dealing With Knots

Knots in natural wood are apt to discolor or stain and should be sealed. Fill them with putty or paste before sealing for a level surface.

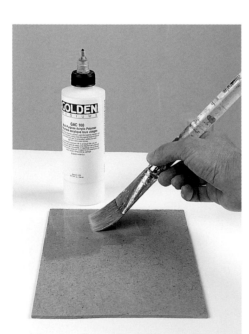

2 APPLY A SEALER

Apply a commercial sealer according to the manufacturer's instructions to the face or front of your wood panel. For more information about staining, called Stain Induced Discoloration (SID), see technique 103.

Use Untempered Masonite

Buy untempered Masonite rather than tempered Masonite, which is impregnated with oil or resin and may cause adhesion problems. You can tell the difference because tempered Masonite is darker and heavier than the untempered variety.

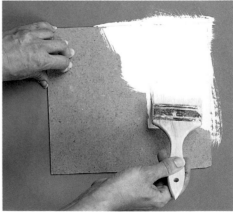

3 PRIME

Prime with 1 or 2 coats of undiluted acrylic gesso.

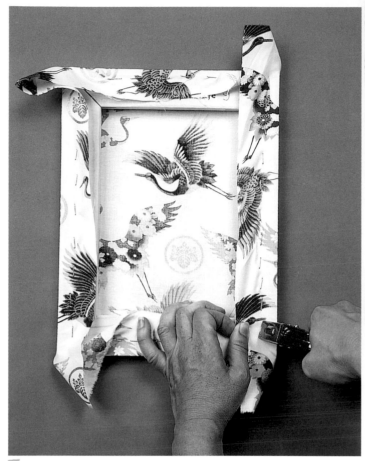

patterned fabric

I love browsing in fabric stores to get ideas for colors, patterns and textures. Sometimes I buy small pieces of fabric just to hang around my studio for inspiration. A fun technique is to take your favorite fabric and use that as the starting surface to begin a painting. No need to stare at that white canvas with fear. Get a jump-start by beginning your painting with colors and patterns already there!

MATERIALS

Cotton fabric, medium- to heavyweight

Stretcher bars

Staple gun and staples

Matte medium

Flat brush

1 STRETCH THE FABRIC

A medium- to heavyweight cotton fabric works best because it's strong enough to be stretched onto wooden stretcher bars without sagging after paint is applied. Cut your fabric 4 inches (10cm) larger than the size of your stretcher bars. Start stretching the fabric in the middle and work your way outward. Use a staple gun to secure fabric around to the back.

Fabric designed by Michael Miller Fabrics, LLC

Extra Tips for Working with Fabric

- Glue lightweight fabrics onto a rigid support such as wood, panel or cardboard using the directions in technique 55 for gluing paper. You can also glue thin fabric onto a stretched canvas. Just add support under the canvas and follow the same gluing technique.
- Acrylic paint will stiffen the fabric a bit. If you want to minimize stiffness and keep the fabric freely flowing to use for clothing or a scarf, see the instructions for technique 5, painting on silk.
- Golden has a special product for use with fabric called GAC 400. It is a fabric stiffener (similar to the fabric sizing known as rabbit skin glue). Try using GAC 400 as a primer and compare it with matte medium. The choice is yours, but both work very well.
- When painting on patterned fabric, it is important to use transparent painting techniques, such as the acrylic washes explained in Section 3 or techniques 82 and 88, to allow the fabric's pattern to show through.

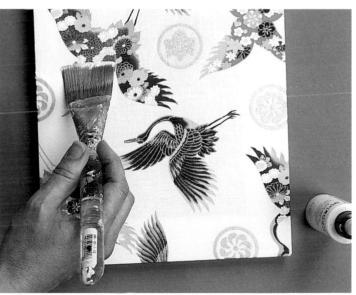

2 PRIME THE FABRIC

Use matte medium brushed on with a wide, flat brush to prime the fabric. (Do not use gesso or it will cover the beautiful pattern.) Dilute the medium if that will help it to soak into the fabric. If you use a diluted medium, apply two coats; otherwise one coat should be sufficient. Let this dry 6 to 8 hours before painting.

silk

If you want to paint on silk and hope to keep the fabric soft and freely flowing to use as a banner, fabric installation or wearable art, fluid acrylics offer a more stable alternative than fabric dyes. Dye works well on silk, but is not as lightfast and stable as acrylic. This technique demonstrates how to use acrylic on silk for durable, lightfast, washable color, while maintaining the softness of the fabric. This technique may be used on fabrics other than silk.

MATERIALS

Silk fabric

Embroidery hoop or other fabric support

Fluid acrylic paint

Golden's Specialty Acrylic Polymer GAC 900

Brush

Palette knife

Golden's Acrylic Flow Release (optional)

1 SECURE THE SILK

Secure the silk to a stable surface to make it easier to paint and to control your brushstrokes. The method you choose should be temporary; use pushpins, staples, fabric tacks on stretcher bars or an embroidery hoop.

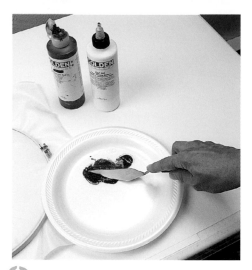

2 PREPARE YOUR PAINT

To keep the fabric from stiffening, dilute your fluid acrylic paints with 1 part GAC 900 to 1 part paint. This will also make the paint launderable (with the heat setting described in step 3) and keep the fabric soft. If these qualities are not important for your work, you can use acrylic paints straight.

Extra Tips for Painting on Slik
- Try substituting Golden's Airbrush Medium for the GAC 900.
- For additional durability and color stability, try spraying a light coat of GAC 900 on your finished piece.
- For working thickly on fabric, use Golden's Silkscreen Fabric Gel with the thicker lines of acrylic paints.

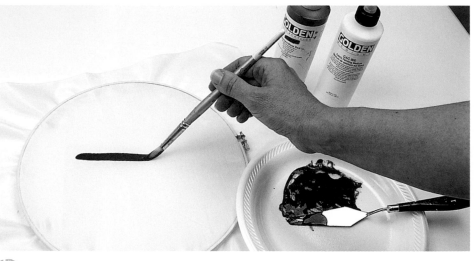

3 PAINT ON THE FABRIC AND HEAT SET

Using the paint mixture made in the previous step, apply to the dry silk using a brush.

Let the fabric air dry to the touch, then use one of these heat-setting options: Iron for 3 to 5 minutes on medium-hot (or longer if you need to use a cooler iron), heat set for 1 to 2 minutes at 300°F (177°C) in an oven [or 4 minutes at 250°F (121°C) for more delicate fabrics], heat set in a commercial clothes dryer on medium/high for 20 to 40 minutes or a household dryer at high temperature for 40 to 50 minutes. Let the paint dry thoroughly at least 4 days before washing. Hand-washing and drip-drying is better than using a washing machine and clothes dryer.

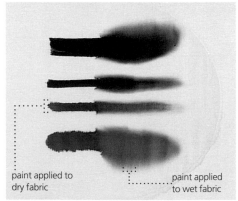

paint applied to dry fabric

paint applied to wet fabric

staining effects

If you want to control the bleeding or spreading of colors, use Acrylic Flow Release. Dilute it with at least 10 parts water to 1 part flow release. Then, either mix the flow release into your paints and use this mixture on the silk, or apply the flow release directly to the fabric and paint while it is still wet. Experiment to get the effects you want.

6

metal

The two issues of concern for preparing a metal support are adhesion and rust control. This technique works best for ferrous metals like steel, and will provide a long-lasting rustproof support for indoor or outdoor use, suitable for coating with acrylic paint. There are many types of metal to choose from. Research safety issues, availability and necessary additional preparation. This demonstration uses 11-gauge, ⅛-inch (3mm) Mild Steel. Whatever metal you choose, have it professionally cut to your specifications.

MATERIALS

Sheet metal cut to desired shape and size
Metal primer
Priming brush or sprayer
Xylene or lacquer thinner
Strong soap
Rags
Sandpaper or wire brush
Acrylic paints
Golden's Acrylic Polymer GAC 200
Clear protective finish

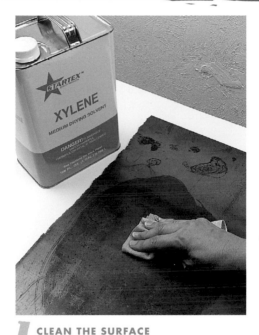

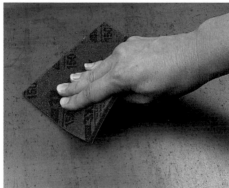

2 ABRADE THE SURFACE

Sand the metal to add tooth to the surface. (Skip this step if the surface has been sandblasted). Use a fine-grit sandpaper such as 150 or 220 to work wet or dry.

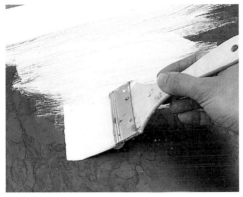

3 PRIME THE METAL

For ferrous metals, apply a white ferrous metal primer with rust inhibitors. For nonferrous metals such as aluminum or stainless steel, use a primer designed for that type of metal. If a smooth finish is desired, use spray equipment. Follow the instructions on the container for drying times and further directions.

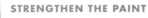

1 CLEAN THE SURFACE

Clean the metal's surface with strong soap and water, remove any rust with a wire brush or sandpaper, rinse and let dry. Remove any oil coating with a rag and xylene or lacquer thinner. The oil coating can also be removed by sandblasting.

4 STRENGTHEN THE PAINT

Let the primer dry about 24 hours, then coat it with acrylic paints. Mix GAC 200 Acrylic in a 1:1 ratio with your acrylic colors to add durability, then apply a clear protective finish, suitable to the metal you are using, with UV protection. The artist painted this car by using both airbrush and brush, with acrylic paints applied directly to metal.

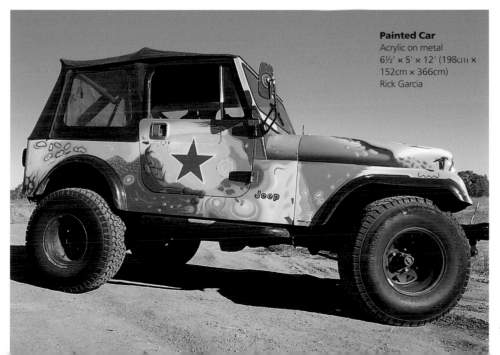

Painted Car
Acrylic on metal
6½' × 5' × 12' (198cm × 152cm × 366cm)
Rick Garcia

glass

One reason to paint on glass is to take advantage of its clarity. The main concern with painting on glass is adhesion. Etching or sand blasting the surface will add tooth. Both methods will make the glass slightly cloudy, so etch only in the areas where paint will be applied. Use the technique below (taught to me by Tucson glass artist Elle Lowe) to etch in selected areas.

Purchase glass at any glass supply store and have it cut to size. *Float glass* and *window glass* are smooth, clear, inexpensive choices that will work well. Glass also comes colored or textured. If you are sandblasting, use glass that is at least ¼-inch (6mm) thick. If your glass piece will be freestanding, cover the sharp glass edges with framing.

MATERIALS

Glass
Dish soap and degreaser
Contact paper
Craft knife
Single-edged blade
Brush or sponge applicator
Etching solution
Acrylic paint
Golden's Acrylic Polymer GAC 200 (optional)
Clear acrylic spray finish

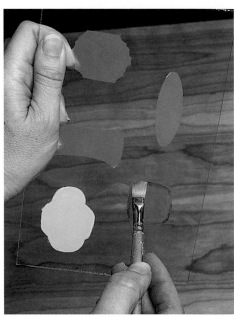

1 CLEAN THE GLASS

Clean the glass using a rag soaked with liquid dishwashing soap, diluted 1:10 with warm water. Wipe the glass with denatured alcohol, glass cleaner or distilled vinegar to remove any grease. Clean both sides of the glass. Be careful handling the edges, as they may be sharp.

Etching Alternatives

If the painting will be kept indoors and durability is not an issue, skip the etching step and add GAC 200 in a 1:1 ratio with your paint. You could also use a clear primer, which is available at craft and hobby stores (look for glass surface preparation products).

2 MASK AND ETCH THE GLASS

Cut a piece of contact paper the same size as the glass. Remove the backing and smooth it onto the glass, adhesive side down. Remove air bubbles using your fingers or a brayer. Draw a pattern using pencils or other tools. Cut along the lines with a craft knife. Peel up the contact paper, and burnish the edges of the unwanted contact paper near the exposed areas.

Using a brush or sponge applicator, apply etching solution on the exposed glass, following the manufacturer's instructions and precautions. Leave this in place for 5 to 10 minutes. Rinse off with warm water. If the glass is still clear, repeat the etching step until slightly cloudy. Remove the remaining contact paper.

3 PAINT THE ETCHED GLASS AND SEAL

Apply any acrylic paint over the etched surface of the glass. For a variety of translucencies and to imitate stained glass, try using different opacities of paint (see techniques 82 and 83). Keep within the edges. Wipe off any overflow paint immediately. If some paint dries in unetched areas, remove it with a single-edged blade. For extra durability and adhesion, add GAC 200 to your paint in a 1:1 mixture. Add a sheen and protective coating with any clear acrylic spray finish.

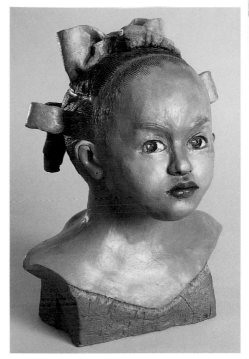

The artist first sculpted this porcelain portrait, then applied an undercoat using a bright color. Additional acrylic paint for the features was built up in layers. (See techniques 88 and 89.)

Four-Year-Old Dominican Girl (Self Portrait)
Acrylic on porcelain
13½" × 10" × 8" (34cm × 25cm × 20cm)
Julia Santos Solomon

8 objects

Painting on 3-D sculptures or objects encourages you to think differently because the object needs to be considered from all angles. You can make your own ceramic sculpture, have a metal shop cut shapes according to your template, or just use an interesting shell, branch or rock. You can also purchase ready-made objects in lawn and garden shops or hobby and craft stores. If the ready-made object is already painted, lightly sand it, prime with acrylic gesso and repaint. Contact the manufacturer's technical department to get recommendations for cleaning and priming. If you are placing the finished artwork outdoors, ask about special sealants or protective finishes, and use paints that rate high on light-fastness tests to keep your art from fading quickly. For information on metal and glass, see techniques 6 and 7.

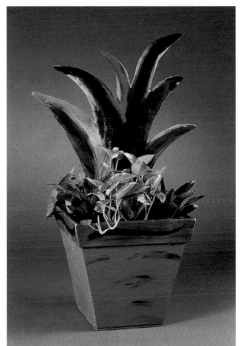

This planter pot is constructed from sheets of steel, welded together. The leaves also are cut from steel. The metal was then primed and painted with a combination of acrylic paint and GAC 200 (see technique 6). Texture was created by scratching the wet paint with rubber tools, and water-soluble crayons were used to add details. (See techniques 6, 43 and 70.)

Planter 2
Acrylic on metal
33" × 17" × 15" (84cm × 43cm × 38cm)
Patricia Forbes

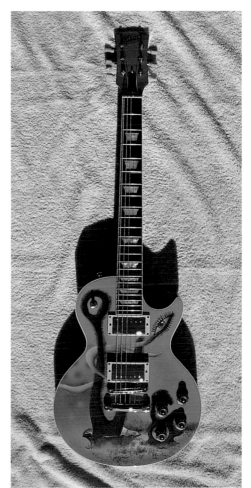

Make It Stick
For challenging and difficult surfaces, try the adhesion-enhancing products made by X-I-M Products, Inc. (www.ximbonder.com).

To paint this Gibson guitar, the artist started with a raw wood guitar, then primed it with tinted gesso. In addition to traditional painting techniques, the artist used an airbrush, taping off some areas prior to painting. The guitar was finished with five coats of polyurethane, each coat sanded before the next was applied. (See techniques 67, 77, 89 and 90.)

Painted Gibson Guitar
Acrylic on wood
36" × 14" × 2½" (91cm × 36cm × 6cm)
Rick Garcia

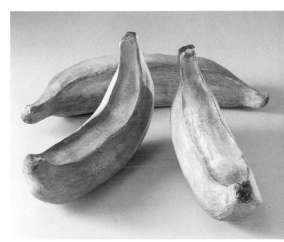

The artist sculpted these plantains using terra cotta. An initial dark color of acrylic paint was applied as an undercoat, then more acrylic paint was applied and built up in layers. (See techniques 88 and 89.)

Plantanos
Acrylic on terra cotta
10" × 1½" × 2½" (25cm × 4cm × 6cm)
Julia Santos Solomon

You Can Paint With Anything

Using unusual painting tools will make you feel like a kid again. Your hand will work in new ways, and fresh ideas will pop into being. Even the conventional, reliable brush can create interesting and varied brushstrokes.

9

dancing with brushes

Four factors affect your brushstrokes: your grip, the pressure you apply, the direction of your stroke and the consistency of the paint.

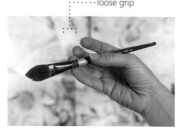

tight-fisted grip loose grip

grip

Load a generous amount of paint onto your brush, then try holding your brush in the following ways while painting: 1) Use a tight-fisted grip, 2) Use a loose grip, 3) Hold the brush in your opposite hand, 4) Hold the brush high on the handle, 5) Hold it low, close to the bristles, 6) Grip the brush loosely and roll it between your fingers while moving the brush across the page.

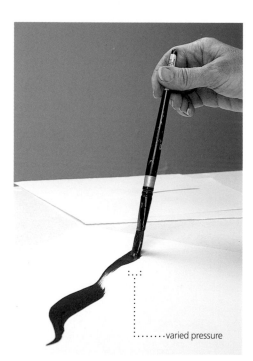

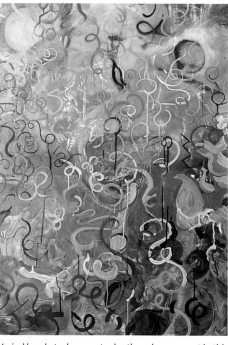

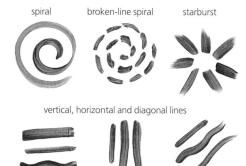

spiral broken-line spiral starburst

vertical, horizontal and diagonal lines

direction

Using your favorite grip and pressure from the previous exercises, try creating different patterns. Remember to keep loading your brush with paint.

varied pressure

pressure

Load a generous amount of paint onto your brush. Press the brush into the paper so the bristles are flat against the paper for a heavy stroke. Use consistent pressure. Now use with a very light pressure, so light that the bristles hardly touch the paper. Now try to vary the pressure as you go across the page.

Varied brushstrokes create depth and movement in this painting. (See techniques 31, 34, 37, 38, 39 and 40.)

Veil
Acrylic on canvas
40" × 30" (102cm × 76cm)
Nancy Reyner

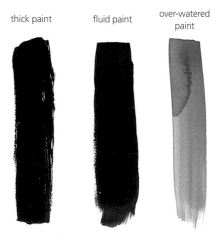

thick paint fluid paint over-watered paint

paint consistency

Thick paint shows the texture of the brushstroke, while thinned paint flows more easily. You can buy paint that is already thick or thin, or you can dilute paint with water—but this will also dilute the color. Over-watered paint is created by adding water to paint 2:1.

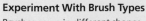

Experiment With Brush Types
Brushes come in different shapes, such as round, flat and filbert. Bristles may be natural, synthetic or a combination. There are short- and long-handled brushes, and a variety of bristle sizes.

palette knives

A popular painting technique called *impasto* uses palette knives to apply paint in heavy layers. These paintings have texture! Use thick paint or add gel to fluid paints to increase volume. The knives leave a characteristic impression similar to icing on a cake.

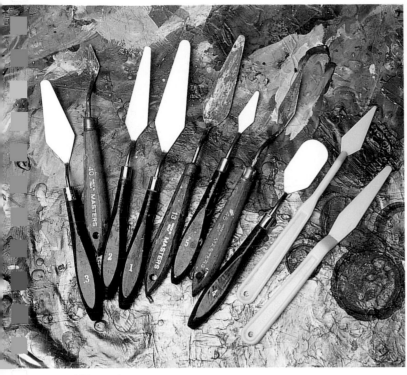

try different knives

Many types of palette knives are available. You can find them in art stores as well as hardware and paint stores. Either plastic or metal will work just fine. Try the ones with stepped handles, which keep your hand from dragging through the paint. Stepped handles usually add spring action to the knife, which gives zest to the handling. Try using different sizes for different textural indentations.

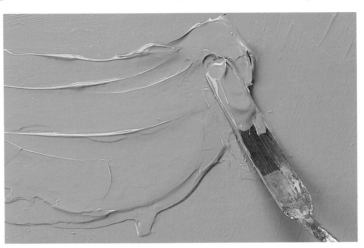

palette knife moving in a sweeping curve

Clearly visible texture can become a focal point in your work. Pay attention to how you move your knife to create interest or texture: if you move it only in one direction, the effect can become boring. I like to move my wrist in all directions, following the contours of the object I'm trying to shape. It feels a bit like sculpting in clay.

accumulation of small dabs

A variety of textures can be created with the palette knife. Here texture is built up with an accumulation of small dabs of paint in various colors.

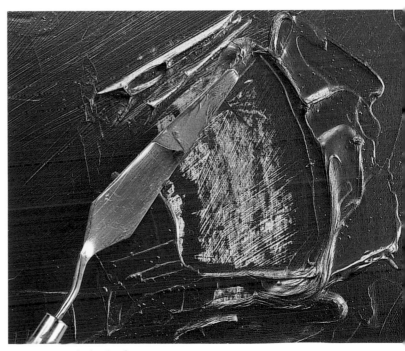

scraping with the knife

Here the side of the palette knife is used to scrape away copper paint while it is still wet.

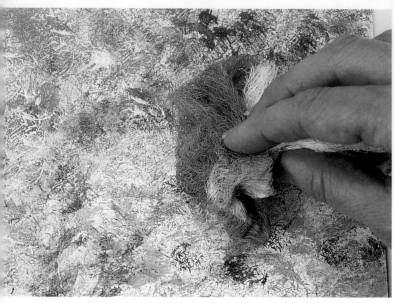

cheesecloth and rags

Rags are inexpensive, easy to find and fun to paint with. Rags can be used to apply or remove paint. You may want to wear protective gloves, as rag painting can get fairly messy. Lint-free rags are the best, but in a pinch paper towels will work. Rags can be rinsed out (before the paint dries) to be reused.

applying paint with a cheesecloth

Try using cheesecloth, which has a coarse weave and gives a noticeable textural pattern. Scrunch up the cheesecloth in your fist. Hold it loosely without smoothing it out and dip it into one or more fluid colors. Press gently onto your surface. Repeat to create overlapping colors.

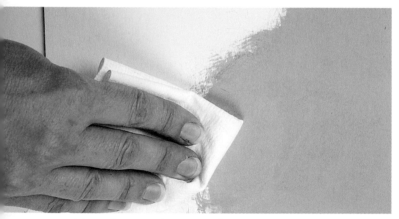

rubbing for smooth, even color

Use a tighter weave cotton rag, preferably one that is lint free. Fold up the rag so that it is a manageable size and has a smooth area. Dip the smooth section of the rag into your paint. Wipe the color in wide strokes to spread it out thinly and evenly. If you get streaks, turn the rag over, use a drier area and continue wiping until the streaks are gone. You can also add some retarder or acrylic glazing liquid to the paint to keep it from drying too quickly. (See technique 74.)

Additional Ragging Techniques

- Create texture by removing excess paint while the paint layer is wet. Working quickly, scrunch up your rag and push it into the painted surface. Dab and pull at it to pick up paint. A damp rag will produce different results than a dry rag, so try both.
- Make the paint come off cleaner as you rub and rag by brushing on gloss medium to seal the surface. Once the gloss medium is dry, add paint.
- Slow the drying process by adding retarder to the paints before you use your rag to rub the surface.

using cloth as a stencil

Lay cheesecloth on your support and lightly spray it with water. Blot excess water with paper towels. Slightly dilute the paint by adding about 20% water. (The paint needs to be fluid enough to run into the crevices of the cheesecloth, but not so diluted that it will lose the textural impression of the fabric.) Apply the paint to the cheesecloth using a brush. Let it dry for about 10 or 15 minutes, until it is almost dry but not completely. Remove the cheesecloth. The impression of the cheesecloth will be visible in the dried paint.

12

string
This playful technique creates rainbow-colored lines.

MATERIALS
Painting support
Cotton string
Fluid acrylic paints

1 PREPARE THE COLORS
Select several colors and put a small amount (about the size of a dime) of each on your palette, about ¼-inch (6mm) apart. If you are using thick acrylic paint, thin it with a small amount of water.

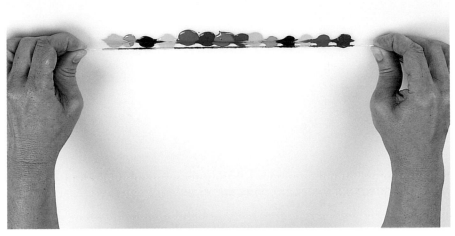

2 COLOR THE STRING
Cut a length of cotton string and let it fall onto the palette directly on the globs of color. Grasp the string at the ends and twist so it rolls in the paint, soaking the string with color on all sides. Move the string back and forth while holding it tightly on both ends, so the colors on the palette start to spread out and touch each other, filling in the gaps and creating a continuous rainbow.

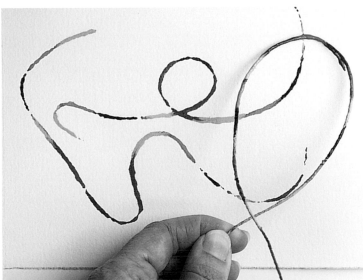

3 DRAW SHAPES WITH THE STRING
Pick up the wet string and transfer it to your painting support. Let it drop haphazardly, or control it to create a specific shape.

4 CREATING LINE PATTERNS WITH THE STRING
Here the string is stretched several times across the support to create multicolored lines.

sponges

Many faux finishers use sponges to simulate textures such as marble, stone or fabric. You can use commercial sponges or select from an array of natural ones found in art stores as well as health stores and spas. Natural sponges offer wonderful organic patterns and can be used like the scrunched cheesecloth in technique 11 for applying paint. I also like to use those inexpensive throwaway "brushes" made of sponge rubber, called *sponge applicators*, found in home improvement stores. They start to fall apart after a few painting sessions, but are rather fun to use. For this demonstration I used a commercial house painter's sponge roller found in the paint department of my local home decorating store.

MATERIALS

Painting support
Sponge-covered paint roller

Painting tray
Scissors or mat knife
Acrylic paint

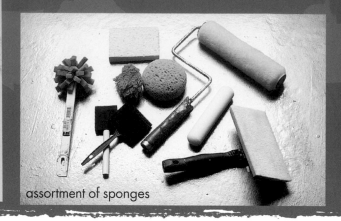

assortment of sponges

1 PREPARE THE SPONGE ROLLER

Using scissors or a mat knife, cut patterns into the sponge roller.

2 LOAD THE ROLLER AND APPLY PAINT

Pour some acrylic paint into a painting tray. The paint should be fluid, so add water if the paint is too thick. Roll your paint roller back and forth in the tray until it is fully coated with paint. Now roll your paint roller over the painting surface. Here the support was previously painted a light blue and then left to dry. The roller was then coated with dark blue. The cut patterns leave the background color showing through.

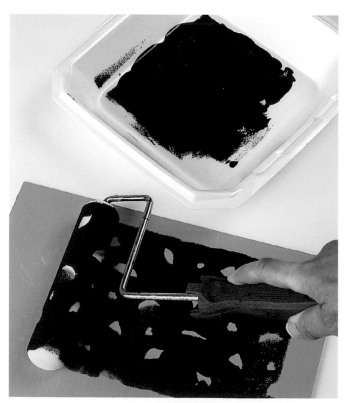

Selecting a Paint Tray
Use a paint tray that is the same size as your roller. If the tray is too big, you will waste paint. If it is too small, you can't load your roller. I like to reuse those disposable plastic trays used for restaurant leftovers.

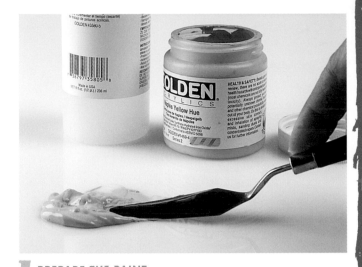

brayers

Brayers are generally used for printing techniques. If you have ever worked with monoprinting, you have probably used brayers to apply paint evenly on your glass plate. For painting with brayers, it is best to use a wooden or composite panel, cardboard, or another flat, rigid support. If you are working on stretched canvas, you will need to place it flat on a table or floor and add some support underneath.

MATERIALS

Painting support	Acrylic paint
Brayer	Retarder
Sturdy palette	Palette knife

1 PREPARE THE PAINT

Select your color and add retarder to the paint in a 1:9 ratio. Add water if necessary, but keep your paint the consistency of soft-serve ice cream. Mix thoroughly with a palette knife. The paint will start to dry quickly, so keep it lumped together in a pile until you are ready to use it.

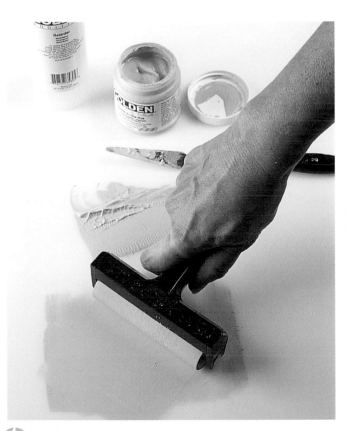

3 ROLL COLOR ONTO YOUR SUPPORT

Using the loaded brayer, roll the color onto your support. To apply the color smoothly and evenly, change directions frequently. Clean your brayer with a wet rag and repeat with other colors for different areas of your support.

using several colors to create a rainbow effect

To get a rainbow effect, prepare three colors with retarder. Place the colors on your palette in a line. The colors should be close enough so the line does not exceed the width of the brayer. Roll your brayer into the colors up and down across the line of colors. When the brayer is completely coated with paint, pick a clean area on your palette and roll the brayer a bit more until the colors start to blend softly, then roll the brayer onto your painting surface.

2 LOAD THE BRAYER

Using a palette knife, spread a line of paint across the palette. Roll your brayer in the paint to start to collect the color. Find a clean place on the palette where you can roll your brayer several times in slightly different directions to distribute the paint evenly over the roller.

eyedroppers

Save those old eye-dropper bottles from discarded medicines.
These make great painting tools.

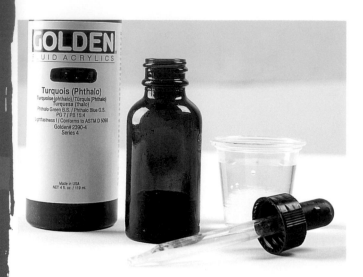

MATERIALS
Painting support
Several eyedropper bottles
Fluid acrylic paint

Spray bottle with water
Flat brush
Paper towels

1 PREPARE THE PAINT

Select an acrylic paint color, put some in a bottle and dilute it with enough water so that it is fluid. If you start with fluid acrylic, you will still need to add water so it can flow easily out of the dropper.

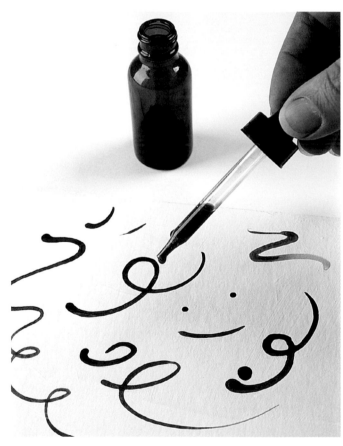

2 DROP OR DRAG PAINT ONTO A DRY SUPPORT

You can use the eye droppers in several ways. First, try squeezing out one drop at a time and letting the drops fall on a dry surface. You can also draw with the droppers by squeezing them while you drag the tip across the surface.

drop paint onto a wet surface

Now try dropping on a wet surface. First, spray water onto an absorbent support such as the watercolor paper pictured here. The wet surface allows the color in the droplets to "bleed." I used several colors in varying degrees of dilution to create this example.

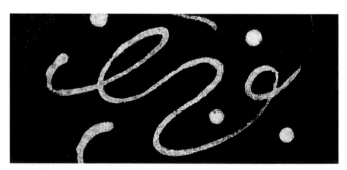

dissolving with water

With a flat brush, paint a thin layer of fluid acrylics on your support. (Here I used undiluted Quinacridone Violet fluid paint.) Before this layer of paint dries, fill your eye dropper with water and deposit small drops, or draw and drag lines of water onto the surface. Let the paint surface dry slightly while the water droplets are still wet. The color will dissolve where the drops of water fall. Blot with a paper towel or let it dry naturally without blotting to get a softer, muted dissolve.

toothbrushes

Toothbrushes are great for adding visual texture. Try this spritzing technique in the foreground of a landscape, on fruit in a still life, or to add some focal interest in an abstract painting.

MATERIALS
Painting support
Toothbrush
Acrylic paint

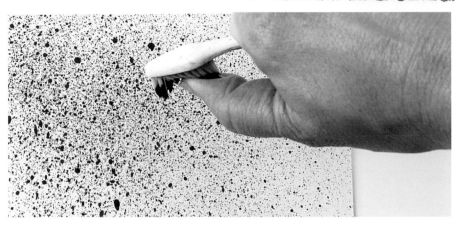

toothbrush spritzing

Mix enough water into your paint to create a runny consistency. Dip your toothbrush into the paint. Using your finger, press and push back firmly against the brush bristles while aiming the toothbrush down toward your painting support.

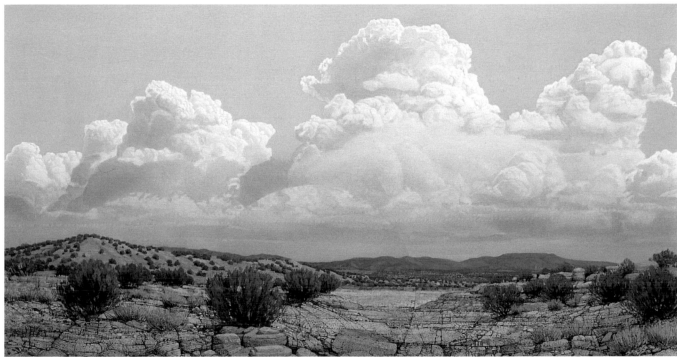

Additional Possibilities
- Try using this technique with stencils in techniques 64 and 68.
- Add more water to produce larger dots.
- Use a thicker paint to create a finer pattern.
- Change the distance from which you spritz. Moving the toothbrush closer to the surface or farther away will produce different effects.
- Spritz several colors, one on top of the other, for a denser pattern.

This landscape uses glazes, soft blending techniques, drybrushing, and toothbrush spritzing to get intriguing surface textures. These techniques, in addition to contrasting color elements, help to create the illusion of real space. (See techniques 34, 37, 38, 39, 40, 88, 89 and 90.)

Arroyo Logic With Gamma Ray Artifacts
Acrylic on canvas
32" × 60" (81cm × 152cm)
Dennis Culver

feathers

A great faux finishing tool, feathers are often used to imitate natural surfaces by creating fine woodgrain lines or the vein patterns of marble. You can purchase feathers or just stop by your local bird or pet store and pick up a few strays ones.

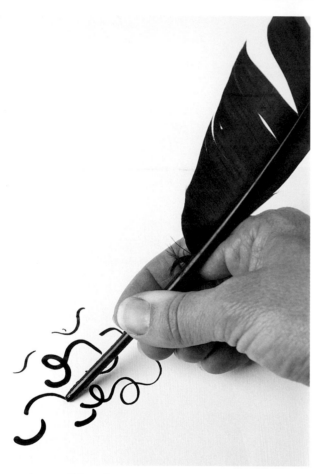

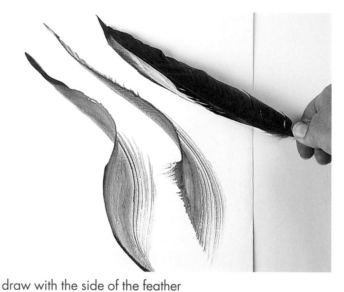

draw with the side of the feather

Dilute your selected color or colors with enough water to make the paint runny. Dip the side of your feather in one or more colors. Move your hand and wrist in different directions as you move the feather across your surface.

paint with a quill "pen"

Use the feather as a quill pen for linear patterns by dipping it into fluid paint.

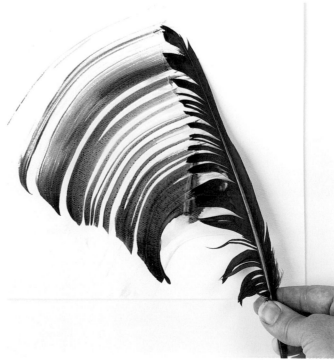

raked patterns

Wipe the feather in diluted paint, then sweep it along the painting support.

paint tubes

You can create some wonderfully raw gestural marks by painting directly from the original containers of the acrylic paints. Tubes are my favorite for this technique. They come in a variety of sizes from very small ¾-oz. tubes to large 5-oz. ones. This technique makes me feel like a kid again, as if I were armed with giant jumbo crayons.

create a variety of lines

Try different colors, tube sizes, hand and wrist gestures and pressures (see technique 9 for more ideas). You may want to wait an hour or two between colors to let the first paint lines dry before adding more paint. This way you can build up layers and keep the color palette bright, rather than continually smearing the colors into each other and turning them into browns.

Substitute Bottles for Tubes

Try substituting bottles for the tubes in this technique. You can paint with the bottles in the same way this demonstration uses tubes. See technique 53 for a related fluid-paint technique.

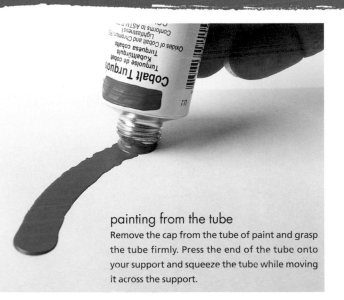

painting from the tube

Remove the cap from the tube of paint and grasp the tube firmly. Press the end of the tube onto your support and squeeze the tube while moving it across the support.

Most of the components of this piece were made separately, allowed to dry, then recombined by gluing them together in an assemblage. Dried paint was shaved into small pieces and compressed into multicolored sheets using a press. These sheets were then stacked and cut into shapes. Paint was also applied directly to this surface from the tubes. (See techniques 3, 55 and 56.)

Untitled II
Acrylic on plywood
12½" × 24½" (32cm × 62cm)
J.E. Newman

Surface Treatments and Grounds

The techniques in this section will affect the surface of your support by changing its characteristics, such as absorbency, texture and color. On top of these new surfaces, you can apply acrylic paint as well as other painting mediums such as oil or watercolor.

19

absorbent surfaces

When a surface is extremely smooth, light will reflect off the surface, and it will appear shiny or glossy. If you rough up a surface, you will give it tooth, or extremely small hills and valleys. Light will not bounce off this surface as easily, so it will appear dull or matte. Matte surfaces are absorbent because the paint collects in the hills and valleys. Instead of roughing up the surface to add tooth, you can apply a product with particles such as sand or pumice. These abrasives also create tooth, increasing the absorbency of your original surface.

If you use undiluted, thick paint on top of an absorbent surface, you will seal that surface, reducing its absorbency. When acrylic paint

is diluted in a ratio of 2 parts water to 1 part paint, however, the binder breaks down, leaving the pigment unsupported or weakened. It is this weakened state that is most desirable for absorbent surfaces, because you can build up layers of pigment without reducing the surface's absorbency. The regular distribution of "valleys" that is characteristic of a toothed surface allows paint to collect evenly across the surface, creating a layer of consistent color. Absorbent surfaces work very well with most watercolor techniques using acrylic paint.

MATERIALS

Arches cold-press watercolor paper, 140-lb. (300gsm)

Acrylic paint
Soft brush
Palette knife

1 DILUTE THE PAINT

Watercolor paper is naturally absorbent, so we can use it as is. Do not prime, coat or seal the top surface or you will lose that absorbency. Undiluted acrylic paint also will seal the paper, so dilute it with 2 parts water to 1 part paint. Mix the paint thoroughly with a palette knife.

Related Techniques

In addition to the watercolor paper used here, try other absorbent supports such as wood (technique 3), cardboard (2), unprimed canvas or fabric (1), pumice (21), light molding paste (22), or crackle paste (28). Try applying matte gel or matte medium to your surface. Matte mediums and gels contain small white particles, called matting agent, that not only make the paint look matte, but also add tooth, creating more absorbency. Or create a paperlike surface on canvas or panel (technique 86).

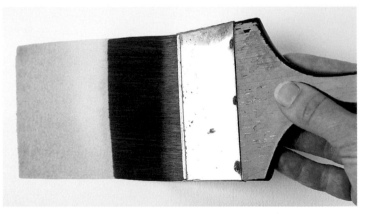

2 APPLY THE PAINT

Load your brush and stroke across the paper.

finished wash on an absorbent surface

The tooth of this absorbent paper distributes the paint evenly across the surface, producing an even color application.

nonabsorbent surfaces

When diluted paint (described in technique 19), is applied to a glossy or nonabsorbent surface, the paint collects unevenly. The resulting pools create interesting effects. Undiluted paint used directly out of a tube or jar will not create these patterned effects. Here we are taking advantage of the slick surface by applying diluted or "weakened" paint.

You can use any glossy acrylic to create a nonabsorbent surface. Fluid mediums may require a few coats to create a glossy surface as the first coat may soak in. Gels are thicker and will give a more substantial coating. Technique 33 uses a glossy gel as a thick textural glaze.

MATERIALS

Watercolor paper

Acrylic gloss gel

Palette knife with stepped handle

Soft brush

Acrylic paint

1 APPLY GEL

Apply gloss gel to your paper using a palette knife. Brushes are fine to use for applying gels but I generally prefer using a knife. By moving the knife in different directions, you can create patterns and texture. Let it dry thoroughly. If applied thickly, drying will take longer, perhaps a day or more. The gel will become clear when fully dry.

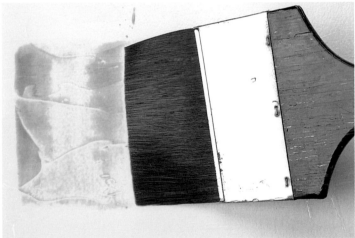

2 APPLY OVER-WATERED PAINT

Dilute the acrylic paint with water 1:2, or add more water if desired. Apply using a brush or any of the other application tools listed in section 2.

finished wash on a nonabsorbent surface

Interesting effects are obtained by just letting the paint dry. The glossy coating removes any absorbency or tooth in the surface. Since there is no place for the diluted paint to collect, interesting organic-looking patterns will form.

Alternate Technique

Try this technique using a gloss medium instead of a gel and a brush instead of a knife. Apply a few coats so the surface is completely glossy before you apply paint.

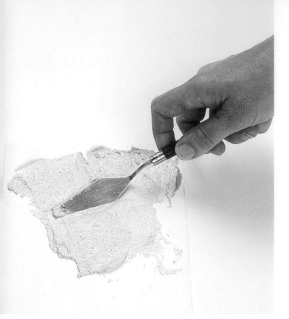

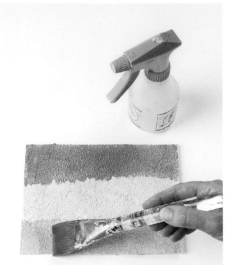

2 APPLY PAINT

Spray the surface heavily with water. Dilute fluid acrylic paint with water in a 1:2 ratio. Add more water if you're using a thicker consistency of paint. Apply colors with a brush, leaving enough space between them for bleeding. This will create soft blends and muted colors. Whites and light colors in this step will either disappear or get darker due to the gray color of the pumice. Let this dry.

1 APPLY GEL TO THE SURFACE

Using a palette knife, spread a layer of Coarse Pumice Gel about ¼-inch (6mm) thick onto your primed surface. If the gel does not spread smoothly, add some water and stir well before applying. Let it fully dry for at least 8 to 12 hours.

3 LET THE COLORS BLEED

The wet surface allows the two colors to bleed together, forming a continuous blend.

21

gritty-textured surface

By adding other materials to acrylic, you can create texture. Sand, pumice, ground-up stone and marble dust are some examples of textural materials to add to an acrylic medium or gel. This is great for beautiful, soft blends of color such as sunset skies. The natural gray tone of pumice neutralizes the color of the paint you use, turning high-intensity colors into natural, realistic ones.

Some paint companies offer ready-made mixtures, cleaned of impurities and mixed in the right proportions that are both convenient and stable.

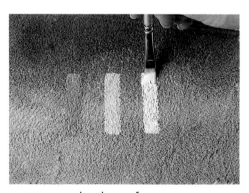

painting on the dry surface

Make sure your surface is dry. This will give you the opportunity to add hard edged forms, lighter values and brighter colors. You still need to add some water to the paint so you can brush it on smoothly. Adding 1 part water to 4 parts paint should work fine. Don't overwater your paint so your strokes of color won't bleed as much. This time when you add white, light or bright colors, they will maintain their appearance.

MATERIALS

Primed painting support

Golden's Coarse Pumice Gel

Palette knife

Brush

Two or more fluid acrylic paints (I used Phthalo Blue and Green Gold)

Spray bottle with water

22

soft-textured absorbent surface

This technique uses a product from Golden called Light Molding Paste. A relatively thin layer will create a surface that feels like a spongy piece of homemade paper. It has a wonderful absorbent quality, great for soft edges and blends, and can be used with any wash or watercolor painting method. This bright white surface maintains the intensity of the painted colors, while offering a soft, textural interest.

MATERIALS LIST
Primed painting support
Golden's Light Molding Paste
Palette knife
Brush
Fluid acrylic paints (I used Phthalo Green, Quinacridone Burnt Orange and Nickel Azo Yellow)
Paper towels

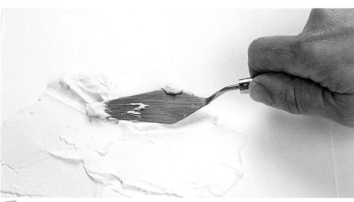

1 APPLY THE PASTE

Using a palette knife, spread a generous amount of undiluted Light Molding Paste onto your primed surface. The paste will shrink in depth by a third, so use it liberally, at least ¼-inch (6mm) thick. Add some specific carved texture if you like, or just allow the spreading of the paste with the knife to create its own soft texture. Let it dry for at least 8 hours. You can paint on it sooner, but for applying washes, it's best to have the surface fully cured.

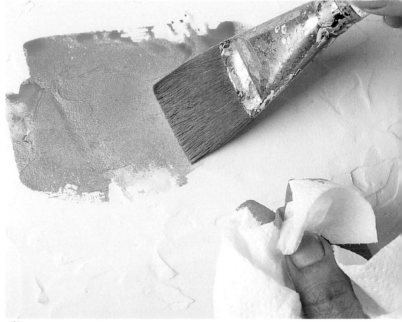

2 PAINT USING DILUTED WASHES OF COLOR

Select two or three acrylic paint colors. Heavily dilute 1 part acrylic paint with 2 parts water and apply to the dry surface using a brush, leaving enough space between colors for bleeding. The high absorbency of the surface will encourage the colors to bleed and spread. Try blotting some areas with a paper towel, or even wiping some areas of paint into the surface with the paper towels to create an even stain. Experiment by spraying the surface with water first before adding paint.

3 LET DRY

When dry, the colors blend softly into each other.

Working With Light Molding Paste
Don't confuse this Golden product with other molding or modeling pastes. This technique works only with the particular product called Light Molding Paste by Golden. Also, try using this paste in thick textural applications. You can carve into it while wet, and it will hold the relief extremely well. See more uses for this paste in technique 81. It also makes a great alternative surface for watercolorists.

23

mixed surface using acrylic products

By applying a combination of absorbent and nonabsorbent acrylic products to the support, you can create a surface that will produce surprising effects when painted. This is a great way to begin a painting when you have no subject in mind. This technique will definitely inspire you with new ideas.

MATERIALS

Primed painting support

Assortment of acrylic gels, grounds and pastes (I used Fine Pumice Gel, Black Mica Flake, Micaceous Iron Oxide, Acrylic Ground for Pastels, Garnet Gel, Light Molding Paste, Molding Paste and Clear Tar Gel)

Palette knife

Brush

Fluid acrylic paints

Paper towels

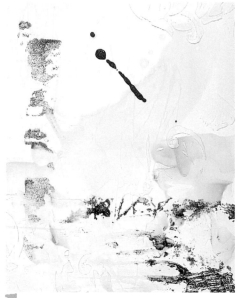

1 APPLY A VARIETY OF PRODUCTS TO THE SURFACE

Apply the gels, grounds or pastes to the primed surface using a palette knife or brush. Try using both absorbent and nonabsorbent products for maximum variety. Let the surface dry fully (about 8 hours).

2 APPLY THE PAINTS

Select several acrylic paint colors. Heavily dilute 1 part acrylic paint with 2 parts water (add more water if you are using a thicker-consistency paint) and apply using a brush. Try blotting some areas with a paper towel, or scrubbing some areas of paint into the surface with the paper towels. Leave some areas of washes alone to dry naturally.

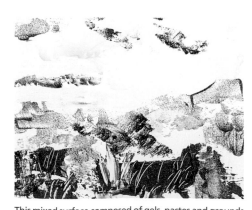

This mixed surface composed of gels, pastes and grounds suggests a landscape.

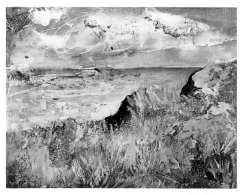

Here the washes are applied over the mixed surface.

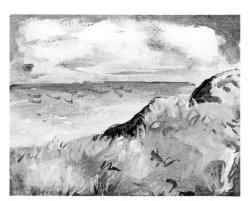

Here are the same washes that were applied in the previous example, but now applied to a plain white surface. Notice the difference.

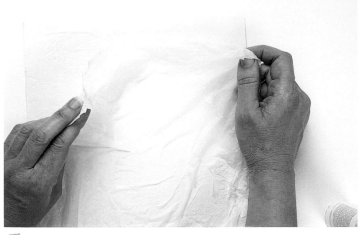

mixed surface using paper overlay

By securing absorbent paper onto your surface and allowing the wrinkles to remain, you can obtain an interesting texture. This is a great way to create atmospheric appeal in a background or as an inspirational beginning.

MATERIALS

Primed or unprimed painting support

Strong, thin paper such as rice or rag paper

Acrylic matte medium

Brush

Spray bottle with water

Fluid acrylic paints

Paper towels

1 PREPARE YOUR PAPERS AND GLUE THEM ONTO YOUR SUPPORT

Spray the rice or rag paper lightly with water. Wad the damp paper into a ball by rolling it in your fist. Brush a coat of matte medium onto your surface. Unfold the paper and loosely spread it over the wet medium without smoothing it out all the way. Place a paper towel over the surface and pat gently to press the paper into the medium. Do not pat too hard or your wrinkles will smooth out. Let the surface dry at least 2 to 4 hours.

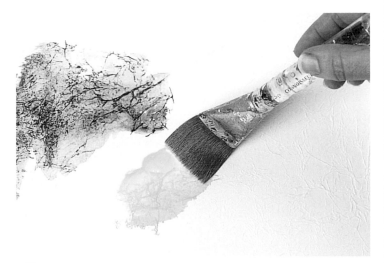

other possibilities

These finished examples were created by Santa Fe artist Joanne K. Baker. One uses a black wash while the other uses a combination of several colored washes.

2 APPLY DILUTED WASHES OF COLOR

Select several acrylic paint colors. Heavily dilute 1 part fluid acrylic paint with 2 parts water (add more water if you are using a thicker-consistency paint) and apply using a brush. Blot some areas with a paper towel, wipe some areas of paint into the surface with the paper towels, or let the washes dry naturally. Experiment by spraying the surface with water before laying in washes of paint.

drip resist

By starting with an absorbent surface and using a glossy or nonabsorbent medium to draw on top, you can create a resist. Using over-watered acrylic paint over this dual-absorbency surface creates two different effects simultaneously. The non-absorbent medium resists the paint and thus remains white. The areas not covered by the medium will produce an evenly colored area when painted over with diluted paint. For this technique, Clear Tar Gel has turned the paint into stringy lines.

MATERIALS
White watercolor paper
Golden's Clear Tar Gel
Palette knife
Flat wash brush
Acrylic paints

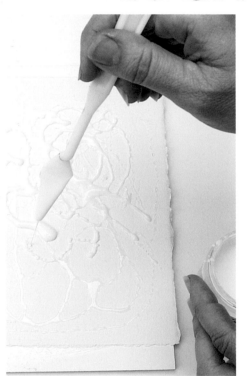

1 CREATE RESIST LINES
Dip your palette knife into the Clear Tar Gel. Load it with the gel and move it quickly to your piece of watercolor paper. Move your knife over the paper, depositing the gel in linear patterns. Let this dry for 8 hours.

Additional Possibilites
Alternatives to white watercolor paper include other absorbent surfaces such as gessoed board or canvas (see techniques 1, 2 and 3). Apply products such as light molding paste (technique 22) or absorbent ground (technique 86) to create more absorbent surfaces. As long as the support is absorbent (or not glossy) this resist technique will work. You can substitute other fluid mediums for the Clear Tar Gel and use them with a ruling pen as in technique 72. See techniques 78, 96 and 97 for further applications of Clear Tar Gel.

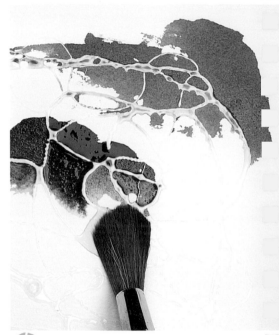

2 PAINT WITH WASHES OF DILUTED COLOR
Select one or more acrylic paint colors. Mix 1 part fluid acrylic paint with 2 parts water to heavily dilute the paint. (Add more water if you are using a thicker-consistency paint.) Apply using a brush.

3 LET DRY
Let the paint dry. Notice the resist areas are white.

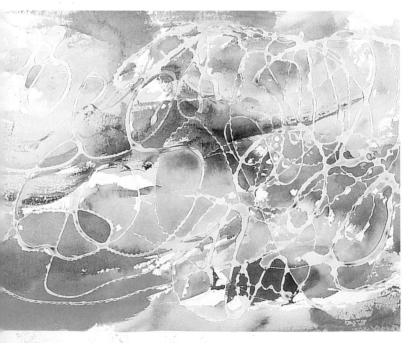

Working With Clear Tar Gel
Do not stir the gel at any time or it will become aerated and will not flow off your knife. If you stir accidentally, let the gel sit in the jar to settle for 1 to 2 hours. If the gel does not flow easily, load the knife with more gel and move it onto the paper quicker. Let the gel dry fully, about 8 hours.

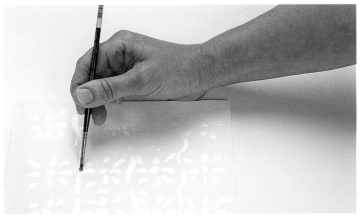

1 PAINT YOUR RESIST DESIGN

Using a brush, paint designs with gloss medium. These will remain white. Leave plenty of unpainted areas. Let dry for about 8 hours.

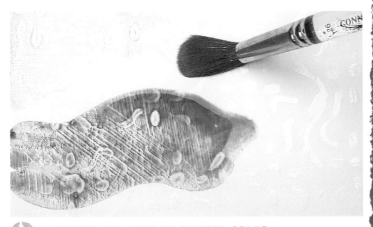

2 PAINT WITH WASHES OF DILUTED COLOR

Select one or more acrylic paint colors. Mix 1 part fluid acrylic paint with 2 parts water to heavily dilute the paint (add more water if you are using a thicker-consistency paint). Apply the paint using a brush. Experiment by blotting with a paper towel, rubbing the paint into the surface, or just leaving it to dry naturally.

finished example of washes over a painted resist

painted resist

This technique is similar to technique 25, utilizing absorbent and nonabsorbent surface areas to create a resist. However, in this technique, we will paint more controlled areas of resist using a brush. Any matte or absorbent support will work. For this technique, I used Polymer Medium (Gloss) to paint designs over gessoed cardboard.

MATERIALS
Absorbent painting support
Polymer Medium (Gloss)
Brush
Acrylic paints

This highly reflective and textural painting evokes an ocean wave with its areas of painted resist and poured layers of interference pigments. Strong, highly contrasting lights and darks are used to create space and drama. (See techniques 3, 39, 90, 93, 94 and 101.)

Wave
Acrylic on panel
24" × 16" (61cm × 41cm)
Nancy Reyner

drawing resist with oil pastel and crayon

With this technique, oil pastels and wax crayons produce nonabsorbent areas to resist the over-watered paint. Any matte or absorbent surface will work. For this demonstration, I chose to use oil pastels and wax crayons on gessoed cardboard.

MATERIALS

Cardboard primed with white gesso (or any absorbent surface)

Oil pastels and/or wax crayons

Brush

Acrylic paints

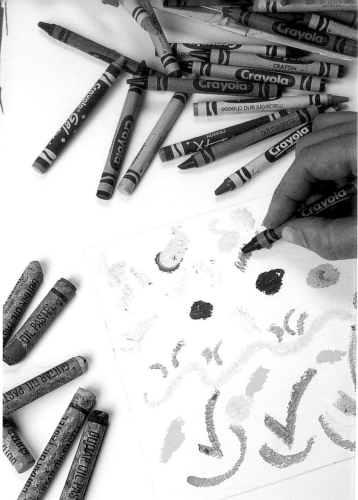

1 DRAW YOUR RESIST DESIGN

Using oil pastels or crayons, draw over the surface to create your resist design. Leave plenty of surface areas uncovered.

finished crayon resist

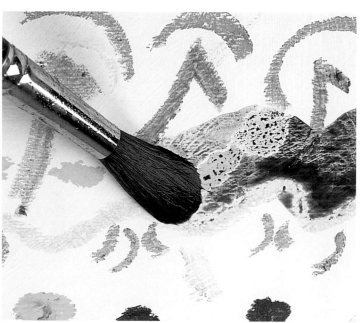

2 PAINT WITH DILUTED WASHES OF COLOR

Select one or more acrylic paint colors. Mix 1 part fluid acrylic paint with 2 parts water to heavily dilute the paint (add more water if you are using a thicker-consistency paint). Apply the paint using a brush.

Removing Oil Pastel From Your Hands

To easily clean oil pastels off your hands, rub baby oil into your skin. Wipe this off with a paper towel before using any soap and water.

cracked surface

The cracked surface created with this technique adds a surprise element and unique quality. I like to use this technique to begin a new painting. Apply crackle paste at least ¼-inch (6mm) thick. The thicker the paste, the larger the cracks. The final surface is very absorbent and can be used in combination with watercolor and wash techniques such as 35, 49, 85 and 86.

1 PREPARE THE SURFACE

Paint the surface a dark color to emphasize the cracks. For this example, VanDyke Brown Hue was painted on cardboard, which was then mounted on foamcore for extra stability. Apply crackle paste using a palette knife. The cracks form in the direction you work your knife. Work in a swirling manner to get crackling all over the surface.

MATERIALS

Masonite or other strong, rigid support

Crackle paste (4 oz. per each 8" × 10" [20cm × 25cm] of surface area)

Acrylic paints

Palette knife

Soft, wide, flat wash brush

Spray bottle with water

Paper towels

Use a Rigid Support

A sturdy, rigid support such as Masonite, Gator board or panel is recommended for this technique. If canvas is used, the pressure of the drying process along with the flexibility of the canvas will produce large potato-chiplike pieces that will not have good adhesion. If you do use canvas, you can strengthen the adhesion by using a pour on top of the dried cracked surface (see technique 101).

2 ALLOW TO DRY

Let it dry overnight, or longer if it is humid, raining or cold.

3 APPLY COLOR TO EMPHASIZE THE CRACKS

Over water your paint to make a runny consistency. Spray your surface with water, then apply the paint using a wide, flat brush. The paint goes into the cracks, making them darker in value and more visible. Blot some of the color with paper towels if you want less color. The colors used here are Dioxazine Purple, Green Gold, Quinacridone Red and Turquois (Phthalo).

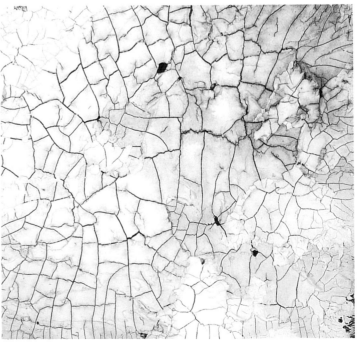

finished cracked and painted surface

metallic underpainting

There are several types of acrylic reflective paints. Some are made of real metals from the ground and look metallic. Others use mica chips and pigment to simulate real metal. Whichever you choose, these paints can add quite a zing to your artwork. You can use them mixed into your paint (see techniques 93, 94 and 95) or as demonstrated here, as a ground to add a subtle metallic sheen to the background of your painting or drawing.

MATERIALS

Primed painting support

Micaceous Iron Oxide Iridescent Paint

Palette knife

Oil pastels

1 APPLY MICACEOUS IRON OXIDE
Spread the Micaceous Iron Oxide onto your support using the palette knife. Spread it to fully cover the support's primed surface. Let it dry approximately 8 hours or overnight.

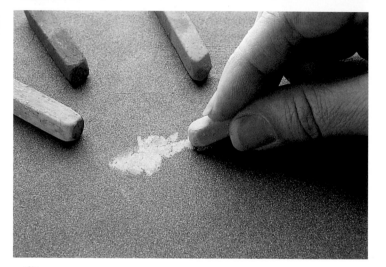

2 DRAW OVER THE SURFACE
Draw over the reflective surface with the oil pastels.

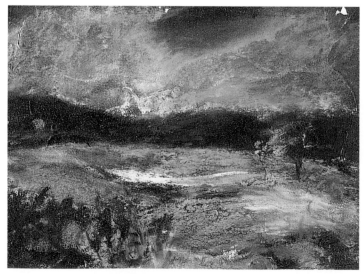

3 FINISH THE DRAWING
Complete the oil pastel drawing. Leave some areas uncovered so the reflective quality of the Micaceous Iron Oxide shows through.

micaceous iron oxide with colored pencils
Instead of the oil pastels, you can use acrylic paint, chalk pastel, colored pencil, crayon or oil paint. Just about anything works on top of this reflective surface.

Spatial Effects

Two-dimensional painting has to address the fact that we live in a three-dimensional world. You can use techniques in this section to create the illusion of deep or shallow space on any surface.

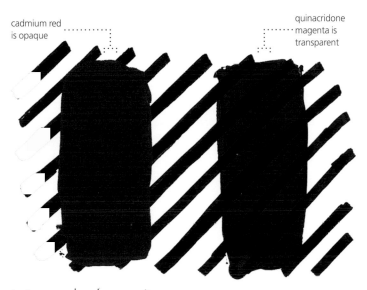

Opacity and Transparency

Some paints are naturally opaque and others are not. If you are not familiar with paint opacity and transparency, refer to technique 80.

cadmium red is opaque

quinacridone magenta is transparent

condensed space

This technique utilizes shapes of flat color to create an up close and personal space. Flat shapes of color do not shift in value, hue or chroma within the boundaries. To paint a shape with flat color, it is important to understand how to eliminate streaking, value variations and other shifting nuances of color. The spatial effect created with this technique is very contemporary. The viewer will not be invited to journey into the depths of the painting, but will be encouraged to peruse the surface, experiencing the sheen, texture and allure of the acrylic itself.

test your colors for opacity

Make a black cross or black lines with a black permanent marker on scrap paper. Load one of your colors onto a palette knife and gently wipe a thin layer of color over the black lines. Don't press hard into the paper; make sure you lift your palette knife slightly off the paper, as if there were a ball rolling under your knife. If the color applied over the black lines is very streaky, or if you can see the black lines under the color, then this color is transparent. If the color goes on smoothly with no streaks and covers the black lines very well, then your color is opaque.

you can make your paint opaque

For this technique you'll need opaque colors, so if your color is transparent, you can make it opaque by adding a small amount of Titanium White. Use your palette knife to mix thoroughly. Here the Quinacridone Magenta is becoming opaque with the addition of Titanium White.

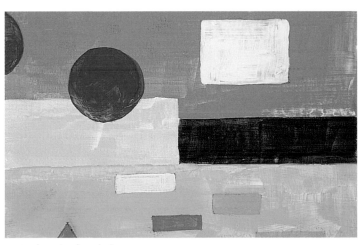

paint hard-edged shapes

Paint shapes onto your support using opaque colors, or transparent colors that were made opaque, or any combination of the two. Have each shape touch one another at the edges. Overlapping will create a sense of depth, so avoid this for flat space. Also avoid having a specific background showing between the colored shapes, or an obvious figure/ground format, which will also create depth.

apply a second coat of paint

Let the first coat dry, then paint the shapes with a second coat. This will eliminate any streaking and will make the surface more substantial. More pigment will also create a richer, more saturated color.

veiling to create depth

Acrylic is naturally glossy. Any acrylic product labeled *matte* has matting agent added to it. Since matting agent is white, it will lighten any color it is applied over. A thin layer won't be noticeable, but a thick layer will be. This technique takes advantage of this lightening aspect to achieve the illusion of depth. Colors will appear veiled or muted when covered by a thick matte layer, pushing the painted elements back in space.

MATERIALS
Painting support
Palette knife
Brush
Acrylic paints
Acrylic matte gel

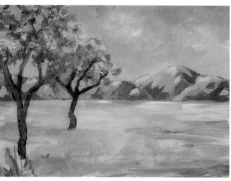

1 CREATE AN UNDERPAINTING
Using any colors, paint your subject without spending too much time mixing up muted tones, shades or tints. Use colors right out of their containers if you'd like. Let this underpainting dry to the touch before proceding.

2 APPLY MATTE GEL
Using a palette knife, apply matte gel at least ¼-inch (6mm) thick over the entire painting. Let it dry.

3 APPLY ADDITIONAL COATS
If the veiling is too subtle, just add another coat. Keep adding layers or coats until the underpainting is veiled enough to your liking, letting each layer dry to the touch before adding the next.

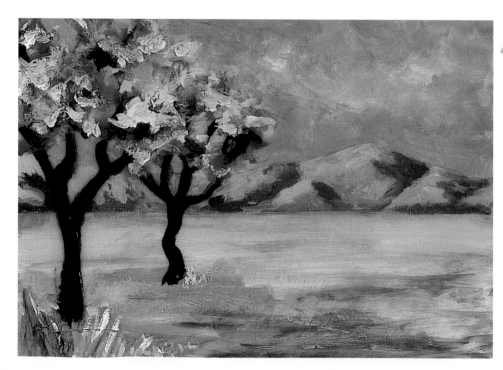

4 REPAINT THE FOREGROUND ELEMENTS
When the matte gel layers have dried to the touch, repaint the forms that you want in the foreground using the same paint colors from step 1. Unmuted, these colors now add contrast, which gives the painting the illusion of depth.

translucent color fields

By using many layers of glazes, a shifting color field can be created with an alluring, eyecatching sheen that adds to the illusion of depth. This to me represents the essence of abstraction: to create an interesting visual experience through color alone, without any recognizable objects or subject matter.

Select four colors, one for each corner of the support. Try using a complementary pair for two of the colors. A warm and a cool pair also can create a pleasing effect.

MATERIALS

Primed painting support

Soft flat or blending brush

Slow drying pourable acrylic medium

Pourable acrylic gloss medium

Retarder

Acrylic paints

1 PREPARE THE SURFACE AND APPLY ACRYLIC GLAZING LIQUID

Apply any gloss medium to your surface to seal it. Let this dry. Using acrylic glazing liquid (or mix 1 part retarder with 9 parts pourable acrylic gloss medium to make your own slow drying medium), apply a thin, smooth layer on top of the sealed surface with your brush. Continue immediately to the next step before this layer dries.

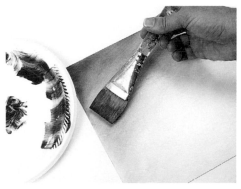

2 APPLY THE FIRST COLOR

Put the color next to an equal amount of acrylic glazing liquid on your palette. Do not mix them together. Load the paint and glazing liquid together on the brush, still not mixing them together. Start the color off strong in the corner, and head towards the middle of the support but stop half way. Wipe excess paint from your brush onto a paper towel. Continue to spread the glaze in a thin layer toward the center, removing excess paint from your brush until you reach the opposite corner with hardly any color left on your brush. If the paint begins to get tacky, stop painting, clean off the brush and let the painting dry before continuing.

3 APPLY A SECOND LAYER OF GLAZE

Let the previous layer dry to the touch before applying more glazes. Select your second color and follow the same process you used for the first glaze in a new corner, starting with a fresh layer of acrylic glazing liquid.

4 APPLY ADDITIONAL GLAZES

Wait for the previous color to dry then apply a fresh layer of acrylic glazing liquid over the entire surface for each new color. Add as many colors as you desire until you get the results you want.

5 COMPLETE THE PAINTING

Repeat more layers to intensify the colors.

Premix the Glazing Colors

If you get too many streaks or find this technique difficult to master, try premixing the glazing colors (1 part paint color to 10 parts medium, mixed with a palette knife) and substituting those mixtures for the colors in the steps.

33

layering textures to create depth

With its varied layers, this technique offers an unusual and very contemporary approach to achieving depth. Depth is created visually as well as physically. In addition to the spatial aspect, this technique has a fun bonus: the result will always be a surprise. If you want to loosen up and create some of those happy accidents, then grab your brush and try this!

MATERIALS
Painting support
Brush

Acrylic paints
Palette knife
Soft Gel (Gloss)

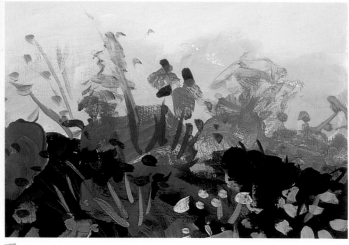

1 CREATE AN UNDERPAINTING
Using any combination of colors—thick, thin, diluted or undiluted—create an underpainting for the background of your image. Since the next layer will be somewhat transparent, fill the entire surface with paint. If your support is unprimed, this step will help completely seal the surface.

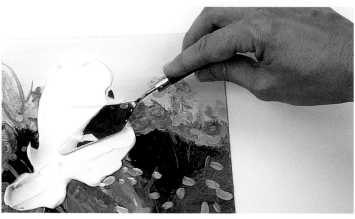

2 APPLY THE GEL
Cover the entire surface with soft gloss gel in a layer at least ½-inch (12mm) thick. The gel will shrink in volume by about 30%. If you don't apply a substantial layer, it will reduce in size to a mere gloss coat; so lay it on!

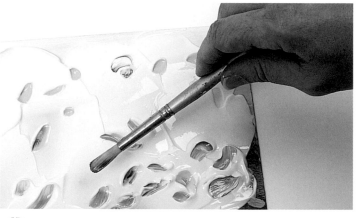

3 OVERPAINT WET-IN-WET
While the gel is still wet, load your brush with paint and drag it through the wet gel. If your gel is soft enough, you will get a nice brushstroke texture. The wet-in-wet technique will produce a variety of opaque and transparent effects that will either cover or tint the colors in the underpainting.

4 COMPLETE THE PAINTING
Continue working wet-in-wet and add enough paint to cover about half of your surface. When the wet gel turns from white to clear, it is fully dry.

contrasting edges

Photographs usually have a range of focus. Some forms are in sharp focus, while others are blurry or out of focus. Forms that are in focus have clearly defined edges, so we tend to see them as closer to us. Forms that are out of focus have fuzzy, soft edges, so we tend to see these as more distant. By combining soft-edged forms with hard-edged ones in your painting, you can create the illusion of space. Varying edges is an essential tool used in both realistic and abstract art.

MATERIALS
Absorbent painting support
Acrylic paints
Brush
Eyedropper
Stencils (optional)

1 CREATE SOFT EDGES
You can start with either hard or soft edges. Here, the soft edges were painted first using an eyedropper application (see technique 15) on wet watercolor paper.

2 PAINT HARD-EDGED SHAPES
Hard edges can be obtained easily with a brush, or by taping off areas as described in technique 67. For this example I used circular stencils (see technique 64) with a solid opaque color. Compare the soft-edged forms in this image with their hard-edged counterparts to see how edges can enhance the sense of depth.

Additional Methods of Creating Soft Edges
On an absorbent surface, you can soften the edges of a painted shape more easily if you first spray the surface with water. Using a brush, blur the edges of the painted shape while the surface is still wet. The more the paint is diluted with water, the more the edges spread or soften. To get soft edges on a nonabsorbent support, use acrylic glazing liquid with a clean brush to lightly brush over the edges of your painted shape while still wet. (See technique 89.)

Natural soft forms evoke blossoming trees in this acrylic painting. Painting warm and cool colors, soft- and hard-edged forms, and intense colors with neutrals creates contrasts that affect space and mood. (See techniques 31, 38, 40 and 88.)

Sphere Blossoms
Acrylic on canvas
24" × 27" (61cm × 69cm)
Nancy Reyner

atmospheric depth using a spray bottle

This is a quick, inexpensive technique for creating atmospheric depth. Timing, however, is crucial to getting results. Have everything ready and easy to reach before starting, including plenty of water in the spray bottle. Test the sprayer and set it for a medium spray. You want a variety of drop sizes rather than an even, fine spray coming out of the nozzle. Have individual sheets of paper towels ready nearby.

MATERIALS

Primed support
Acrylic paints

Large brush
Spray bottle with water
Paper towels

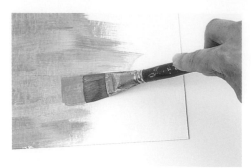

1 APPLY THE FIRST COAT OF PAINT

Apply a thin layer of undiluted color to your primed surface. Use a large brush to apply the paint quickly enough so the whole surface will dry at the same time. For a larger surface, select a small portion to work on at a time.

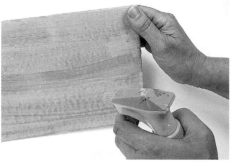

2 SPRAY DROPLETS ONTO THE SURFACE

Let the previous paint layer dry for 10 to 30 seconds (timing depends on outside conditions). From 1 to 2 feet away, use your sprayer to lightly deposit individual water droplets. Cover at least 50% of your surface, but avoid allowing the droplets to join together in one big puddle. If the paint spreads or bleeds a bit when you apply the water droplets, the surface is still too wet. Let the paint dry a few seconds more.

3 BLOT

Let the water droplets sit on the surface for about 20 seconds. Gently lay a paper towel over the surface and lightly pat it down. Lift the towel, then blot a few more times using a clean paper towel each time.

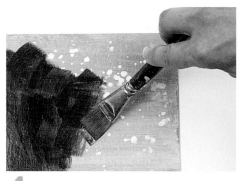

4 REPEAT WITH ANOTHER COLOR

Repeat from step 1 using a different color.

results after second paint layer

5 FINISH THE PAINTING

Add as many layers as you like until you feel your work is complete. Here, I added another layer of light green and then a small amount of black repeating the spraying and blotting for each layer. Keep in mind that the more you spray and blot for each separate layer of color, the more the color underneath will show through.

36

atmospheric depth with sanding

This layered technique is a great way to create variety and depth in your painting. Since it involves sanding, I recommend using waterproof sandpaper and wetting it. Even though most acrylic is considered nontoxic, dry sanding requires protective gear because it creates fine particles that may be hazardous to inhale.

MATERIALS
Primed painting support
Acrylic gloss medium
Acrylic paints
Brush

Waterproof sandpaper (220 to 400 grit)
Spray bottle with water
Paper towels

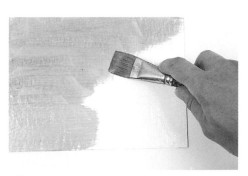

1 SEAL THE SURFACE AND APPLY THE FIRST LAYER OF PAINT

Using any acrylic gloss medium, apply one coat to the primed painting support. Let dry. Brush one color over the entire board, applying a layer thick enough to be opaque, but not thick enough that it holds texture. (Here I used Indian Yellow Hue.) Let this dry a few hours.

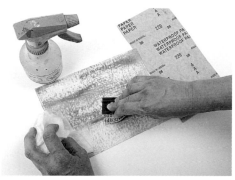

2 WET SAND THE FIRST PAINT LAYER

Spray a generous amount of water onto the dried painted surface. Using a small piece of waterproof sandpaper, sand the painted layer. Try sanding in different directions. If the paint seems difficult to sand, use a coarser grit. Don't let the sandpaper get dry. Keep using the spray bottle liberally and make sure there is always a good amount of water between the sandpaper and the painted surface. Sand about 60% of the area, then wipe the surface down with clean, dry paper towels.

3 REPEAT WITH MORE COLORS AND LAYERS

Paint more colors. (I used a dark blue and a bright blue in a few places.) Let this layer dry and repeat the sanding process. You can "spot" sand by sanding only the recently applied colors, or sand the entire surface.

4 COMPLETE THE PAINTING

Keep adding more color layers, sanding after each until you are satisfied with the results. After sanding the layer with two blues, I applied another layer with red and beige, then sanded that as well.

The Nitty Gritty of Sandpaper
I usually use a 220 grit sandpaper. A finer grit such as 400 gives a smoother finish, while a coarser grit such as 120 leaves interesting sanding lines and scratch marks.

drybrushing

Drybrushing involves painting with very little color or moisture on the brush so that the colors do not blend. The paint is usually applied with a frayed natural-bristle brush, which gives an open, brushy, textural feel. By building up layers of different, dry-brushed colors, you can use this technique to create an inspiring textural background.

MATERIALS

Painting support

Old, used natural or stiff bristle brush

Acrylic paints

Paper towels

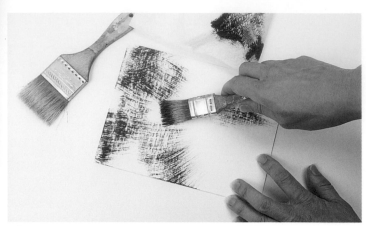

1 APPLY THE FIRST DRYBRUSH LAYER

Select a color and dip your brush into the paint. Immediately unload most of the paint on paper towels before applying it to your support. Using a light touch and holding your brush at a low angle (about 45 degrees), gently swipe the paint onto the support. Keep your wrist loose and move the brush in different directions. Let some of the white of your painting surface show through this first layer.

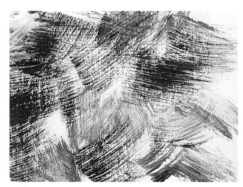

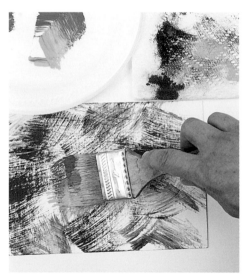

3 REPEAT WITH MORE LAYERS

Repeat with as many layers as needed to get the desired results.

2 REPEAT WITH A SECOND COLOR

Apply more colors and more layers. The paint will always be applied using a light touch, so the previous color doesn't have to be completely dry. If the paint is blending and smearing too much, however, let the bottom layers dry a bit before starting a new one. As you clean your brush with water between colors, blot it well on paper towels. Excess water on the brush will inhibit the textural look.

4 COMPLETE THE PAINTING

Try using several colors at the same time on your brush. This technique is sometimes referred to as "dirty brush." Using white or light colors in the middle or final layers keeps the painting from getting too dark or too solid looking.

quinacridone magenta with a small amount of titanium white

cadmium yellow medium hue

vat orange

phthalo green (yellow shade) with a small amount of titanium white

phthalo blue (red shade) with a small amount of titanium white

mute the bright colors

Mix the colors in separate jars or add retarder. Divide each of your bright colors into two piles. One will stay bright while the other will be muted. To mute these colors, add some Titanium White and a tiny amount of Carbon Black to each of the color piles. To each of these grayed colors add a very small amount of its complementary color. (To red add green; to orange add blue; to yellow add purple, and their reverse.) Use a palette knife to stir each mixture well. If you add too much of either the gray or the complement, the color will turn too muddy, losing its reference to its initial hue. This chart shows each of the bright colors and their muted counterparts. The ratio is approximately 12 parts color to 2 parts black to 2 parts white to 1 part complementary color.

···· phthalo blue (green shade)

···· phthalo blue (green shade) with a small amount of titanium white looks brightest

···· phthalo blue (green shade) with titanium white in a 1:1 ratio. The color is already losing its brightness and starting to get chalkier

getting bright colors

Modern pigments are brightest, but need special handling. Since these pigments are transparent, they can brush out streaky and dark. I recommend adding a small amount of Titanium White to these paints (1 part white to 25 parts paint) to make them more opaque, easier to apply evenly, and brighter in appearance.

Modern vs. Mineral Pigments
There are a variety of paint colors. If you are not familiar with the differences between modern and mineral pigments, see technique 80.

see technique 80.

38

contrasting color intensities

Using a variety of color intensities in your painting is a great way to create a sense of space. In general, bright colors (also known as colors with high chroma) will appear to come forward, while dull colors (or ones with low chroma) will appear to recede. Instead of using a multitude of hues, this technique employs a limited palette. Start with a selection of several bright colors, which will be muted to a lower chroma. By using bright and dull versions of each hue in the same painting, the illusion of space is enhanced. A benefit of using a limited palette is that relationships are more apparent and the forms appear more integrated.

39

contrast with values

Values, gray tones, shades and tints are all terms used to describe variations in a hue when white or black is added to make it lighter (a tint) or darker (a shade). A value scale shows variations in equal steps from white (or the color at its lightest) through its various tints and shades, and ending with black (or the color at its darkest). When two tones far from each other on this scale are selected—say black and white—and these two very different tones are painted right next to each other, sharing a common edge, then that pair of tones is said to be in high contrast. Two colors that are very close to each other on the value scale—for example, two grays—are in low contrast when paired together. High-contrast pairs of colors will appear to come forward, while low-contrast pairs appear to recede. Such contrasts can be used for realistic or abstract paintings to establish spatial relationships.

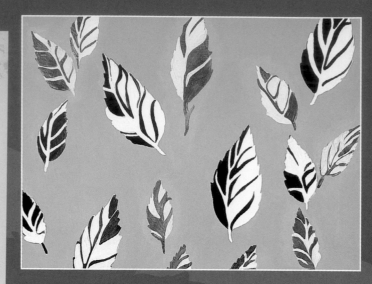

MATERIALS

Painting support

Acrylic paints (including white and black)

Brush

Palette knife

Slow-drying medium or glazing liquid

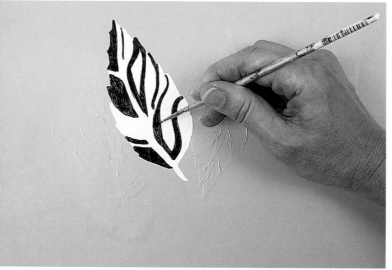

1 PAINT A BACKGROUND AND HIGH CONTRAST SHAPES

Mix a neutral color, making enough to cover the background but leave some left over to use later for the glaze. This neutral blue-green color was made with turquoise, black and white. Paint the entire background with this color. Using two high-contrast colors, paint some shapes. Dark green and light cream were used here to paint leaf shapes. These two tones are far from each other on the value scale. The green is almost black and the cream is very light and close to white in value, creating high contrast.

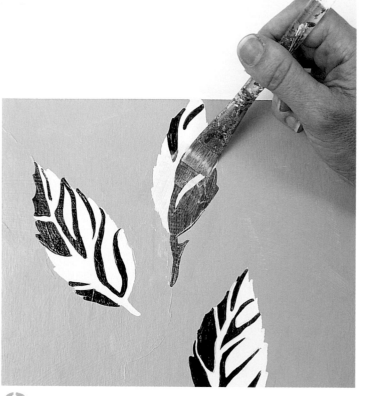

2 APPLY GLAZE TO SELECT SHAPES

Mix a glaze color with 1 part background color to 10 parts slow-drying medium or glazing liquid. Mix this well with a palette knife. Once mixed, use a wide, flat, smooth brush to apply a thin layer of glaze over the shapes that you want to appear to recede. Leave some shapes without glaze. Because these will contrast with those that are glazed, they will appear to come forward.

warm sky with
cool clouds

using warm and cool hues

The concept of warm and cool hues refers to a color's proximity to red, yellow or blue—the three primary colors that are the foundation of the color wheel. Red and yellow are usually considered warm, while blue seems cool. Traditionally, blue is thought of as a color that recedes or goes back in space, away from the viewer, while red and yellow forms appear to come forward. Many contemporary artists like to tease this traditional concept, often reversing the norm. Pictured here are two sky images. The idea is not so much whether cool recedes or not, but to use cool tones alongside warm ones, creating a contrast, and therefore spatial differences. Even though the warm sky with cool clouds shows that cool may not always recede, both images have created depth with contrasting warm and cool hues.

cool sky with
warm clouds

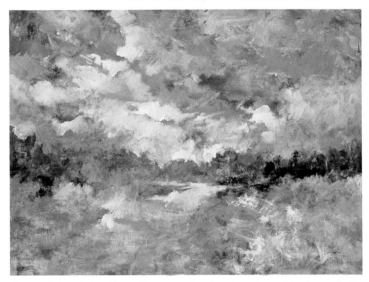

Fingerpainting, drybrushing and expressive brushstrokes using wrist action evoke the essence of nature. Spatial effects are enhanced through contrasts of cool and warm colors, high-key and muted tones, and soft and hard edges. (See techniques 10, 34, 37, 38 and 39.)

Airlightspace
Acrylic on canvas
30" × 40" (76cm × 102cm)
Joanne K. Baker

This tropical landscape uses warm and cool contrasting colors to create space, focus and a playful mood. Other contrasts, such as hard-and soft-edged forms, intense colors paired with neutrals, and lights paired with darks are used for more dramatic effect. (See techniques 34, 38, 39, 84, 87, 88 and 89.)

Mary's Floral 2
Acrylic and oil on canvas
32" × 20" (81cm × 51cm)
Nancy Reyner

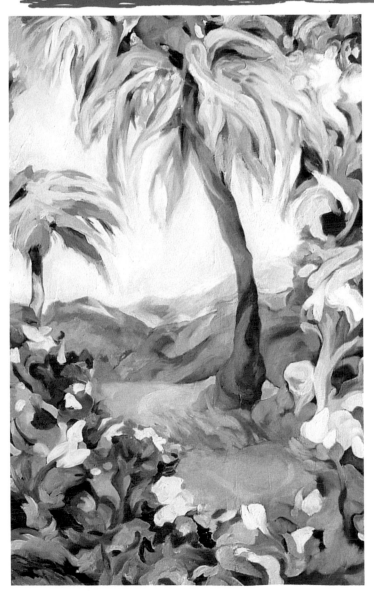

embedding objects for 3-D depth

This technique takes three-dimensional objects and embeds or buries them in a painting using a clear acrylic gel. Supports for such a thick layer of clear gel benefit from the application of stain sealers and primers. (See technique 103.)

MATERIALS

Sturdy painting support, such as Gator board, Masonite or wood panel

Stain sealer

Gesso

Objects to embed

Acrylic paints

Very thick acrylic gloss gel

Clear, pourable acrylic medium or gel

Palette knife

1 PREPARE YOUR SUPPORT, THEN BUILD A RETAINING WALL

Seal the support with a stain sealer, then prime with gesso. Apply a coat of paint on your support or create an underpainting. (I painted a blue-to-green gradation.) Select a thick gel for creating the retaining wall. (See technique 42 for help in selecting a gel.) Using a palette knife, apply the gel and sculpt a wall. Make sure the wall is high enough so you can cover your objects as much as you'd like. Acrylic will shrink in volume by about 30%, so the wall needs to be built a bit higher than you want it to be. If it is too short when dry, add more gel, building it up as high as necessary.

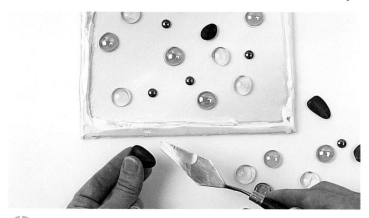

2 SECURE OBJECTS ON THE SUPPORT

Decide where to arrange the objects you want to embed. Apply a small amount of the gel you used for the wall to the underside of each object and put it in place. You must glue them down first or the smaller and lighter objects will float to the top after you pour. Let this dry for a few hours before continuing.

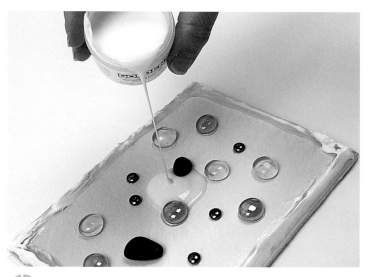

3 POUR ACRYLIC OVER THE OBJECTS

Use any acrylic medium or a diluted gel that will pour easily into the recessed area created by the walls. Pour enough to fill. Let dry. When the medium or gel turns clear, it is dry. Because acrylic shrinks in volume as it dries, you may need to pour additional layers. Make sure the first pour is fully dry before continuing with additional pours.

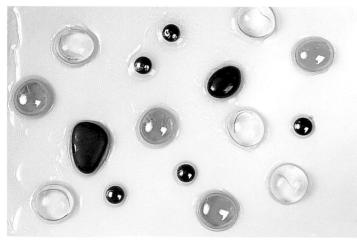

finished example

Eliminating Crevices
In hot, dry climates, acrylic will sometimes crack when poured in a deep layer. Use Golden's Specialty Acrylic Polymer GAC 800 for the pouring medium to avoid this problem. Be aware, however, that GAC 800 will dry slightly cloudy.

Texture

The techniques in this section use gels, thick paint and pastes in various ways to create textured surfaces. When experimenting with these techniques, try alternatives such as adding color directly to any of the gels or pastes before using them to create a textured surface.

42

products that add texture

There are many thick acrylic products on the market that will create texture. Just remember that if it's thick, you will have texture. Various paint lines are available in thick or thin versions; the only difference is in the paint's viscosity.

Consider these four factors when deciding which product to use: (1) ability to hold texture, (2) sheen, (3) transparency and (4) absorbency.

SHEEN

Acrylic mediums and gels are naturally glossy. When you see "matte" on the label of an acrylic product, it generally means that a matting agent has been added to the acrylic to change its sheen. Matte mediums and gels can be added directly into your paints or used as a separate layer to reduce the naturally glossy finish of acrylics to matte. Matting agent will not only reduce the sheen of your paint, but also will lighten your colors. (See technique 31 to learn how to use this whitening effect to create depth.)

TRANSPARENCY

Glossy gels are clear while pastes are usually opaque. Matte gels contain matting agent, and therefore will be less transparent. Matte gels look a bit milky or cloudy but still remain somewhat translucent.

ABILITY TO HOLD TEXTURE

Different thickeners are used in each of the Golden gel products shown here. All of these products offer some texture when added to paint or when used by themselves on your support to create a textured ground. Soft Gel (Gloss) is the softest and will give you a melting type of texture, while Extra Heavy Gel (Gloss) will stiffly hold any texture you carve into it with a palette knife or other tool.

ABSORBENCY

In general, anything that is glossy is reflective and extremely smooth and therefore is probably a nonabsorbent surface. Any matte surface has tooth and therefore is probably absorbent.

gloss gels are transparent

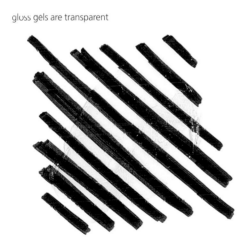

matte gels are cloudy or translucent

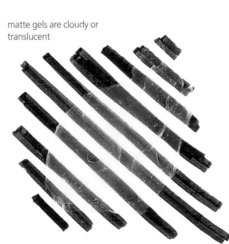

molding pastes are opaque

soft gel (gloss)

regular gel (gloss)

extra heavy gel (gloss)

gels
Each of these gels is naturally clear, but I added some red paint so the textural qualities would be more evident.

43

enhancing your picture with logical textures

Texture can be used in many ways to enhance the subject matter, image or forms in your painting. This technique shows you how to create logical textures for natural forms such as trees, mountains or water. In addition to scoring outlines, you can use a variety of tools to add different textures such as fluffy, undulating forms for clouds or rough relief for tree bark. Decide on the image you want to paint before you create the textures.

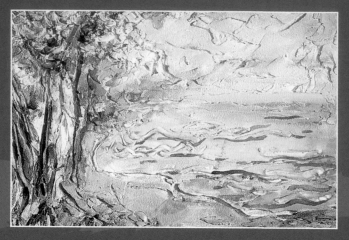

MATERIALS

Painting support

Acrylic molding paste or gel

Palette knives and/or rubber shaping tools

Acrylic paints

Brush

1 APPLY THE PASTE

Decide on the image you plan to paint on the textured surface. Make a sketch or have your reference images ready. Apply gel or paste over the entire painting support using a palette knife. (I used Light Molding Paste for an abosrbent surface.)

2 CARVE OUT TEXTURE

While the paste is still wet (usually there is a 15 to 20 minute window), carve out the lines or textural elements of your picture. Try using the flat bottom of the palette knife for flat, wide strokes. Use the tip of the knife for thinner lines. Rubber shaping tools are also great for carving out clean lines and areas. Let the paste dry fully for about 6 hours.

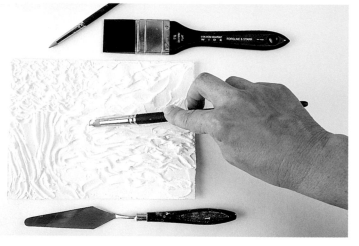

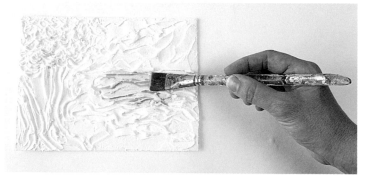

3 PAINT THE IMAGE

Using undiluted paint, diluted washes, or a combination, paint your image, using the previously carved texture as a guide. You can always go back and add more paste over painted areas that you want to change.

This heavily textured surface uses sculptural lines, scored outlines and relief to reinforce the subtle forms. (See techniques 23, 28, 31, 34, 37, 38, 39, 40, 47, 65, 67, 85 and 92.)

Rose Colored Glasses
Acrylic on canvas
36" × 48" (91cm × 122cm)
Nancy Reyner

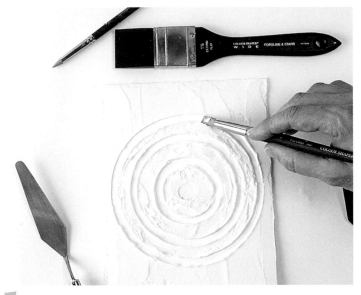

surprise viewers with contrasting texture

Unexpected textural elements in a painting can surprise your viewers or create visual tension that adds to the intended effect. Whatever you are planning to paint—a portrait, landscape, or abstraction — determine the natural forms of your painted image and then select an unexpected texture to go with it. Unlike the logical textures created for technique 43, this texture will contrast with your image, encouraging viewers to stop and take note of the discrepancy, and to find their own meaning in the relationships presented. Encouraging the viewer to actively participate in finding meaning in a work of art is an essential concept of contemporary painting. For this demonstration, I decided to use concentric circles—a bull's-eye—to contrast with the painted portrait.

MATERIALS

Painting support

Acrylic molding paste or gel

Palette knives and/or rubber shaping tools

Acrylic paints

Brush

1 APPLY THE PASTE AND CARVE OUT TEXTURE

Decide on the image you plan to paint on the textured surface. Apply gel or paste over the entire painting support using a palette knife. While the paste is still wet, carve out the lines or textural elements of your picture. Let the paste dry fully for at least 6 hours.

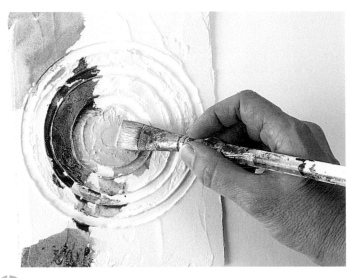

2 BEGIN PAINTING THE IMAGE

Using undiluted paint, diluted washes or a combination, paint your image on top of the textured surface.

3 FINISH THE PAINTING

Continue painting washes over the textured surface. You can always go back and add more paste overpainted areas that you want to change.

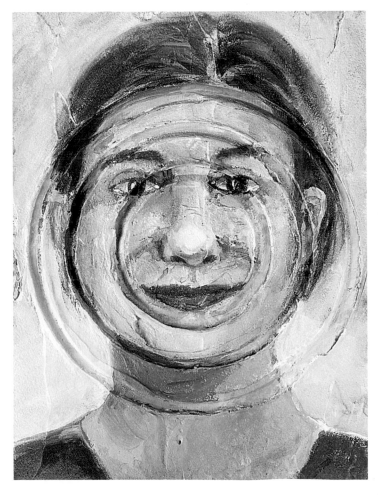

experimental texture

You can create an organic, playful texture on your painting surface by diluting the molding paste in different ways, and by employing application methods such as flinging, dripping and splattering.

MATERIALS

Painting support
Acrylic molding paste
Palette knife
Mixing container
Acrylic paints
Brush

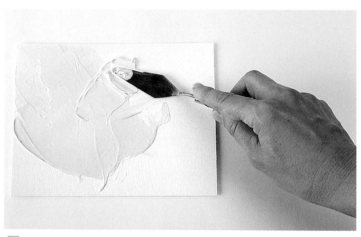

1 APPLY A FOUNDATION OF PASTE

Apply paste over the entire surface of your support. You may either go right on to step 2, or allow the surface to dry first.

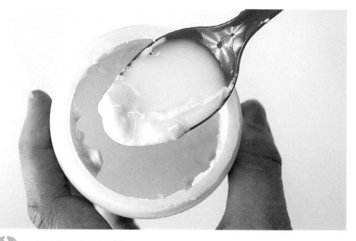

2 DILUTE THE PASTE

In a separate container, mix 2 parts paste with 1 part water. Barely stir the mixture so it stays lumpy and does not become homogenized.

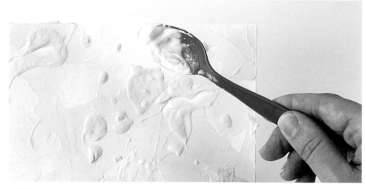

3 FLING, DRIP AND SPLATTER

Using knives, brushes, fingers or any other tool, fling, drip and splatter various amounts of this lumpy, diluted mixture all over your support. Let this fully dry to the touch before painting.

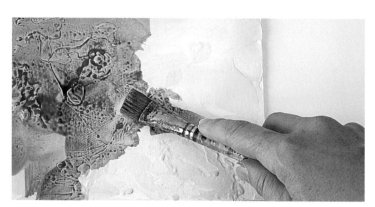

4 ADD COLOR

Using undiluted paint, diluted washes or a combination, paint your image on top of the textured surface. You can always go back and add more paste, diluted or undiluted, over painted areas that you want to change.

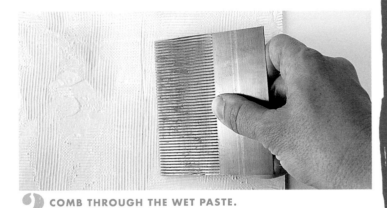

APPLY PASTE TO THE SURFACE

1 Apply a thin layer of paste or gel about 1/16-inch (1.5 mm) thick over your entire painting support using a palette knife. Smooth and even out the layer as much as possible with the knife.

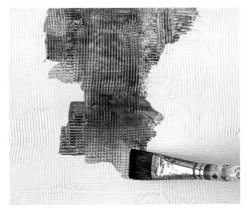

COMB THROUGH THE WET PASTE.

2 Gently drag a comb through the wet paste from one end of the support to the other. For a support larger than the width of the comb, drag it a few times in rows. After each drag, wipe off the excess paste before continuing. Repeat with vertical lines, dragging the comb for a crosshatched effect. Use a very light touch when you change directions or you will eliminate the horizontal lines. Let the surface dry.

hatched-line texture

This technique uses combs in wet paste to create a beautiful hatched-line surface. Regular hair combs can be used as well as combs made specifically for this purpose found in art stores.

MATERIALS

Painting support	Combs
Acrylic molding paste or gel	Palette knife
	Acrylic paint
	Brush

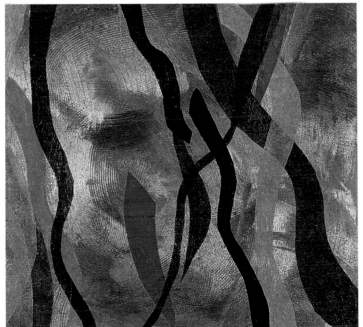

This painting began with a textured surface made with combs and gels. Iridescent copper was used as an underpainting beneath overlays of interference glazes and a collage of torn tissue and vellum papers. (See techniques 3, 23, 24, 29, 34, 38, 39, 40, 55, 93 and 95.)

Waterplay 2
Acrylic and mixed media on board
16" × 16" (41cm × 41cm)
Patricia Forbes

ADD COLOR

3 Using undiluted paint, diluted washes or a combination, paint on top of the hatched-line surface.

pressing shapes into the surface

Look around your home or studio to find small objects with interesting edges or relief patterns. You can press these into wet paste to create texture.

MATERIALS
Painting support
Acrylic molding paste
Found objects

Palette knife
Acrylic paints
Brush

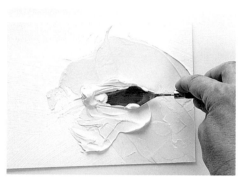

1 APPLY PASTE TO THE SURFACE
Apply a layer of paste about ⅛-inch (3 mm) thick over your entire painting support using a palette knife. Smooth and even out the layer as much as possible with the knife.

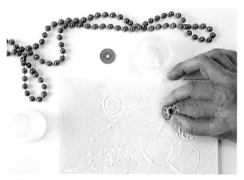

2 PRESS OBJECTS INTO THE PASTE
While the paste is still wet, press your objects into the paste using their edges, sides or faces. Here I used jars, lids, coins, shells and beads. When you are satisfied with the result, let the surface fully dry to the touch before painting.

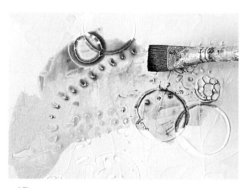

3 ADD COLOR
Using undiluted paint, diluted washes or a combination, paint on top of the textured surface.

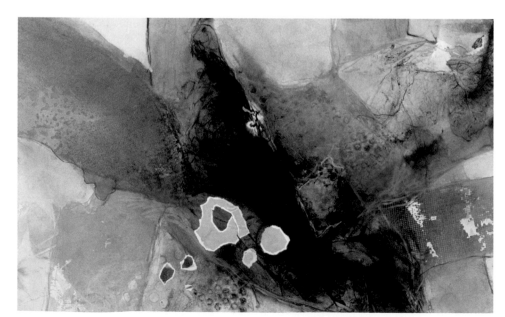

Subtle effects and color fields are created with watercolor and fluid acrylics. Bubble and plastic wrap were pressed into wet washes. A collage of torn paper provides more surface texture. Colored-pencil line work adds direction and focus. (See techniques 19, 32, 34, 38, 39, 40, 55 and 58.)

Phoenix Rising
Acrylic, collage and mixed media on watercolor paper
26" × 32" (66cm × 81cm)
Eydi Lampasona

crackle effects with hide glue

Hide glue is made from animal hides. It is used by wood workers and is found in most wood shops, hardware and home improvement stores. It is inexpensive and easy to use to create a crackling or antiquing effect. The crackle is created when hide glue is sandwiched between two layers of acrylic paint. The effect is most dramatic with two layers that contrast in color or value. Apply your colors in any order. Try a light or bright color as the first layer and a dark or dull color as the top layer, or vice-versa. You can vary the crackle by several controlling factors: the dilution of the glue, the thickness and/or water content of the top layer of paint, and the direction of the brush strokes in the top layer. Experiment by varying all these factors to find out which crackle effects you like the best.

MATERIALS

Painting support
Hide glue
Thick acrylic paints
Brush

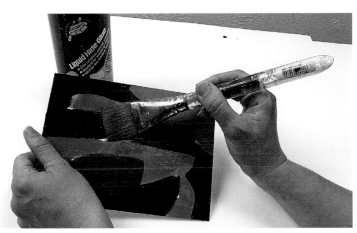

1 PAINT THE UNDERLAYER COLOR

Select a color for your first layer and apply it to your support. This color will appear only in your final piece as the cracks. (Here I am using patches of Carbon Black, Raw Umber, Cobalt Blue and Violet Oxide.) The paint should be thick enough so the surface is completely covered. If the paint is thin and soaks into your support quickly, apply another coat to seal the surface. Let this fully dry to the touch.

2 APPLY THE GLUE.

Diluted glue will give you smaller cracks, while undiluted glue gives larger cracks. Select your preference and apply a thin, even layer with a brush over the dried underpainting. Let this dry thoroughly, approximately 12 to 24 hours.

3 PAINT THE TOP COAT AND CREATE CRACKS

Select a color for the final coat. (Here I used Titan Buff.) The paint must be diluted with water to create the crackle. Starting with a thick paint, add water 1:1. Apply the diluted paint over the dried glue surface. The crackle should happen immediately, so if you do not see a crackle right away with your first brushstroke, add more water to your paint and try it again. Control the crackle by moving your brush in the direction you want the cracks to go.

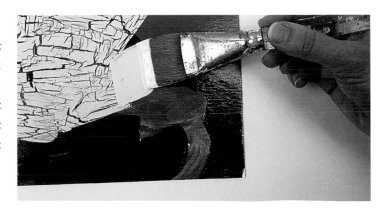

fresco effects with crackle paste

Technique 28 uses crackle paste to create a dried, cracked, white painting surface. This technique uses the same product but differs in that the paint is applied very quickly to wet paste, simulating fresco. The image itself cracks, giving the illusion that it is old. When using crackle paste, it is important to use a sturdy surface such as Masonite, Gator board or wood panel.

MATERIALS

Masonite or other strong rigid support

Crackle paste (4 oz. per each 8" × 10" [20cm × 25cm] of surface area)

Fluid acrylic paints

Palette knife

Rubber shaping tools (optional)

Soft, wide, flat wash brush

Other brushes as desired

Spray bottle with water

Water sprayer

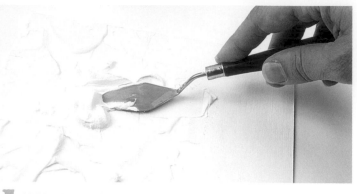

1 APPLY THE PASTE

Using a palette knife, apply crackle paste over your entire surface with a minimum thickness of ⅛-inch (3mm). The thicker the paste layer, the larger the cracks will appear later. If you are working on a large surface, apply the paste to a small section and move immediately to step 2. Complete the first section before applying paste to a new one.

2 PAINT WET-IN-WET

The top surface of the paste layer will start to dry after only 10 to 20 minutes, so work quickly. If you want to carve any lines or texture into the paste, do that first, using a knife or rubber shaping tool. The paste takes overnight to fully crack, but you should paint on it within the first few hours. Use fluid paints, which are easier to apply on the top surface. Spraying the surface with water also will allow your brush to glide more easily over the surface. You can use either diluted or undiluted fluid paints or a combination.

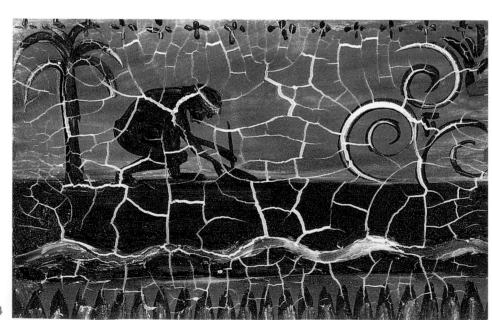

3 FINISH THE PAINTING

Let your finished painting dry overnight to create the cracks. If the paint layer you apply over the crackle paste is too thick, it won't crack, so keep the paint layer fairly thin.

peeling paint with petroleum jelly

The weathered-wood look created in this technique uses petroleum jelly as a resist. The petroleum jelly is spread between two layers of paint, both of which will remain visible in the completed painting. The technique works best when the two colored layers are painted with contrasting hues.

MATERIALS

Painting support	Brushes
Petroleum jelly	Palette knife
Fluid acrylic paints	Paper towels
	Strong soap and water

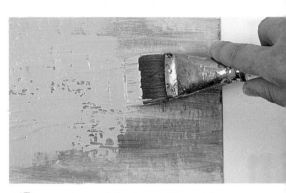

1 APPLY THE UNDERCOAT

Using any color or combination of colors, apply a layer of paint to your support with a brush. Here I used yellow, orange and green applied with a dry-brush technique (see technique 37). Let this layer fully dry to the touch.

2 APPLY THE PETROLEUM JELLY

Using your fingers, brushes, knives or a combination of tools, apply petroleum jelly over the underpainting in selected areas. Wherever you apply petroleum jelly, the undercoat will show through in the end. Try raking the petroleum jelly with your fingers in streamers, as peeling layers of paint would appear.

3 APPLY THE TOP COAT OF PAINT

Select a color that is different from the colors used in the first layer. Add water to the paint to dilute it enough so that the paint will glide easily over the petroleum jelly. (Use about 1 part water to 4 parts fluid paints, or about 1 part water to 2 parts thicker paints.) The paint shouldn't be as thin as a watery wash, or it won't have enough opacity to create the effect. Let this layer dry.

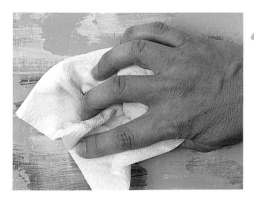

4 REMOVE THE PETROLEUM JELLY LAYER

Using paper towels, rub vigorously over the dried surface. Wherever petroleum jelly was applied, the paint on top of it will easily rub off. After rubbing and removing all the resisted paint, remove the greasy film left by the petroleum jelly by washing the surface with a strong soap and water. Rinse.

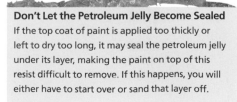

Don't Let the Petroleum Jelly Become Sealed
If the top coat of paint is applied too thickly or left to dry too long, it may seal the petroleum jelly under its layer, making the paint on top of this resist difficult to remove. If this happens, you will either have to start over or sand that layer off.

51

plastic wrap

Here is a popular-faux finish technique that creates a great background or an inspirational beginning for a new painting. It's easy, doesn't require much practice and can be done in one quick session. It utilizes two layers of paint and is most effective when the two layers differ from each other in value, hue or chroma. Contrasting complementary colors work well, too. Try using blue with orange, red with green or violet with yellow.

MATERIALS
Painting support
Acrylic paints
Acrylic glazing liquid
Soft, wide and flat brush
Plastic wrap

Using a Semitransparent Glaze
Adding glazing liquid to your paint will enhance the texture that results from this technique. Another benefit of the glazing liquid is that it will keep the paint from drying quickly, giving you more time to apply the plastic wrap in step 3.

1 APPLY A PAINT UNDERCOAT
Using a brush, apply a generous coat of paint so that your support is fully sealed. If the paint soaks into your surface quickly, wait until this dries and apply a second coat. Let this fully dry to the touch.

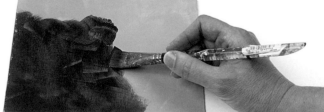
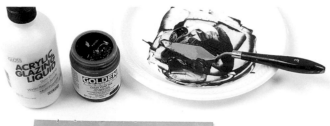

2 APPLY THE TOP COAT OF PAINT
Mix your second color with acrylic glazing liquid in a 4:1 ratio or 2:1 for a semitransparent glaze. (Here I mixed 2 parts Cobalt Violet Hue with 1 part acrylic glazing liquid.) Brush thinly over the first color. Continue immediately to step 3 before this layer dries.

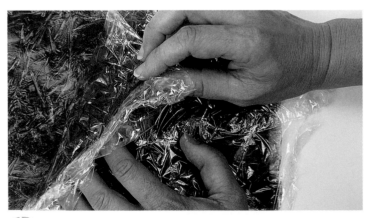

3 ADD PLASTIC WRAP TO THE WET LAYER
Wad a sheet of plastic wrap in your hands. Unfold it loosely and place it onto the wet surface, keeping its wrinkles. If the plastic wrap goes on too smoothly, it won't create interesting textures. Gently press it down with your hands, patting it all over. Before the paint layer dries, remove the plastic wrap.

1 APPLY A THIN PAINT LAYER

Using either fluid or diluted acrylic paints, apply a thin layer of paint onto a primed support. If the paint is applied too thickly, the alcohol won't be able to penetrate it. (Here I used undiluted Burnt Sienna and Quinacridone Burnt Orange fluid paints.) Immediately proceed to the next step. This technique must be executed very quickly as the thin paint layer dries rapidly and the effect diminishes as the paint dries.

alcohol dissolve

Alcohol will dissolve acrylic when dropped onto wet paint, creating some interesting effects. This technique works best on a primed painting support, so that the surface is not too absorbent. You need to keep the surface paint wet long enough to produce the effect.

MATERIALS
Primed painting support
Isopropyl alcohol

Application tools such as an eyedropper, spray bottle and toothbrush
Acrylic paints
Brush

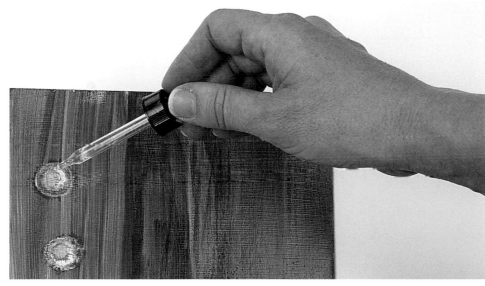

2 DROP OR SPRAY ALCOHOL

Apply undiluted isopropyl alcohol to the wet paint using an eyedropper, toothbrush or spray bottle. (See techniques 15 and 16.) After applying a small amount of alcohol, wait a few minutes to watch it take effect. The alcohol will dissolve the paint and will keep spreading outward from the initial spot for a few minutes. If you put too much alcohol onto the surface it will dissolve the whole layer. The technique works best when the alcohol is dropped onto only about 20% of the surface.

creating a variety of effects
Pictured here is a variety of alcohol-dissolve effects. The large circles were made with an eyedropper, while the smaller ones were made with a spray bottle and a toothbrush.

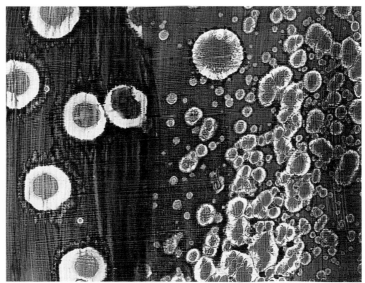

Acrylic can be considered a glue. It is the perfect medium for contemporary image-making methods such as transfers, collage and mixed media.

53

poured shapes

This technique takes advantage of the free-flowing consistency of fluid acrylics to produce colored acrylic shapes. These can be removed from their original surface and glued onto a painting as a collage item.

MATERIALS

Nonstick surface for acrylic such as plastic wrap, freezer paper or HDPE plastic sheeting

Fluid acrylic paints

Empty containers for pouring (optional)

Brush or palette knife

Acrylic gel or medium

Painting support

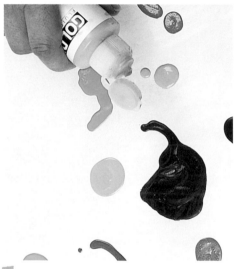

finished example
Here I used a piece of cardboard painted black to show off the colors. After deciding where to place the shapes, I put Golden's Soft Gel (Gloss) under each one, pressed them gently, and let the composition dry.

1 POUR FLUID ACRYLIC INTO SHAPES

Pour fluid acrylics directly out of their containers onto the nonstick surface. Move the bottles in patterns to create a variety of shapes. You can mix your own colors in empty bottles or jars, then pour from those containers. You can further manipulate your shapes with a palette knife or brush. Let them fully dry (2 to 3 days).

2 PEEL, STORE AND ADHERE

Peel the shapes off the surface. To store the shapes for later use, keep them between sheets of wax paper, plastic wrap, freezer paper or HDPE plastic. To add them to a painting, you may cut them into different shapes or leave them as is. Using acrylic gel or medium, adhere the shape to your painting surface. (See techniques 55 and 56.)

Selecting Plastic Wrap
For this technique, avoid using the expensive plastic wraps that boast "extra grip" because they will not release the acrylic paint. Using a cheaper, generic brand of plastic wrap is best.

Solid Shapes Are Best
Small or thin-lined shapes are difficult to manipulate and may break when you try to work with them later, so keep your shapes solid and fairly substantial in thickness and shape.

Artist J.E. Newman pours elongated shapes or sheets of acrylic paint onto a removable surface. When they dry, he peels them off the surface and rolls them into his trademark sculptures.

Paintrolls ™
Acrylic paint
16 ½" × 3" (42cm × 8cm)
J.E. Newman

54

reusing your old palettes

Many times, at the end of a painting session, I have enjoyed looking at the wonderful array of colors and shapes on my used palette and been reluctant to throw it away. Here is a fun technique to salvage those wonderful happy palette accidents. The best palette to use for this technique is HDPE plastic. The acrylic will peel off this surface with great ease.

Before you begin, precoat the plastic with a layer of acrylic. All your paint will stick to this layer and not flake off while mixing. Also you will be able to peel off your entire palette in one large sheet, making it easy to remove and store.

MATERIALS

HDPE plastic sheet (any thickness or size)

Acrylic gloss gel

Acrylic paints

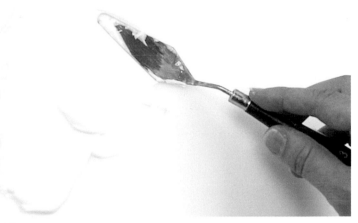

1 APPLY GEL TO YOUR PALETTE

Using a palette knife or other spreading tool, apply a gloss gel to the entire surface. Gloss gels work better than matte gels. Let it fully dry. When the white of the wet gel clears, it is dry enough to proceed.

2 PAINT, PEEL AND STORE

When the gel coat has dried, your palette is ready. Just paint with it as you would any palette. Mix colors, spill them or splash them. I often use the same palette for weeks before changing it. When it gets so busy and confusing that you can't see what colors you are mixing, you can paint a layer of white at the end of your painting session. When you come back the next day your palette will seem like new. Whenever you are ready to completely change your palette or to create some collage pieces with it, simply peel it up. It should come off in one sheet with little effort. If it breaks, then apply the gel thicker next time. Store the palette between sheets of wax paper, plastic wrap, freezer paper or HDPE plastic until you are ready to use it.

3 CREATE COLLAGE SHAPES

To use it in a collage, cut the peeled-off palette sheet into desired shapes with scissors. Using acrylic gel or medium as a glue, adhere the shapes to your painting surface. (See techniques 55 and 56.) The reverse side of the sheet will be glossy and smooth and very different from the side you used as a palette. Use either side for your collage.

55

gluing paper

Here are some tips and techniques for gluing paper smoothly and evenly onto a painting support. A gloss gel works best, but there is a benefit to using a matte gel. If some of the gel seeps under the paper and onto the surface, the matte will not be as noticeable as a gloss. For thin papers, use a gel instead of a medium; it will not wrinkle the paper.

MATERIALS

Sturdy painting support
Paper to be glued
Brush or palette knife
Golden's Soft Gel (Gloss)
Plastic wrap

Scrap paper
Brayer or other roller (optional)
Cotton swab
Heavy objects such as books or weights
Sturdy board

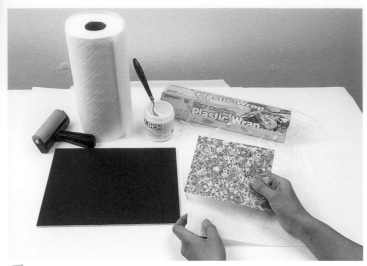

1 SET UP IN ADVANCE
Speed is the trick to successful gluing, so have everything ready and close by so you can do the steps quickly.

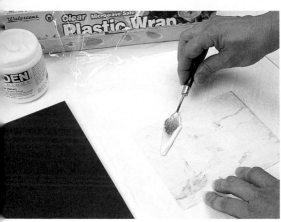

2 APPLY GEL TO THE COLLAGE PAPER
Place the gel on the back and in the center of the paper and spread it out toward the edges with a palette knife. Apply enough gel so that the entire area, including the edges, gets thoroughly covered, but keep it thin.

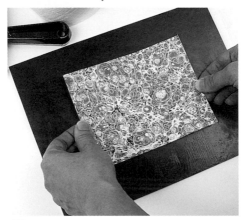

3 POSITION THE COLLAGE PAPER
Quickly lift the paper, flip it right side up and press it in place on your painting support. Make sure the gel remains wet, and that it doesn't dry by soaking into the collage paper before you place it on your support.

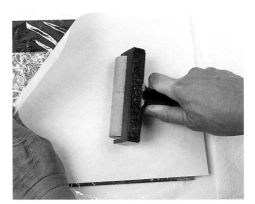

4 SMOOTH THE COLLAGE PAPER
Put plastic wrap over the paper with some excess on all sides. Place scrap paper on top of the plastic wrap. Using a brayer or your fingertips, start in the center of the collage piece and roll or press out toward the edges, smoothing out air pockets and wrinkles. If excess gel seeps out, clean it off with a damp cotton swab.

5 PRESS WITH WEIGHTS IF NEEDED
Leave the plastic wrap over the surface, then place weights. If your collage item is larger than the weights, place a sturdy board such as a Masonite or wood panel that covers the entire piece between the plastic wrap and the weights. Let dry at least 20 to 30 minutes before removing the weights, board and plastic wrap.

Gluing Large Pieces of Paper
If the collage paper piece is large, it is best to glue it in stages so that the gel won't start to dry before you finish. Apply gel to a section at one end of the paper. Place the paper on the support, press down gently on top of the end where the gel has been applied. Flip back the part of the paper that is not glued and apply gel to the next section. Another set of helping hands can make this process much easier.

gluing objects

Acrylic works well as a strong glue to adhere objects to paintings. Thick gels work best for objects. I prefer Golden's Regular or Heavy Gel (Gloss) for most small objects, and the Extra Heavy Gel (Gloss) or High Solid Gel (Gloss) for heavier items. (See the gel comparisons in technique 42. Objects can also be embedded in acrylic; see technique 41.)

MATERIALS
Painting support
Object to glue
Sandpaper (optional)
Golden's Gel (Gloss) (choose a thickness according to the weight of your objects)
Palette knife

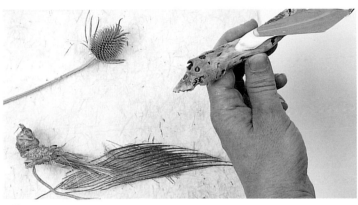

1 APPLY GEL TO THE OBJECT

Find a flat area on your object that will allow it to be placed evenly on your painting support. If this area is very smooth, lightly sand it. Select the appropriate gel for your object. The heavier the object, the thicker the gel you should use. Using a palette knife, apply a generous amount of gel to the back side of your object.

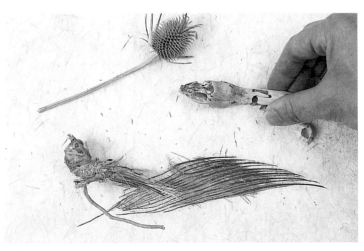

2 PLACE THE OBJECT ONTO YOUR SUPPORT

While the gel is still wet, place your object onto your painting support. Leave it undisturbed in a level position so the object remains stationary while drying. Let it dry for at least 3 days before any further activity.

This painting uses many techniques to create a reflective and highly textural surface. Gems, beads and glitter were glued into poured acrylic layers. Contrasts between warm and cool colors, hard- and soft-edged forms, intense colors and neutrals, and lights and darks create depth, focus and mood. (See techniques 3, 16, 28, 34, 38, 39, 40, 41, 85, 90, 93 and 101.)

Waterscape
Acrylic and mixed media on panel
24" × 16" (61cm × 41cm)
Nancy Reyner

metallic leaf and acrylic

This technique shows how to apply metal leaf over an acrylic painting.

MATERIALS

Primed painting support

Waterproof sandpaper (350 to 600 grit)

Stencil or tape (optional)

Metal leaf in thin sheets

Leaf adhesive

Cotton balls or cheesecloth

Wax paper

Soft brush

Solvent-based clear acrylic (spray or brush-on)

Acrylic paints

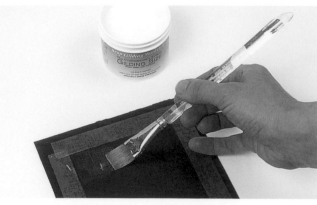

1 PREPARE THE SURFACE AND APPLY LEAF ADHESIVE

Seal a raw surface with gesso, clear acrylic or a solid coat of glossy paint. Wet the primed surface with water and sand it with wet sandpaper. (See technique 77.) Using a soft brush, apply leaf adhesive in a very thin layer. For a specific design, tape off the area to be leafed, use a stencil (see technique 64), or just paint. Remove any tape. Wait 15 to 20 minutes or until the adhesive gets tacky.

2 APPLY THE METAL LEAF

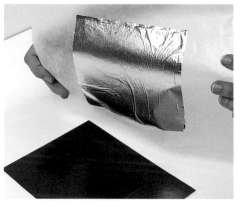

Using a piece of wax paper slightly larger than the leaf, place it waxed side down over the leaf and gently wipe it with your hand. The leaf will temporarily stick to the wax paper. Lift and position the wax paper with the gold leaf over your adhesive area and gently place it down. If your area is larger than the leaf sheet, repeat the process, slightly overlapping the sheets. If any areas remain bare, rip small pieces of leaf to size and apply them to the bare spot, overlapping the leaf around it.

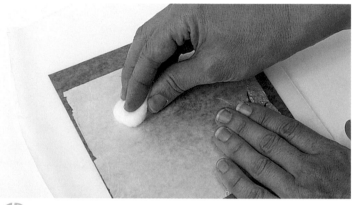

3 BURNISH THE LEAF

Gently pat the area with a cotton ball or cheesecloth, then rub a bit harder with a cotton ball. Remove the wax paper and let the leaf set 12 to 24 hours.

4 CLEAN THE EDGES AND SEAL THE SURFACE

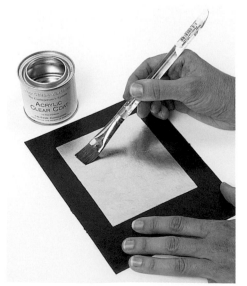

Using a soft brush, gently wipe away any excess leaf at the edges and where leaf pieces were overlapped. Use a clear solvent-based acrylic finishing product to seal the surface. Let it fully dry for a few days. Now that the leaf has a protective acrylic finish, you can overpaint using acrylic if desired.

Selecting Leaf Adhesive

There are two basic types of adhesives for metal leaf: oil-based and water-based. Water-based adhesives will not work with real gold leaf, but will work with imitation or combination leaf. Water-based adhesive is less toxic, so I used it for this demonstration.

drawing over acrylic

Drawing on a painting expands the range of artistic possibilites. However, most drawing materials will not adhere to a glossy acrylic surface. This technique offers a great way to create a clear tooth over your acrylic painting so it can accept these materials without obscuring the underlying painted image.

MATERIALS

Painting support

Drawing materials such as chalk pastel, charcoal, colored pencil or Conté

Golden's Acrylic Ground for Pastels

Palette knife

Brush

colored pencil

water-soluble pencil

lead pencil

charcoal pencil

vine charcoal

conté

chalk pastel

ball point pen

oil pastel

............. glossy acrylic paint

............. matte acrylic paint

............. acrylic ground for pastels applied over acrylic paint

examples of drawing materials on different surfaces

As you can see, acrylic ground for pastels produces the cleanest results. Mix water with Acrylic Ground for Pastels as much as 1:1 or as little as 1:2. Diluting acrylic ground for pastels makes it more transparent.

1 APPLY ACRYLIC GROUND FOR PASTELS

Brush a thin layer of the diluted mixture over your entire surface. Let it dry to the touch.

3 FINISH THE PIECE

Once you have a gritty surface you like, continue drawing. The colored pencils used here were easy to handle and show up very bright and bold.

2 TEST THE DRAWING MATERIALS

Try a few test lines with your drawing materials. If the materials resist or aren't working very well, add another coat of your same diluted mixture, or make a new mixture using less water. Test the drawing materials again.

Additional Uses for Acrylic Ground for Pastels

Apply acrylic ground for pastels straight or diluted to any new surface to add grit and tooth. Try tinting it by mixing some paint color into it, and apply this to a surface for a toothy, colored underpainting.

stabilizing drawings over acrylic

Drawing materials (such as colored pencil, charcoal and Conté) are somewhat delicate and may smear easily if you try to paint with acrylic on top of them. First, test the drawing materials by brushing acrylic medium over a small area of the drawing. If the drawing materials do not smear, then the easiest way to stabilize the drawing would be to overpaint it using a thin layer of acrylic medium. If they do smear, use this technique, which demonstrates how to spray an isolation coat or stabilization layer over them. When spraying, make sure you have adequate ventilation and safety gear, or work outdoors.

MATERIALS

Support with drawing materials

Spray equipment

Jar or mixing container

Golden's Specialty Acrylic Polymer GAC 500

Golden's Airbrush Transparent Extender

1 MIX THE SPRAY SOLUTION

Combine GAC 500 and Airbrush Transparent Extender in a 1:1 ratio. You can store any unused mixture in a container with a lid for future use.

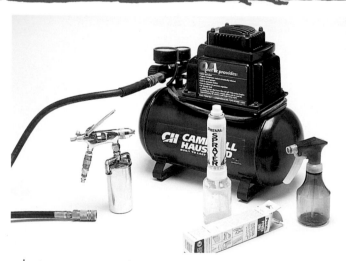

select your spray equipment

For small artwork, use a household spray bottle. Upgrade to a Preval spray gun for larger artwork or work with delicate drawing lines. Use an airbrush and compressor for higher-quality spraying needs such as applying finishing coats to get a perfectly smooth, flawless spray. Experiment to find what works best for your needs.

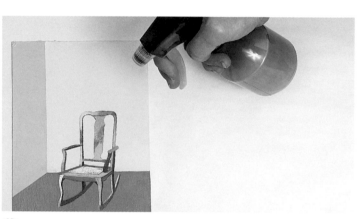

2 SPRAY YOUR ARTWORK

Test your sprayer first with water. If you have a setting choice, set the spray to fine. Remove the water and fill the container with your GAC 500/Airbrush Transparent Extender mixture. Follow the instructions for filtering in technique 69 if you are using a spray gun or airbrush. Begin spraying at least 5 inches (13cm) outside of the edge of your artwork and continue about the same distance beyond the opposite edge with each pass. Maintain a consistent speed and work in even lines. Overlap your lines slightly. After spraying, place the work flat to dry to avoid any dripping. When dry, add more coats if necessary.

If the Sprayer Gets Clogged

If your sprayer gets clogged, remove the mixture from the sprayer. Clean the sprayer immediately by spraying clean water through it. Change the mixture by adding more Airbrush Transparent Extender and try it again.

Stabilizing Chalk Pastel

This technique is not meant as a finishing spray for chalk pastel. If chalk pastel is the main medium of your artwork, or if it covers most of the last layer, frame it behind glass. Spraying chalk pastel with acrylic medium will cause a change in its appearance. However, if the pastel is used in conjunction with acrylic paint and/or other mixed media or if a change in appearance is not an issue, then this spray will be fine.

sticker mania

I developed this quick, fun sticker technique for people who want to create a painting in a short period of time. Stickers can be found in hobby and craft stores, stationery stores, toy stores, art stores and on the Internet. They are inexpensive and fun to collect. You can make your own stickers, too. (See technique 61.) This technique will also let you experiment with composition, blending soft edges, creating hard edges, flat areas and gradations.

MATERIALS

Painting support	Stickers
Acrylic paints	Golden's Soft Gel (Gloss)
Tape	Palette knife
	Brush

1 PAINT A BACKGROUND
Create any background on your surface. Here, I decided to use a soft gradation that looks like a sky by using blending technique 89.

2 FINISH THE BACKGROUND
Continue painting on the background until you like it. Here I added a third color on the bottom. By using a hard edge, I created a horizon line and changed the sky into a simple landscape. (See techniques 67 and 68 for more about hard edges.) Let this dry fully.

3 ARRANGE STICKERS
Place the stickers, rearranging them if necessary until you come up with a composition you like. If the stickers grip the surface too tightly, put a thin layer of matte medium over the background and let this dry before reapplying the stickers.

4 APPLY GEL OVER STICKERS
Using a palette knife, add a thick layer of gloss gel over the entire work to seal the stickers and add a wonderful glossy sheen. Apply the layer at least ¼-inch (6mm) thick. Too thin a layer will cause the stickers to curl off your board. If you prefer, you can overpaint the gel layer when dry with glazes or opaque paints to further enhance the image.

basic transfers

This technique transfers the ink from a photocopied image onto an isolated piece of acrylic on a removable surface. It can then be cut up and used for a collage on any support, or stored for later use. The black ink from the copier is absorbed into the acrylic, and when paper from the photocopy is removed, those areas become clear.

MATERIALS

Photocopied image

Clear acrylic gloss medium or gel

Brush or palette knife

Nonstick surface for acrylic such as a plastic garbage

bag, glass, HDPE plastic, freezer paper or inexpensive plastic wrap (do not use super-grip wrap)

Spray bottle with water

Soft rag

Acrylic paints

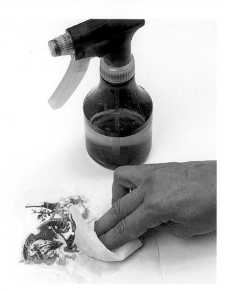

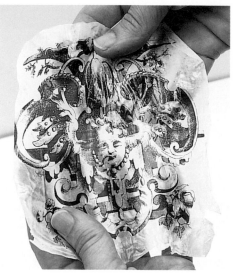

1 APPLY ACRYLIC TO YOUR IMAGE

Select a black-and-white photocopied image. Keep some margins and do not crop the excess paper too much. Apply a clear glossy acrylic medium or gel to the front side of your image, continuing into the margins. Let this layer dry overnight. Repeat, applying at least three coats in total, letting each dry overnight. After all coats are applied, let it dry for at least one day.

2 REMOVE THE PAPER

Using a sprayer or your sink, wet the entire paper side with warm water. Let the paper absorb the water for a few minutes. Using a soft rag, gently rub over the paper, moving from the center out toward the edges. Remove any paper balls that collect on your rag so they don't roll back onto your image. Continue to rewet and remove any remaining paper.

3 USE OR STORE

The acrylic gel or medium will dry clear. Store between pieces of plastic wrap or freezer paper to keep it from sticking. The skin can later be cut into shapes with scissors, painted and/or added to a collage.

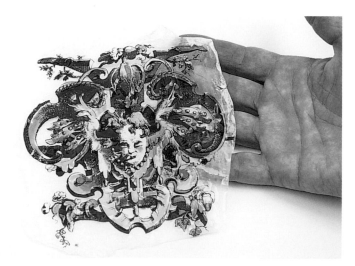

Not All Copies Are Created Equal

This technique will work only with an image that has been copied with a photocopy machine. Images printed on a fax or computer printer will not work.

painting the reverse side of the gel skin

Here is an example of the same skin with acrylic colors painted onto the back. (The back may be whichever side you choose.) When painting on the reverse side, you can paint rather sloppily and the black lines on the front will help to clean up the whole image.

direct transfers

The transfer process described in technique 61 produces an acrylic transfer skin. The technique described here transfers a photocopied image directly onto your painting.

MATERIALS
Painting support

Photocopied image in reverse

Acrylic gloss medium or gel

Brush or palette knife

Spray bottle with water or a wet sponge

Soft rag

1 PREPARE THE IMAGE AND SELECT A MEDIUM

Your image will be transferred in reverse from the copy machine, so keep this in mind, especially if your image contains any text. Do not crop your image too closely; you will need some excess paper. If you want your underpainting to show through the transfer, use a clear glossy medium or gel. If you want to block out what is behind your transfer, use a paste or white paint. Acrylic paint can also be used or added to any medium, gel or paste for color.

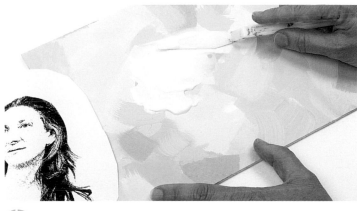

2 ADHERE IMAGE TO SUPPORT

Apply the acrylic you select to the area on your painting where you want the transfer, using a brush or palette knife. You can also apply the acrylic to the entire support if desired. Apply a generous layer to adhere the image, or more if you want extra texture. Place the image face down into the wet acrylic. Do not let acrylic get onto the reverse side of the paper. Let this dry for at least one day, or more if the acrylic is thickly applied.

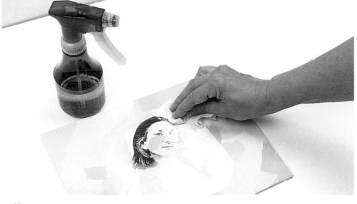

3 START REMOVING THE PAPER

Wet the entire paper side with water using a sprayer or sponge (or directly out of the faucet). Let it sit a few minutes so the paper can absorb the water. Gently rub the paper with a soft rag. Remove any balls of paper that collect on your rag so they don't roll back onto your image.

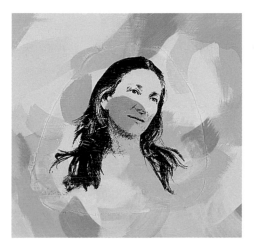

4 REMOVE THE REST OF THE PAPER

Remove all the paper, rewetting as necessary to help removal. A clear glossy gel allows the background to show through the transfer.

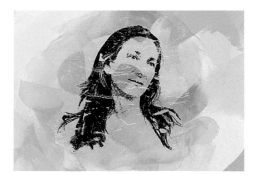

tint the image, if desired
You can mix a few drops of gold color into a glossy gel in step 2 and use it to adhere the transfer, tinting the final background.

63

foundation drawing with transfers

Transferring an image directly into an acrylic gesso primer is a fun and quick way to produce an underdrawing, or pre-painting sketch. This is the only transfer technique that can be completed within an hour or two, due to the quick drying time of gesso.

MATERIALS
Primed painting support

Photocopied image in reverse

Acrylic gesso

Brush

Spray bottle with water or wet sponge

Soft rag

Pencil or marker

Acrylic paints

1 PREPARE YOUR SUPPORT
Seal your support with a first coat of gesso so the second coat in step 2 will stay wet long enough to create the transfer.

2 ADHERE THE IMAGE TO GESSO
Apply a generous coat of undiluted gesso to the support, enough so that it doesn't dry too fast, but not enough for the brushstrokes to show. Working quickly while the gesso is still wet, place your photocopied image face down into the gesso and press gently to smooth it out. Let this dry at least 45 minutes. The longer it dries, the cleaner the image will transfer.

3 REMOVE THE PAPER
Wet the entire paper side with water using a sprayer or sponge (or directly out of the faucet). Let this sit a few minutes so the paper can absorb the water. While the paper is wet, gently rub it with a soft rag. Remove any paper balls that collect on your rag so they don't roll back onto your image.

4 REINFORCE THE IMAGE
Using a pencil or marker, reinforce any lines or areas that are missing from the transfer, or those that you want darker. Add additional freehand drawings if desired.

5 OVERPAINT
Try using a variety of glazes, transparent and opaque paints to overpaint the transfer image.

Innovative Stenciling and Line Work

Using stencils, tape, spray equipment, graphic and drawing tools will add variety to the edges and lines in your artwork. These tools can also offer new ideas and inspiration.

64

make your own stencils

Even with all the commercial stencils available, you may still have trouble finding just what you need. Here is a quick and inexpensive technique for creating your own.

MATERIALS

Heavyweight paper (such as bristol)	Cutting board
	Pencil or other drawing tool
Acrylic gesso	Painting support
Brush	Masking tape
Palette knife	Thick acrylic paints
Craft knife	Paper towels or scrap paper
	Sponge

1 PREPARE THE PAPER AND DRAW YOUR DESIGN

Brush acrylic gesso onto both sides of a heavyweight paper. Let each side dry to the touch before proceeding. Use any drawing tool to work out your design on the paper. Keep your shapes simple and large enough to cut easily. Each shape should be solid so pieces of the design won't drop out.

2 CUT OUT YOUR DESIGN

Using a craft knife with a sharp blade and a cutting board or protective cardboard under your stencil paper, cut out your design. Cut the small detailed shapes first, then cut out the larger areas.

3 PAINT THROUGH THE STENCIL

Position your stencil on your painting support and secure it with masking tape. Apply thick paint with a brush or palette knife over the stencil. To use multiple colors, have knives or brushes in each color ready before starting to paint. You can also paint this at a more leisurely pace by completing one color at a time and letting each dry before continuing.

4 REMOVE THE STENCIL

Press firmly on the stencil, remove the tape and carefully roll back one end of the stencil. Keep rolling until the stencil is completely detached. Move the stencil onto a paper towel or scrap paper. Scrape the excess paint from your stencil and return it to jars with lids to store for later use. If you plan to use the stencil again, immediately rinse it with water and rub the excess paint off with a sponge.

raised stenciling

This technique creates a raised relief design, or a thick, textural stenciled application. Textural designs can add a contemporary element to your work. Purchase a commercial stencil or make your own (see technique 64), substituting ⅛-inch (3mm) foam from a hobby store for the paper.

MATERIALS

Painting support
Stencil
Masking tape

Thick acrylic paste or gel
Palette knife with a stepped handle
Acrylic paints
Paper towel or scrap paper

1 APPLY PASTE OVER THE STENCIL

Position your stencil on the support and tape it in place with masking tape. Select a thick acrylic gel or paste (see technique 42). Scoop a generous amount of gel or paste onto a palette knife with a stepped handle and apply it over the stencil. Keep your knife above but parallel to the stencil to create a thick layer. The more heavily you spread the gel or paste, the deeper the relief of your design. Since acrylic will shrink in volume by about 30% when dry, spread it a bit thicker than you want. You can add color to the paste or gel in this step, creating a colored relief.

2 LEVEL OUT THE TOP SURFACE

Using the bottom, flat side of your knife, smooth out the top of the paste so that the paste is a consistent thickness and evenly spread.

3 REMOVE THE STENCIL

Press firmly on the stencil and then carefully roll back one end. Keep rolling until the stencil is completely detached. Move the stencil onto a paper towel or scrap paper. Scrape the excess paint from your stencil and return it to jars with lids to store for later use. If you plan to use the stencil again, immediately rinse it with water and rub the excess paint off with a sponge.

4 OVERPAINT

Once the paste or gel has dried, you can overpaint the relief design with washes, glazes or opaque paint.

Reducing Ridges

As you lift the stencil off the support or the relief design, you may get ridges right at the edge. If the stencil is flimsy or made of a thinner plastic, the ridges will be more pronounced. If the stencil is stiff and thick, the ridge effect will be less noticeable.

rainbow stenciling

This technique presents a unique way of working wet-in-wet with stencils. By adding wet paint to wet gel, you can add a variety of colors, transparent effects, blending and texture to your stenciled design. See technique 65 for more information on working with a thick relief design.

MATERIALS

Painting support
Acrylic paints
Palette knife
Brush

Stencil
Masking tape
Thick acrylic gloss gel
Paper towel or scrap paper

1 PREPARE MATERIALS

Paint your support with a background color if desired. Position a commercial or homemade stencil on the support and tape it in place with masking tape.

2 APPLY THICK GLOSS GEL

Using a palette knife, apply a generous amount of thick acrylic gel over the stencil. Hold the stencil firmly with your hand pressing down, very close to where you are spreading the acrylic. As you move the knife over the stencil, keep the knife slightly lifted to create some depth.

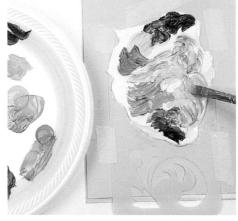

3 ADD PAINT TO THE WET GEL

While the gel is still wet, apply paints with a palette knife or brush. Try varying the consistency and application of the paints. Don't forget about using white as a color and applying it unmixed with other colors in some areas, creating some opaque effects. Wash your brush thoroughly between colors to keep the hues clean. Once the colors are applied, use a clean brush to gently blend them in places.

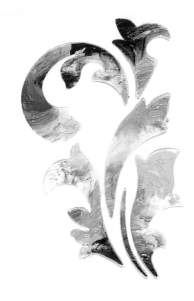

4 REMOVE THE STENCIL

Press firmly on the stencil, remove the tape and carefully roll back one end. Roll until the stencil is completely detached, then move it onto a paper towel. Scrape off excess paint and store it in jars. Rinse your stencil with water and rub off excess paint with a sponge.

An Alternative to Wet-in-Wet

As an alternative, you can overpaint the design after it is dry instead of working with wet paint on the wet gel. After the gel dries, replace the stencil over the dried design to help protect the edges and keep them clean while painting. This will produce very different results. Experiment with both ways to see which works best for you.

67

creating sharp edges

Taping offers an easy way to create hard lines and edges in your artwork. Applying thick paint over the tape generally produces good results. Often, bleeding edges result from thinner diluted paints, or from working on a textured surface where the tape can't lie flat. This technique shows how to seal the taped edge, reducing glitches and guaranteeing a clean edge every time.

MATERIALS

Primed support

Golden's Specialty Acrylic Polymer GAC 500 or an acrylic gloss gel or medium

Cellophane or masking tape

Brush or palette knife

Acrylic paints

Blow-dryer

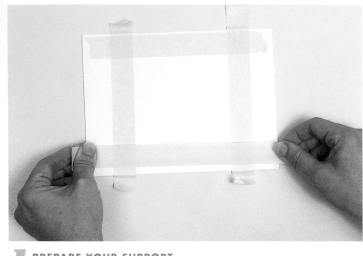

1 PREPARE YOUR SUPPORT

Use a primed or sealed surface for taping, or the tape may damage it. Measure the area you would like taped off, or just apply the tape freehand. Let the first length of tape be long enough to extend beyond the edges of your painting support. This makes tape removal easier. Press the tape firmly near the edge closest to the area to be painted.

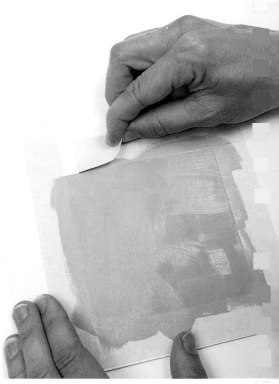

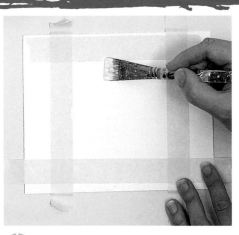

2 SEAL THE TAPED EDGES

Using a brush or knife, apply a gloss medium or gel to the entire area within the tape, making sure to extend well over the taped edges. Use a gel for textured surfaces. Quickly dry the area by exposing it to a blow-dryer for about 30 seconds.

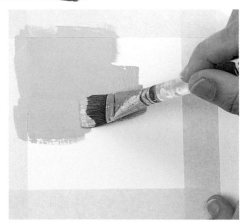

3 PAINT OVER TAPED AREA

Apply paint over the taped and sealed area using a brush or palette knife. Be careful to keep the paint inside the taped areas.

4 REMOVE THE TAPE

Once the paint is applied, remove the tape. Grasp one end of the tape from one side. Don't pull the tape straight up towards you; instead, flip the tape edge over and carefully roll the tape almost as if you were rolling it back onto itself.

MATERIALS

Heavyweight absorbent paper (such as bristol, poster board or construction paper)

Pencil (optional)
Painting support
Thick acrylic paints
Flat brush

creating controlled, ripped edges

This technique makes a natural looking ripped-edge stencil, enabling you to control the form and direction to get the rip exactly the way you want it. Ripped-edge stencils work beautifully for a tree line on the horizon, or for mountain ranges in the distance.

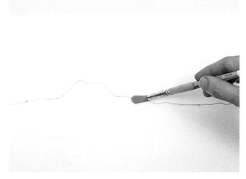

1 DRAW YOUR LINE DESIGN

If you prefer to use a guide, use a pencil to draw a line on heavyweight paper the way you want it to rip. Load a brush with water and apply it directly over your drawn line, or freestyle. Keep loading your brush with water so the line becomes soggy. Wait one or two minutes for the water to soak through the paper.

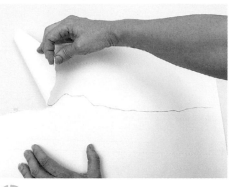

2 TEAR YOUR EDGE

While the water line on the paper is still wet, grip the paper at one end and gently tear the paper along the line. The paper will rip exactly where your brush marked it with water.

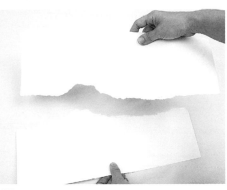

3 TWO STENCIL CHOICES ARE CREATED

You can use either side for your ripped-edge stencil.

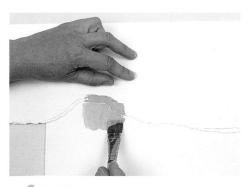

4 PAINT THE STENCIL

Position the ripped paper stencil over your painting support. Use a brush to apply thick paint. As you work, always move your brush downward from the paper stencil toward the painting support, rather than upward from the support toward the stencil, so you don't push paint underneath the stencil. Notice how the edge looks organic and natural.

5 FINISH THE PAINTING

Apply a second layer using a different color to the other half of the ripped edge stencil paper, if desired.

spraying

The Preval spray gun is an excellent tool for quick spraying sessions, spot spraying small areas or for those times when you just don't feel like hauling out all that airbrush equipment. The Preval, found in paint and hardware stores, is inexpensive and produces a finer spray than a household plant sprayer but a bit coarser than an airbrush and compressor.

For all spraying techniques, you need adequate ventilation and a protective mask, or you can spray outdoors. Work on a flat surface, and protect areas you do not want sprayed with plastic drop cloths or scrap paper.

MATERIALS

Preval Spray Gun with jar
Fluid acrylic medium or paint
Mixing container
Old nylon stocking
Funnel
Painting support
Acrylic retarder
Masking tape
Scrap paper or drop cloth
Blow-dryer (optional)

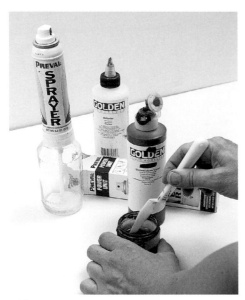

1 MIX THE SPRAY SOLUTION

Mix your spray solution in a container or jar, using any combination of acrylic mediums and paint. It should be thin like milk, not like heavy cream. If the mixture is too thick, dilute it with water. Add 1 part acrylic retarder to 9 parts solution to slow down the drying time. For a great clear coat spray formula that can be used between painting layers or to stabilize drawing materials, see technique 59.

2 FILTER THE SOLUTION

Filter the solution to keep it spraying freely. This is an easy step and worthwhile to do at the start. Pour your solution into the Preval jar through a piece of nylon stocking fabric placed in a funnel. Rinse the stocking material with water so you can reuse it later. Be careful when removing the stocking filter to keep the lumps it collected from getting back into your clean solution.

3 SPRAY

Hold your Preval at a slight angle. Begin spraying at least 5 inches (13mm) before you reach the first edge of your artwork or area to be sprayed, and continue spraying the same distance beyond the other edge. Overlap your lines slightly. Use several light coats instead of one heavy coat. Reduce drying time between coats by using a blow-dryer. If you want a crisper, cleaner edge, spray a preliminary coat of any acrylic gloss medium. Quickly dry this clear layer with a blow-dryer, then spray on your color.

integrating water-soluble drawing materials

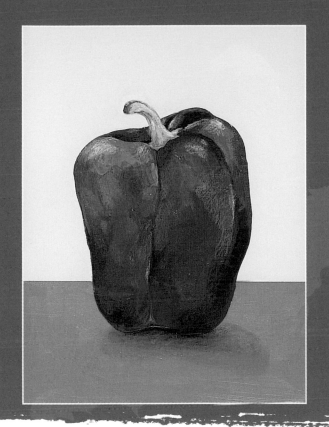

The technique on this page focuses on water-soluble drawing materials. Pencils and crayons are both available in water-soluble form and are sold in sets or singly. Check the label on the packaging to make sure it says "water-soluble." Experiment with different types and brands to find your preference. Integrating these materials into an acrylic painting is easy. When blended with acrylic, these materials create a unique effect.

MATERIALS

Painting support	Brush
Acrylic paints	Matte medium (optional)
Water-soluble pencils or crayons	Acrylic medium (optional)

1 PREPARE YOUR SUPPORT

Use acrylic paints for your background or underpainting. Drawing materials, even water-soluble ones, generally work better on a matte or absorbent surface, something with tooth. If the painting surface is shiny, apply a thin layer of matte medium to add some tooth (see technique 58).

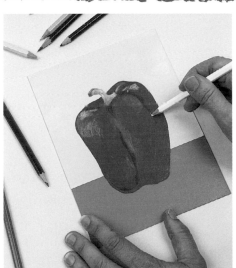

2 DRAW ON YOUR PAINTING

Using any water-soluble drawing materials, draw directly over your painting wherever you want to add some detail. Apply heavily where you need the most color saturation.

Make It Waterproof

Blended areas will become waterproof after they dry if you use medium instead of water. This gives you the advantage of being able to overpaint or glaze without smearing the underlying layer. Another way to make a drawn layer waterproof is to spray it with a clear layer of acrylic (see technique 59).

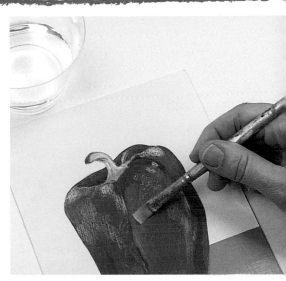

3 BLEND WITH WATER OR MEDIUM

Using a brush dampened with water or medium, brush lightly over the drawn lines in areas that you wish to blend. Leave some areas unblended to provide contrast. Begin blending where you want the color to be the boldest and move outward to soften the color and line. Clean the brush frequently, blotting excess water for more control.

line applicators

When your artwork requires some very fine detail or line work, squeeze bottles offer a good alternative to a brush. You can use any type of paint or medium with the tips and bottles shown on this page. They are fun to try, and all come with a variety of tip applicators for different widths. It is helpful to have several varieties around the studio with which to experiment.

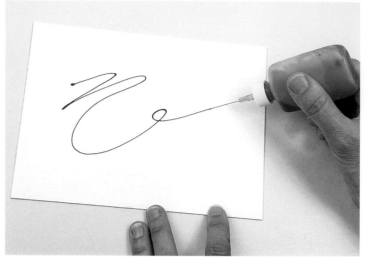

holding the bottle and applying the paint
Hold the bottle at a slight angle to the painting surface, approximately 30 degrees. Fluid acrylic paint usually works fine undiluted. If you find the tip clogging frequently while you work, try adding a small amount of water to the paint.

USING BOTTLES WITH TIP APPLICATORS

Keep some spare bottles filled with water close at hand, and work near a bucket or the sink so that you can clean the applicator tips quickly. The thinner the tips, the faster the acrylic will dry in them. Whenever you stop or pause, remove the tip from the bottle you are working with and place it over a spare bottle already filled with water. Squeeze the bottle until the water coming out of the tip is clear. When stopping for more than an hour, do a complete cleaning by removing the tip and taking it apart (some of the better quality bottles have a two-part tip) and rinsing it well with running water. Test the applicators on a piece of scrap paper before using them on your artwork. Then, if a big blob of paint comes out first, or water from a previous rinsing, you won't ruin your artwork.

the possibilities are almost endless
A variety of lines using black fluid acrylic paint, applied with different bottles and tips.

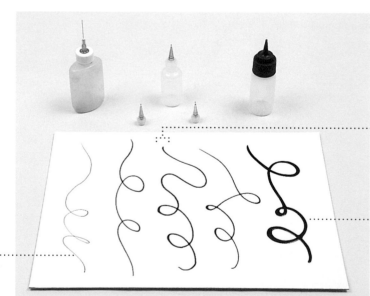

thicker lines made with different applicators from Jacquard's line of squeeze bottles

a thick, dark line made with a bottle and tip found at most hobby stores

a very fine line made with a hypodermic solution applicator (Hypo-200, 25-gauge)

Hypodermic Solution Applicators
Hypodermic solution applicators are available in 6 different fine gauges from Gaunt Industries (www.gauntindustries.com). You can sometimes find these bottles in larger art supply stores. Jacquard's squeeze bottles with stainless steel tips, as well as other refillable bottles and tips, can be purchased at hobby and craft stores.

ruling pens

Ruling pens, available in art stores, offer a wonderful way to create straight, even lines with acrylic paint. The ruling pen has an open well that you can fill with any fluid or diluted acrylic paint. It is easy to clean and can be used freehand for a loose line, or with a ruler or T-square for measured, even lines.

MATERIALS
Painting support
Scrap paper
Ruling pen
Brush
Paper towels
Fluid acrylic paint

1 ADJUST THE LINE WIDTH

Turn the dial on the side of the pen to change the distance between the two metal drawing blades at the tip of the pen. This controls the width of line. Tighten it to create a very thin line or widen it to create a thick line. The widest it will go is about ⅛-inch (3mm).

2 PREPARE THE PAINT AND LOAD THE INKWELL

Dilute the paint with water until the consistency is like heavy cream: very smooth with no lumps. Load a brush with paint, then wipe the bristles off on the pen, unloading the paint into the inkwell. Repeat until the well is fairly full. Carefully wipe off the excess paint along the outside of the inkwell blades with a paper towel to avoid wiping the paint out of the well.

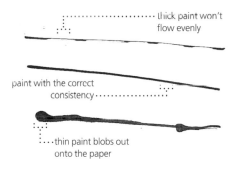

thick paint won't flow evenly

paint with the correct consistency

thin paint blobs out onto the paper

3 TEST THE PAINT'S CONSISTENCY

Hold the pen directly upright after it is filled with paint. If the paint's consistency is correct, the paint will hold inside the well but will form a slight bulge at the bottom tip. Test the consistency by trying to draw a line on a piece of scrap paper. Adjust the ratio of paint to water if necessary. Keep testing until the paint produces an even line.

4 DRAW WITH THE PEN

Draw with the pen as soon as it is filled with paint. If the paint gets stuck, clear it by running a small brush through the well to release the color. Hold the pen at a slight angle to your paper, about 30 degrees. Experiment on a piece of scrap paper to find the angle that allows the most even flow. Refill when necessary.

Cleaning the Pen
Turn the valve to open the inkwell wide. Rinse the pen with water and wipe the inside of the inkwell with a sponge or rag.

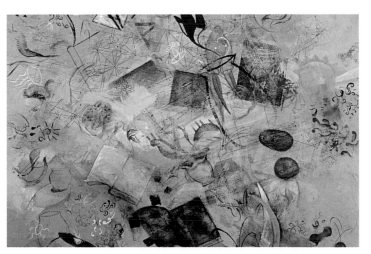

Cosmic Haze
Acrylic with oil and tissue paper collage on canvas
48" × 62" (122cm × 157cm)
Nancy Reyner

Hard-edged mechanical lines contrast with hand-drawn softer lines, adding focus and direction. (See techniques 8, 31, 34, 37, 38, 39, 40, 55, 58, 59 and 70.)

scrafito

Scrafito, meaning to scratch, is used for many techniques in various mediums, including jewelry and ceramics as well as painting. The technique demonstrated here involves scratching through a wet top layer of paint to reveal a dry layer of color underneath. It is best to use two colors that are very different from each other. For instance, the bottom layer might be a bright color, while the top is a muted or dark color. Or the bottom layer may be multicolored, while the top layer is one solid color. This technique is a great way to create a wide variety of colorful lines in your painting.

MATERIALS

Painting support
Acrylic paints
Acrylic gel, medium or retarder

Brush
Palette knife
Scraping tools

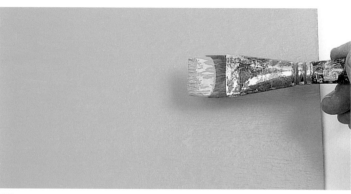

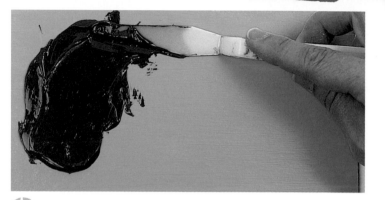

1 CREATE AN UNDERPAINTING OR FIRST LAYER OF COLOR
Create an underpainting or paint an initial layer of color. This layer eventually will be covered by another layer of color, then will be revealed as "lines" are scratched through the top layer. If the first layer is not shiny when you hold it up to the light, apply a second coat of paint or apply a coat of acrylic gloss medium on top. Let this layer dry fully.

2 APPLY A SECOND LAYER OF COLOR
Select a color for the top layer that differs from the first. Test your paint color on a piece of scrap paper. If it is streaky or very transparent, try adding white or another opaque color to it to increase its opacity. Then slow the drying time by adding about 1 part gloss gel to 4 parts paint or 1 part retarder to 9 parts paint. Mix well. Using a brush or palette knife, apply this second layer over the previously painted layer. Smooth out the layer with the flat bottom of the knife.

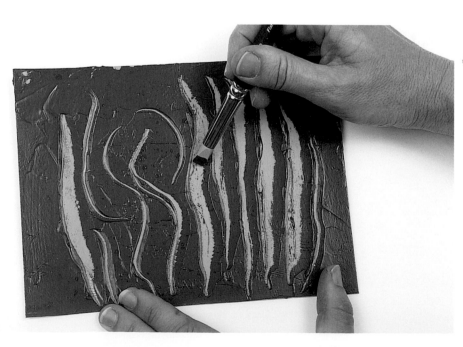

3 SCRATCH THROUGH THE TOP LAYER
While the second layer is still wet, scratch through it using any sharp tool, such as the edge of a palette knife, the tip of a brush handle, or a rubber shaping tool. Scrape through the wet layer to reveal the color of the underpainting below.

Customize Your Paint

Acrylic paint can be made thinner, thicker, slower-drying, stringy, reflective, glossy, matte—just about any aspect of the paint can be changed.

SURFACE TREATMENTS

- **Seal the substrate.** A sealed substrate or surface is less absorbent and will slow down the paint's drying time. Prime your painting support with acrylic gesso and then apply a layer of acrylic gloss medium or gel. Let it dry before applying paint.
- **Wet the back of the canvas.** When painting on stretched canvas, periodically spray the back of the canvas with water to keep some moisture under your paint layer. Attach wet sponges to the back of the canvas with tape to keep it moist even longer.
- **Work on wet layers.** Apply a thin coat of retarder or acrylic glazing liquid over the entire surface, or a selected area. While this is wet, paint over or into it and your painted areas will stay wet longer.

PAINT ADDITIVES, MEDIUMS, WATER AND GELS

- **Add retarder.** When you are using an additive, carefully follow the instructions on the label. Use a maximum of 1 part retarder to 9 parts paint.
- **Use a retarder medium (slow-drying medium or glazing medium).** Add any amount of this medium to your paint, blending well before using.

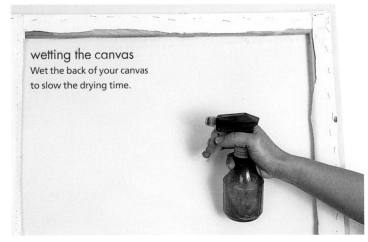

wetting the canvas
Wet the back of your canvas to slow the drying time.

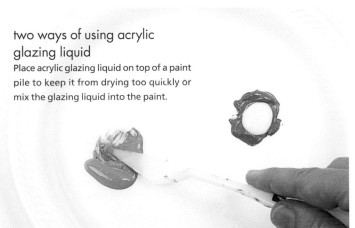

two ways of using acrylic glazing liquid
Place acrylic glazing liquid on top of a paint pile to keep it from drying too quickly or mix the glazing liquid into the paint.

74

slower drying

Many factors influence the drying times of acrylic paint. The most influential factor is climate. Wet and cold climates give the paint more open time, slowing the rate at which it dries. Below are some techniques to keep your paint from drying too quickly.

You can also add it on top of a pile of paint on your palette without mixing. This is a great trick for plein air painting.

- **Add water.** Diluting your paint with water in a 4:1 ratio will make the paint more fluid and slower to dry without affecting its opacity too much. Adding more than a 1:1 ratio of paint and water will turn your paint into a diluted wash or stain.
- **Add gloss gel.** A thickened medium is often called a gel. By mixing 1 part paint with 1 part gel, you can slow the paint's drying time. If you continue to add more gel to the paint, you will achieve more open time but the paint's opacity will be decreased. Matte gels won't work.

STORAGE AND PALETTES

- **Store paints in air-tight containers.** Purchase small plastic jars with well-fitting lids to mix and store your paints. Paint the top with a small amount of the color so you know what is inside. Repaint the lid whenever you change the color. Mark the lids when adding gel, retarder or glazing liquid to identify which jars can have the lids off for longer periods of time without drying out.
- **Use a larger quantity and thicker layer of paint.** Keep pushing the paints into a pile on your palette as you mix colors because a thick clump will take longer to dry. Transfer paint into smaller storage jars as the color gets used. A thick layer of paint on your surface will take longer to dry than a thin layer.
- **Use nonabsorbent palettes.** The best palettes to use are nonabsorbent ones such as glass, HDPE plastic or freezer paper. (See page 12 for more information.)
- **Spray your palette.** Spraying paints periodically with water is a popular method of keeping paints moist. However, this is my least favorite method because it slowly turns the paint into overly diluted solutions, and reduces your control over the paint's consistency. Instead, spray your paints with a mixture of 10 parts water to 1 part retarder, or any undiluted acrylic airbrush medium.

faster drying

Even though acrylic dries quickly, sometimes you may need to speed the drying even more. When working in multiple layers, you may need to quickly dry each layer before working on the next. Absorbent surfaces like watercolor paper, raw canvas or plaster walls speed drying because moisture will be absorbed quickly. See techniques 19, 21, 22, 58 and 86 for ideas about how to increase your surface's absorbency. The technique described here uses a hair dryer to blow-dry the paint layers, speeding your painting process—a real convenience when you're working in multiple layers.

MATERIALS

Blow-dryer
Painting support
Brush
Acrylic paints

Drying Considerations

Avoid blow-drying any wet acrylic layer that is more than ½-inch (12mm) thick. If the top of this thick layer dries much faster than what lies beneath, it may form cracks or crevices. While drying, acrylic shrinks about 30% in volume and therefore needs time to dry evenly. With a thick layer, blow-drying it or placing it out in the sun may dry it too quickly. Acrylic is "dry to the touch" when the top paint layer has dried, but the acrylic is not considered completely cured until the entire thickness of the layer is dry. This may take several days to several weeks, depending on the layer's thickness and environmental factors.

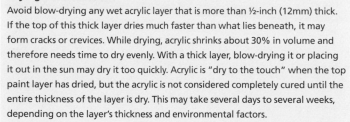

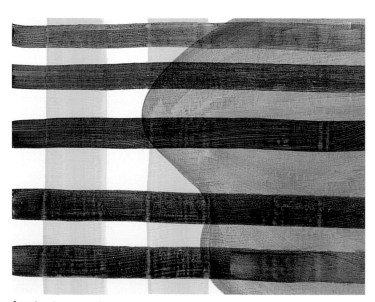

finished example

This three-layer composition took less than five minutes to create because I blow-dried each layer.

1 BLOW-DRY THE FIRST LAYER

Blow-dry the first layer of paint for 10 seconds from a distance of 8 to 12 inches (20cm to 30cm). Use the blow-dryer longer in rainy or cold weather, in humid locations or for thick layers of paint.

2 BLOW-DRY THE SECOND LAYER

Blow-dry the second layer of paint the same as you did for the first paint layer.

thickening for texture

Several acrylic products are designed to thicken acrylic paint to enhance or increase its textural qualities. Visible knife strokes will result from thickened paint, adding texture to your work.

This technique focuses on mixing gels and pastes with paint to thicken it. Gels and pastes are basically thickened acrylic binders. Technique 42 shows the differences between gels and pastes. Technique 81 demonstrates how to use these products to lighten and brighten colors. Techniques 43–47 use gels and pastes straight, with no added color or dilution, to create a textured surface or relief.

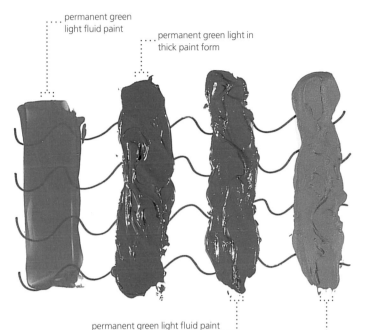

permanent green light fluid paint

permanent green light in thick paint form

permanent green light fluid paint with gloss gel added in a 1:1 ratio

permanent green light fluid paint with paste added in a 1:1 ratio

choices for texture

Acrylic paints come in different consistencies. Golden has a line of fluid acrylics that come in bottles, and a line of heavy bodied, thick acrylic paints that come in jars and tubes. Gels are usually clear or translucent, while pastes are opaque.

extend your paint

Acrylic products such as gels and pastes do not contain pigment and generally are much cheaper than paint. By adding such products to your paint, you can save quite a bit of money. This is called *extending your paint*. You can add quite a bit of these extenders to your paint without dramatically affecting the pigment's opacity and color intensity. Here, Turquois (Phthalo) was combined with a clear glossy gel in varying proportions and applied over black lines to show decreasing opacity.

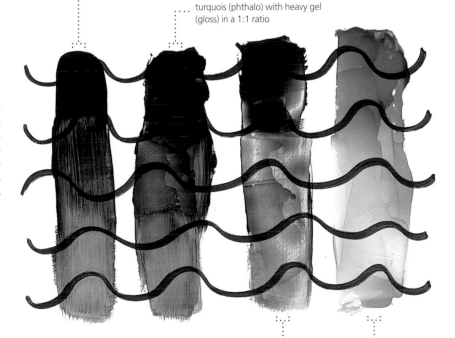

fluid turquois (phthalo) paint with nothing added

turquois (phthalo) with heavy gel (gloss) in a 1:1 ratio

turquois (phthalo) with heavy gel (gloss) in a 1:4 ratio

turquois (phthalo) with heavy gel (gloss) in a 1:30 ratio

"brushless" and smooth

Smooth surfaces create a lustrous, sheen, as well as a perfect surface for drawing or fine detail. Below are the most popular methods for achieving smooth painting surfaces.

MATERIALS

Primed painting support
Fluid acrylic paint color
Brush
Golden's Specialty Acrylic Polymer GAC 500
Water
Water sprayer
Waterproof sandpaper between 350 and 600 grit
Mixing cup and lid
Lint-free rag

OPTIONS FOR CREATING SMOOTH PAINTING SURFACES

- Mix 2 parts fluid acrylic paint with 1 part water. Using a soft, flat brush, apply to your substrate.
- Add Golden's GAC 500 Acrylic, a leveling product, to acrylic fluid paint. The paint may be slightly diluted with water or undiluted.
- Try painting with matte fluids, which, in addition to having a matte finish, are made to level out more than other acrylic paints.
- Wet sand your substrate's surface to make it smooth before applying paint. Try sanding various grounds, experimenting to find your preference.
- Pour a layer of clear acrylic over your finished painting, or pour several times between layers. (See technique 101 for pouring tips.)
- Pour a layer of paint for a smooth color field. (See techniques 100 and 101.)
- Spray your paint to apply color smoothly. (See technique 69.)
- Using a mineral-spirit-soluble protective varnish on your finished painting will often level out any remaining texture. Applying the varnish with a brush will give a more substantial coat than spraying.

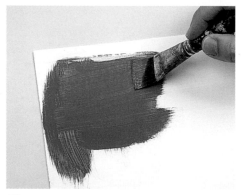

1 APPLY PAINT

Use a primed or sealed substrate so the support can handle the sanding. Keep your paint somewhat fluid in consistency, but not too thin or too diluted. Apply one or more coats to build up a good strong paint layer. Let this layer dry.

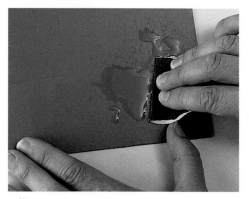

2 SAND THE PAINT LAYER

Spray the surface with water. Sand the paint, making sure there is always water between the sandpaper and the surface. Use circular motions, sand in small overlapping circles, and stop every few minutes to spray the surface and wipe off excess paint with a lint-free rag. Once the substrate shows through more than half of the sanded area, stop sanding and let it dry.

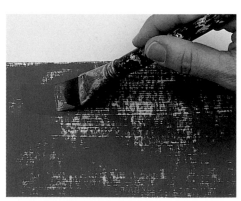

3 APPLY A DILUTED PAINT LAYER

Using a separate container with a lid, dilute your paint with water in a 1:1 ratio. Apply a thin layer of this diluted color. It should have enough covering power to keep the color looking uniform, and not be so diluted as to allow the white substrate to show through. After this layer dries, you can make the surface even smoother by repeating steps 2 and 3 until it is as smooth as you like.

MATERIALS

Painting support
Golden's Clear Tar Gel

Acrylic paints
Palette knife
Mixing jar with lid

"Jackson Pollock" drips

This technique takes advantage of a unique product created by Golden called Clear Tar Gel. When you combine acrylic color with Clear Tar Gel, you create a stringy or tarlike paint. This paint can then be drizzled onto a surface with a palette knife to create varied lines and drips, similar to the quality of marks that the artist Jackson Pollock made on his canvases. (For other uses of Clear Tar Gel, see techniques 25, 96 and 97.)

1 ADD COLOR TO THE GEL

Add 1 to 3 drops of fluid paint to a 2-ounce jar of Clear Tar Gel. Mix well, using a knife or other mixing tool. Put the lid on the container so it won't dry out and allow the mixture to sit for at least 2 hours.

2 DRIZZLE LINES

Dip a palette knife or other tool into the container and load up a good quantity of the gel. Try not to remix it. Bring the container close to the support and let the paint drizzle off the knife. Have all the colors you want to use ready in advance.

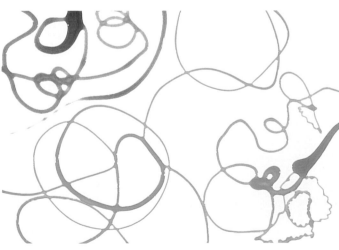

3 CREATE VARIOUS LINES

Let one layer of drizzled acrylic dry, then apply another layer. Add layers until you get the results you want.

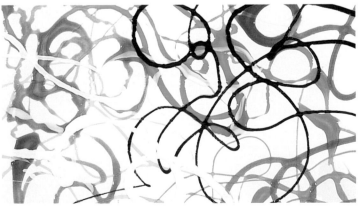

drizzling in layers

This example was created by drizzling several Clear Tar Gel color mixtures in the same session to create a multicolored layer. The first layer was allowed to dry for a few hours, then a second layer was applied using different Clear Tar Gel color mixtures. The result, a densely packed drizzle design, was obtained by repeating separate multicolored layers three or four times.

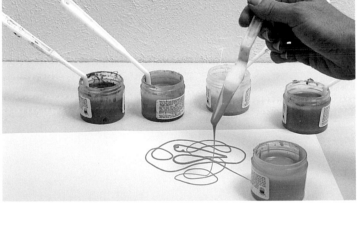

staining control

Staining refers to color applied with thin layers of very diluted paint. The art of staining takes some experimentation and practice. Three factors influence a stain: the substrate's absorbency, the dilution of the paint, and the application method. By varying these factors, you create stains that vary in edge, bleed or spread, as

well as the evenness of the tone. An absorbent surface such as raw canvas, watercolor paper or fabric will yield a more even stain. To increase the absorption of paint into the substrate's depths, you can use an additive called Acrylic Flow Release. You can apply your stain with a brush or pour it from a container.

hard edge, uneven stain
Here, fluid acrylic paint was applied undiluted with a brush to a dry, absorbent surface. This is the best combination for keeping a hard edge with minimal bleeding.

hard edge, even stain
Fluid acrylic paint was diluted with water and brushed onto a dry, absorbent surface.

soft edge, penetrating stain
Here, fluid acrylic paint was diluted with water and brushed onto an absorbent surface covered with wet Acrylic Flow Release.

soft edge, feathered stain
Fluid acrylic paint was diluted with water and brushed onto an absorbent surface wet with water.

Preparing Canvas for Stain Applications
Some raw canvases are precoated with a water repellent that will inhibit good stain applications. Work with uncoated canvas to get the best results, or prewash the fabric. Use a solution of 1 tablespoon (15ml) of Jacquard's Synthrapol and 1 tablespoon (12g) soda ash to a washer load of canvas.

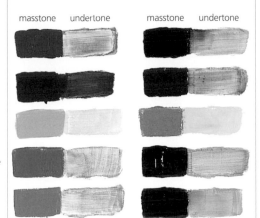

mineral (inorganic)	masstone	undertone	masstone	undertone	modern (organic)
burnt sienna					quinacridone burnt orange
cadmium red medium					quinacridone red
yellow ochre					nickel azo yellow
cerulean blue					phthalo blue (green shade)
chromium oxide green					phthalo green (yellow shade)

masstone and undertone

This chart compares mineral and modern pigments. The masstone is the full-bodied color that is seen when the paint is applied in a thick layer. The undertone is the color that is seen when the paint is applied very thinly. Note the difference in masstone and undertone of modern pigments.

pigment control

Become familiar with the two main categories of pigments to better control your work. Pigments, both natural or synthetic, fall into two categories: organic and inorganic. In general, the organic pigments, which I call "modern," tend to have new or modern sounding names like *Phthalo* and *Quinacridone*. The inorganic pigments, which I call "mineral," have names that sound familiar and natural, like *ochre*, *cadmium* and *burnt sienna*. If you are interested in learning more, there are many books available that focus on the history and chemistry of pigments. Techniques such as 82 and 83 explain how to reverse the transparent and opaque characteristics of the two categories of pigments.

modern pigments: turquois (phthalo) and quinacridone magenta

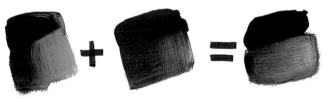

mineral pigments: permanent green light and cadmium red medium

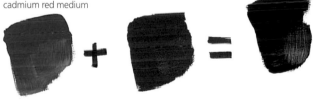

cleaner color mixing

Modern pigments will mix cleaner colors, while mineral pigments tend to form muddier mixtures. In this example, two pairs of complementary reds and greens are mixed together. The modern pair yields a beautiful purple. The mineral pair, however, yields a muddy brown.

cadmium red medium has good coverage and brushes out evenly

quinacridone magenta is transparent and brushes out in streaks

covering power

Mineral pigments are generally more opaque and have better coverage, while modern ones are transparent. Remember that the modern pigments have a big difference between their masstone and undertone, which becomes visible as streaks when painted.

	pure color	mixture with 1 part titanium white to 10 parts color	mixture with 1 part titanium white to 1 part color

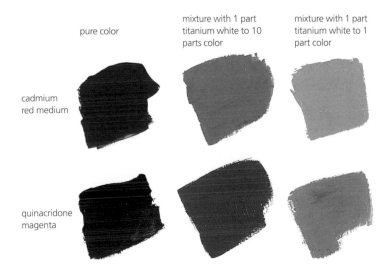

cadmium red medium

quinacridone magenta

tinting strength

When opaque white is added to mineral paints, they get lighter but lose some intensity and seem chalky. Modern paints get immediately brighter as well as lighter with a very small amount of the same white. As more white is added, the modern pigment will start to act like a mineral pigment and get chalkier.

light but still bright

To make a color lighter we usually reach for a tube of white paint and add that to make a tint. But as you add white, the color often loses its brightness and gets chalkier. Here are three alternatives for making a color lighter while maintaining its chroma or brightness. Technique 80 explains why different colors vary in their tinting strengths and thus require different handling to achieve results.

ADDING LIGHT MOLDING PASTE

My favorite way of lightening a color without affecting its intensity is to use Golden's Light Molding Paste. (Don't confuse this with another Golden product called Molding Paste. Molding Paste is slightly gray in color because it contains marble dust, so it will not lighten in the same way as Light Molding Paste.) Only a very small amount of color is needed to mix with the paste to create a vibrant tint of your color. Compare the tint made with Light Molding Paste to the tint made with Titanium White in the picture below. The difference is obvious. Also notice that the paste creates an opaque tint, whereas the gel makes a transparent one. Paste will thicken the paint's consistency, so if you do not want too much texture in your artwork, try applying the paste thinly, or dilute it with a small amount of water.

ADDING GLOSS GEL

Mixing gloss gel with your paint in moderate amounts, about 1 part paint to 10 parts gel, will lighten the color, bringing it close to its bright undertone. I like to think of the gel as "bringing out the flavor" of the color. Use the gel also if you want your color to be transparent.

ADDING ZINC WHITE

Zinc White is a much more delicate whitener than Titanium White. Zinc is a transparent pigment, so adding it to your color will create a more subtle, yet vibrant tint.

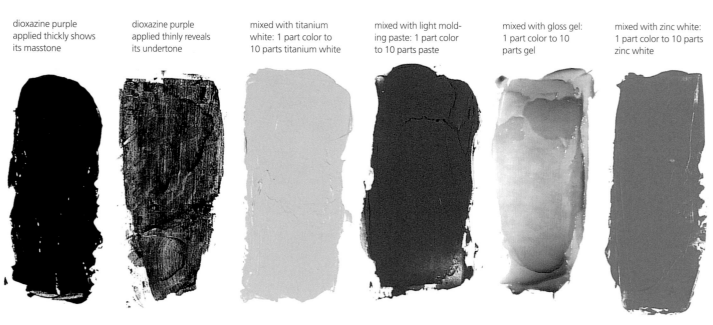

dioxazine purple applied thickly shows its masstone

dioxazine purple applied thinly reveals its undertone

mixed with titanium white: 1 part color to 10 parts titanium white

mixed with light molding paste: 1 part color to 10 parts paste

mixed with gloss gel: 1 part color to 10 parts gel

mixed with zinc white: 1 part color to 10 parts zinc white

lightening a color

Compare the masstone and undertone of the original color with four lightening methods: 1) mixing with titanium white, 2) mixing with light molding paste, 3) mixing with gloss gel and 4) mixing with zinc white.

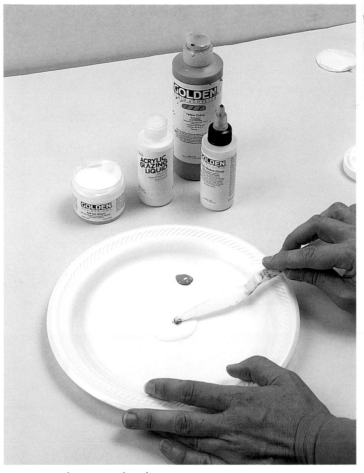

changing opaque to transparent

Regardless of a paint's natural opacity or transparency, you can change it in any way you like. The more opaque a paint, the better it will cover what is underneath. An opaque paint will also brush out evenly in color. Transparent paints are "see-through," revealing and influencing any color underneath. This technique explains how to make a paint more transparent; technique 83 shows how to make it more opaque. When you add more medium to a paint, you are increasing the ratio of clear binder to the colored pigment, which makes the paint more transparent. Choose a medium for a smoother look, or a gel for more texture. (See techniques 42 and 76 for more about gels.)

mixing medium or gel with your paint

Place the amount of medium or gel you need on a palette or in a mixing cup, then add a small amount of paint. Mix well with a palette knife. If you reverse the order and start with paint and then add medium, it doesn't work as well.

yellow ochre paint in its original form

yellow ochre made transparent with a medium

yellow ochre made transparent and textural with a gloss gel

test for transparency

Test a stroke of your paint mixture over some black lines made with a permanent marker to see if the transparency is to your liking.

quinacridone/nickel azo gold paint in its original form

paint applied in a thin layer without anything added

adding acrylic glazing liquid makes the paint easier to apply evenly

making your paint a glaze

Quinacridone/Nickel Azo Gold is an organic, modern pigmented paint, therefore it is naturally transparent. (See technique 80 for more information on organic and inorganic pigments.) If you wish to make a glaze, adding a medium will help. A slow-drying, clear, glossy medium, such as Golden's Acrylic Glazing Liquid, will make the paint easier to apply in thin, even applications. Add more medium to make the paint even more transparent.

83

changing transparent to opaque

Modern pigments are naturally transparent. (See technique 80.) There are several options for changing these transparent paints into opaque ones. Try the options singly or combined for a full range of possibilities. For ease of comparison, all the following demonstrations for this technique use Quinacridone Burnt Orange.

original form
Quinacridone Burnt Orange, an organic pigment, with nothing added.

option 1: apply paint thickly
When applied thickly, organic pigments can be dark and have good covering power.

option 2: add titanium white
Titanium White is opaque, so it will make this organic pigment more opaque as well as lighten its tone. Add a very small amount to keep the chroma bright. (See technique 80.)

option 3: combine with an opaque color
Burnt Sienna and Quinacridone Burnt Orange are both warm browns, but one is opaque and the other transparent. Combine them in any proportions to create a hybrid color with some of each paint's characteristics.

mixed with light molding paste mixed with molding paste mixed with matte gel

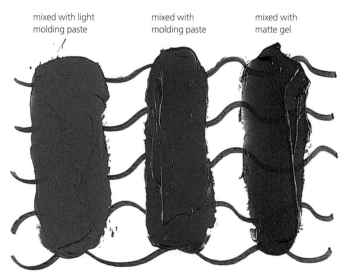

option 4: add an opaque paste or matte gel
Try mixing a molding paste into the color to make it more opaque, or mix a matte gel into the paint. Matting agent also helps to make the color more opaque.

step 1: apply tint **step 2:** glaze over tint

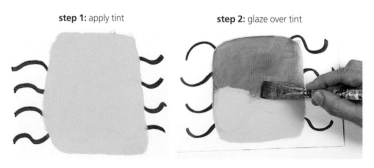

option 5: glaze over a tint
This technique is accomplished in two separate layers. First make a tint of the color by adding about 1 part Titanium White to 1 part paint. Mix well. Apply an even film on your painting support using a brush or knife. Let this dry (use a blow-dryer if desired). Make a glaze by adding about 1 part acrylic glazing liquid to 3 parts of original color, not the tint. Apply this glaze in a thin layer on top of the previous layer.

maintaining color intensity

Colors such as yellow that are light in hue can lose intensity when painted over darker colors. It is often difficult to maintain their original color and lighter value when used over anything but white. Here is a great trick for maintaining intensity when working with light colors. This technique also provides useful hints for painting a still life.

MATERIALS

Painting support

Acrylic paints

Brush

Titanium White (thick, not fluid)

Blow-dryer (optional)

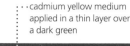
cadmium yellow medium

· cadmium yellow medium applied in a thin layer over a dark green

· cadmium yellow medium applied in a thick layer over a dark green

· two paint layers: titanium white applied first over the dark green, then cadmium yellow medium applied in a thin layer over the white

apply a layer of white to maintain intensity

Whenever you need to use a light color, first apply Titanium White in the place you wish to use the light color. Let the white dry (use a blow-dryer if desired). Then apply a thin layer of the color, and it will remain bright.

1 USE TITANIUM WHITE TO PAINT THE OBJECT'S SHAPE

Paint the background and foreground of your still life, ignoring any objects that will be placed in the still life later. Decide what form or objects you wish to add to the composition and paint them in with a brush using thick, heavy-bodied, undiluted Titanium White paint. Allow to dry fully.

2 ADD LOCAL COLOR

Using a brush, apply an opaque color that best represents the average overall color of your object over the painted white area. Use as many coats as you need to get the full intensity of your color. Let this paint layer dry. The white underneath allows the color to be at its brightest.

3 ADD FINISHING TOUCHES

Now that the colors are bright and clean, you can leave them as they are, or use any number of techniques to blend and add detail. (See techniques 88 and 89 for tips on blending.)

Simulating Other Mediums

Acrylic is the great imitator. In addition to having unique qualities of its own, acrylic can simulate the look of other mediums such as watercolor, tempera, oil and encaustic.

85

simulating watercolor

For imitating watercolor, it is best to start with fluid acrylics. If you are using thicker paints, you will need to add more water to compensate for the thickener they contain, so your hues will be more diluted.

Add enough water to completely break down the acrylic binder—more water than you normally would add to watercolor paints. I usually dilute the acrylic paint with water 1:3 or 1:4, but you should experiment with different ratios. Overdiluted acrylic looks and acts like watercolor, so absorbent surfaces work best.

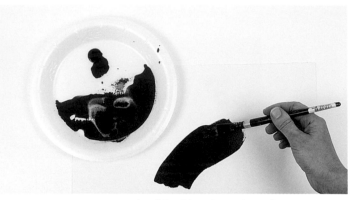

method 1: dilute heavily with water
Dilute 1 part Dioxazine Purple fluid acrylic paint with 3 parts water. Brush this onto watercolor paper.

method 2: blot excess paint

While the diluted acrylic paint is wet, blot any excess paint to get a lighter variation of the color or create texture. Here I am using a crumpled paper towel to dab at the wet paint, creating a blotchy, varied stain.

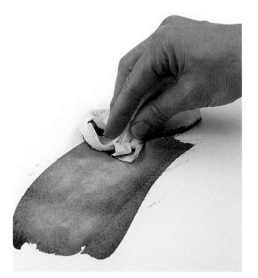

method 3: working wet color into wet color

Here I am brushing Diarylide Yellow into Cadmium Red Medium while both are wet. Where they meet, they naturally blend into an orange hue.

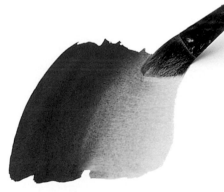

method 4: wipe with a rag

While the diluted acrylic is still wet, wipe the excess paint off using a soft, lint-free rag. This will create an evenly colored stain. Here I am using Turquois (Phthalo) fluid acrylic paint diluted with water.

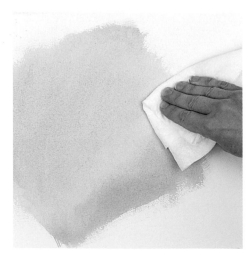

method 5: work on a wet surface

Diluted Phthalo Blue (Green Shade) fluid acrylic paint bleeds quickly on this wet surface. Experiment with different amounts of water on the surface, using a household spray bottle for a light mist or a brush for a heavier application. The wetter the surface, the faster and wider the color will spread.

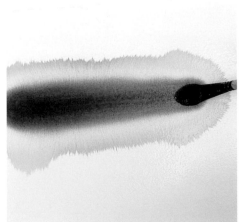

beyond watercolor

This page demonstrates unique wash effects from acrylic paint that watercolor paints cannot accomplish. (Technique 85 shows ways to replicate more traditional watercolor effects.)

idea 1: create your own watercolor paper

Prime any support with one coat of acrylic gesso. Mix 2 parts Golden's Absorbent Ground with 1 part water. Stir well. Cover the mixture and let it sit a few hours or overnight. Apply at most six coats, letting each layer dry between applications. When the surface is dry, paint on it using diluted fluid acrylics or watercolor paints.

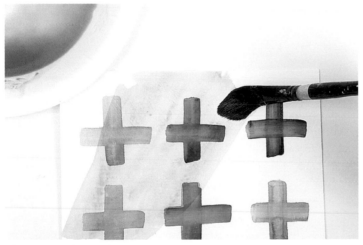

idea 2: washes in layers

A layer of acrylic paint can be applied over a previously dried layer without smearing it. By applying layers of acrylic washes, you can create a clean built-up effect, similar to glazing.

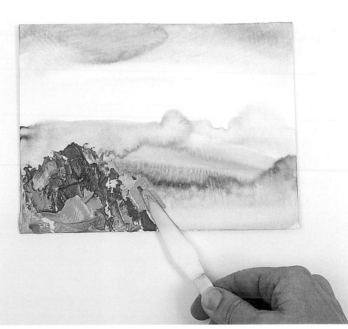

idea 4: combine opaque and transparent wash effects

Using transparent washes in some areas and thick, opaque paint in others, you can create aesthetically dramatic contrasts quite easily. Here I am adding thick applications of green opaque paint with a palette knife. This contrasts with the washy landscape to create depth.

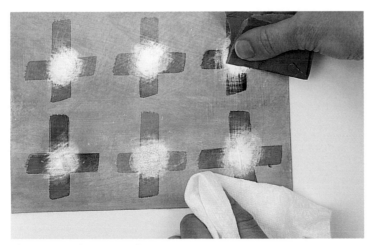

idea 3: sand a painted area

Sanding paint off an absorbent ground can create interesting textural effects (see technique 36). It also can correct some painting mistakes by acting as an eraser. Always use wet sandpaper, especially with Absorbent Ground, to avoid creating toxic dust.

Create a Unique Paper Surface on Any Support
Absorbent Ground can be reapplied midway through your painting as correction fluid. See technique 23 to create a support that has an unusual absorbent surface.

making acrylic feel like oil

This technique, along with techniques 88, 89 and 90, offers various methods to simulate the look and feel of oil paint. The only difference I have found between oil and acrylic is in the handling. Acrylic dries quickly, while oil dries slowly. This page focuses on simulating the feel of oil by slowing the drying time of acrylic paint.

I recommend three products that each slow the drying of acrylic paint. Golden's Soft Gel (Gloss) and Acrylic Glazing Liquid are both mediums that can be added to paint in any amount. Paint mixtures containing 20 to 30% of either medium will dry more slowly without significantly changing the paint's color or opacity. Retarder is an additive, not a medium, so there is a limit to how much you can add. Mixtures with more than 15% retarder may never fully dry. In addition to significantly slowing drying time, the Soft Gel (Gloss) adds a slippery quality to the paint, making it feel much like oil. It also gives an oil-like luster to the paint's sheen, and adds enough body to obtain the soft textural brushstrokes that are characteristic of oil.

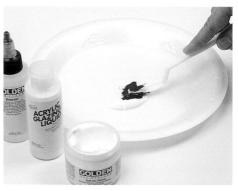

Mixing soft gel gloss into acrylic paint.

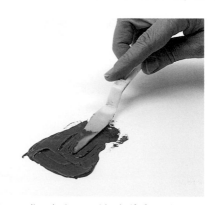

Applying acrylic gel mixture with a knife for an impasto texture.

Applying acrylic gel mixture with a brush.

still life using oil

still life using acrylic

same painting, two different mediums

These two paintings look very similar, but the two types of paint had to be handled differently to make them look the same. The oil painting was created with one wet layer, while the acrylic painting was created with several quick-drying layers. Add Acrylic Glazing Liquid to acrylic paints to slow the drying time and make it easier to handle blended areas (see technique 89). Slower drying allows more time to mix colors on the palette (see technique 74).

old masters glazing

Here, you'll build up a painting with multiple transparent layers of color, or *glazes*, over a black-and-white underpainting, or *grisaille*. This is the same concept used in Old Masters glazing techniques. The underpainting is created using darks and lights to set up the range of tonal values. As transparent glazes are applied on top of this underpainting, the colors automatically become lighter or darker according to what's underneath.

MATERIALS

Painting support

Brush

Fluid acrylic paints (I used Cadmium Red Medium,

Carbon Black, Green Gold, Raw Sienna, Titanium White, Ultramarine Blue and Violet Oxide)

Golden's Acrylic Glazing Liquid

1 CREATE AN UNDER-PAINTING

Establish the tonal range with a grisaille underpainting. Use Titanium White and Carbon Black and several gray mixtures. Add about 1 part acrylic glazing liquid to 4 parts paint to make blending easier. Use a wide range of values from white to black with a variety of gray areas. Let the grisaille dry.

2 MIX GLAZES AND APPLY THE FIRST LAYER

Use Raw Sienna for the pear, Ultramarine Blue for the background and Violet Oxide for the table, adding acrylic glazing liquid to each. Add about five drops of fluid acrylic paint to a half-teaspoon (2.5ml) of the medium. Apply one thin coat of glaze to each of the three areas and let dry.

3 REPEAT IN LAYERS

Adding additional layers is up to you. The more layers you add, the deeper and richer the color, but the more you will cover the grisaille underpainting. Try another layer using a Violet Oxide glaze over the pear, Green Gold over the background and Cadmium Red Medium over the table. Apply as many layers as you like, letting the previous layer fully dry before applying the next. If you apply too many layers and lose the tonal range of the underpainting, just add more dark and light glazes on top.

Test Your Glaze First

Before applying a glaze mixture to your painting, test the transparency of your mixture on scrap paper with some black lines drawn on it. Use a waterproof black marker for the lines so they don't bleed into the color. Apply a thin layer of your glaze mixture over the black lines. If the paint obscures the lines, it is too opaque and needs more medium. If the glaze barely shows any color, then add more acrylic color. Mix each color to a transparency that feels right for your artwork.

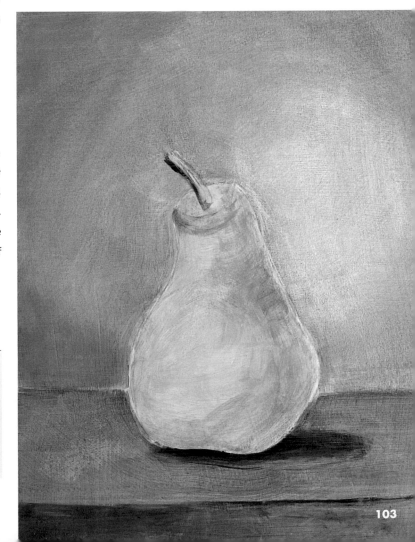

oil-like blending

Since oil paint dries much slower than acrylic paint, oil is often considered an easier medium for blending purposes, especially for softening the edges between two colors. This is a technique that simulates the oil-like blending of wet paint using acrylic.

MATERIALS

Painting support
Flat, soft brush
Palette knife

Acrylic paints
Acrylic glazing liquid
Paper towels

1 APPLY PAINT NEAR THE HARD EDGE
Where two colors meet with a hard edge, rewet the colors with paint right along that edge. (For large areas, add up to 1 part acrylic glazing liquid to 4 parts paint before applying.)

2 BLEND
Before they dry, blend the colors using a soft brush. Gently stroke back and forth along the edge. Extend each stroke beyond the sides of the painting's surface. Turn the brush as needed so the colors on the brush always correspond to the colors to be blended.

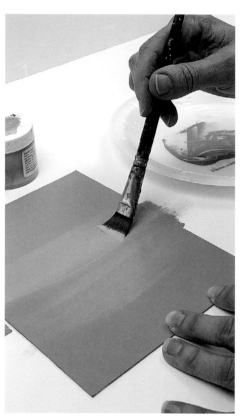

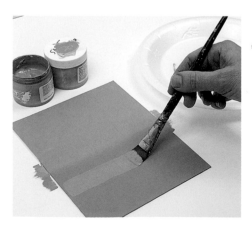

3 INCREASE TRANSPARENCY OF PAINT COLORS AND REAPPLY ONE COLOR
Add acrylic glazing liquid to one of the paint colors and mix well. Apply the color a bit further from the edge you are blending. Using a clean brush and the brushing technique in step 2, gently stroke the paint back and forth. Slowly move the brush and paint toward the edge you want to blend. Remove any excess paint from your brush by frequently wiping it on a paper towel.

4 ALLOW COLOR TO GRADUALLY DISAPPEAR
Dip your brush into acrylic glazing liquid without adding more color and stroke this over the blended area and a bit farther. Let this dry, then repeat steps 3 and 4 for the other color on the other side. Add more medium each time. Continue until the blending is acceptable to you.

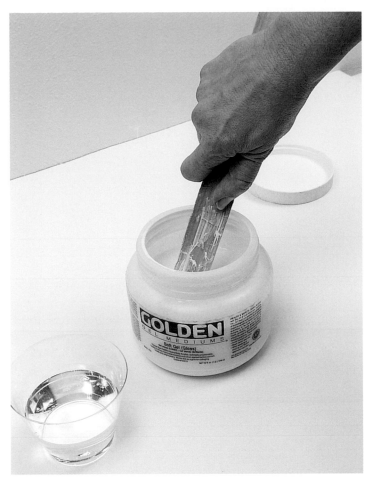

mix the gel with water

Dilute 3 parts soft gloss gel with 2 parts water. Allow the mixture to settle for a few hours after stirring to minimize bubbling. The water will slow down the drying time and allow any bubbles that may form in the gel to rise to the surface and disappear. If you do not add any water, bubbles may get trapped as the top of the gel layer starts to dry.

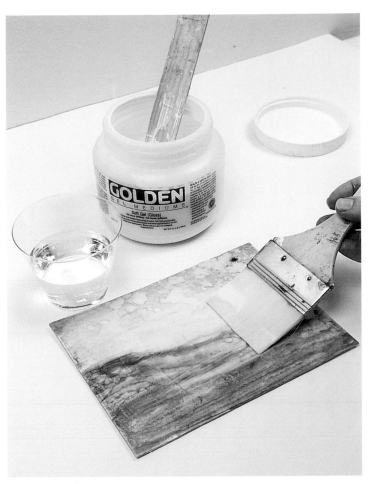

applying isolation coats

When your painting is dry to the touch and you don't plan to work on it for another hour or two, that is a good time to apply an isolation coat. Apply the gel-and-water mixture using a wide, soft brush to minimize bubbling. Let dry. You can apply as many isolation coats as you want, whenever you want. The more isolation coats you apply, the greater the refraction. If the isolation coat is your last coat on the painting and you plan to apply a varnish, allow it to dry for a longer period—from a few days to a week—before applying the varnish.

Alternative Methods for Isolation Coats

- Try using the pouring methods described in techniques 100 and 101 to create extremely smooth isolation coats. Pours take longer to dry than the brush technique described here and are sometimes a bit trickier to accomplish, but adding some water to the gels and applying them in thin, poured applications should prove successful.

- Another alternative is to spray the isolation coat. Spraying is essential if you are using fragile materials like pastel, or water-soluble mediums like watercolor. See technique 69 for an easy spraying method, and technique 59 for a good spray formula.

90

simulating the luster of oil

This technique describes how to increase refraction in acrylic paintings to simulate the so-called richer refraction that gives oil paintings their characteristic luster. Clear glossy binders or mediums can add refraction to give acrylic color a rich, glowing look. By adding layers of clear acrylic between layers of acrylic paint, you can add luster to the sheen and create a similar appeal. A clear coat used between paint layers is often called an *isolation coat*. An isolation coat may also be used between the finished painting and the final coat of protective archival varnish. Using varnish as a finishing coat also will enhance refraction. (For more information on varnishing, see technique 104.)

faux tempera

Tempera paintings are usually characterized by dense, rich colors that level well and produce an even flat or matte finish. This technique demonstrates ways to manipulate regular acrylic paint to create a tempera feel and appearance. In addition, Golden has two specially formulated lines of paints, both of which replicate the look and feel of tempera. High Load Acrylics have a high pigment content that imparts a beautiful matte finish, similar to the look of chalk pastel. This line comes in a limited number of colors. Another paint line called Matte Fluid Colors produces level, matte colors that look just like tempera. These paints come in a large array of colors. Experiment with both the High Load Acrylics and Matte Fluid Colors to see which you prefer.

MATERIALS
Painting support
Matte medium
Fluid acrylic paints

Brush
Palette knife

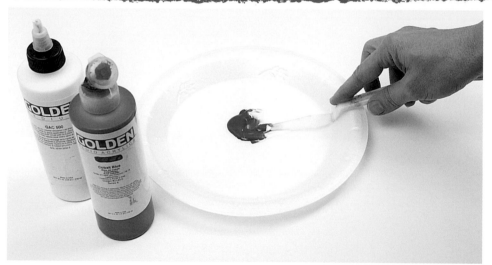

1 INCREASE THE LEVELING QUALITY OF THE PAINT
Mix your acrylic paints with a small amount of water to increase the leveling quality.

2 ADD A MATTE FINISH
As a final coat on your painting, apply a matte medium or varnish. Here I am brushing matte medium directly over the finished painting. If, however, you are applying a varnish, it is very important to apply it over a glossy surface. If your surface is not glossy, apply an isolation coat first so that the matte varnish can go on evenly. (See technique 90 on isolation coats and technique 104 on varnishing.)

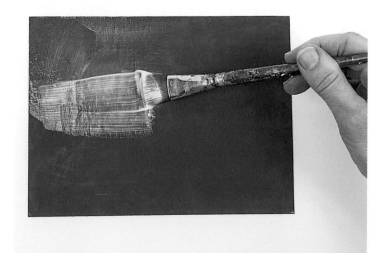

Increasing the Leveling Quality
To increase your paint's leveling quality add enough water to loosen the binder, but not so much that the paint gets watery and over-diluted. Try mixing 1 part thick acrylic paint with 1 part water or 4 parts fluid acrylic paint with 1 part water. As an alternative to water, Golden makes a specialty medium called GAC 500, which thins and increases the leveling quality of the paint. Try mixing up to 1 parts of this medium with 1 part of your paint. Since GAC 500 has a very thin consistency, the more of it you add to the paint, the less water you will need to add. Experiment with different combinations of water and medium to find your preference.

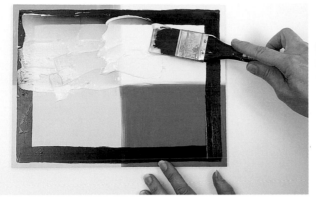

1 APPLY THE GEL

Use any painting background or underpainting and select a faux encaustic formula. I am using Formula 1. Using a long, wide palette knife or other spreading tool, apply the gel in a layer about ⅛-inch (3mm) to ¼-inch (6mm) thick. Smooth the layer as much as possible, leaving some remnants of spreading texture. Let dry.

2 PAINT OVER THE GEL

Here I painted some circular shapes on top of the dried formula layer, and another coat of black over the black border. I used fluid acrylic paints, diluting some with water to create more transparency. Others I used undiluted for more opacity and intense chroma. Once the paint has dried, repeat the process with another layer of the encaustic formula and paint. The more layers you add, the more you increase the depth and encaustic effect.

Faux Encaustic Formulas

Whichever formula you use, mix it ahead of time.

Formula 1: Unrefined Beeswax

Combine 6 oz. (177ml) Regular Gel (Matte) with 2 tablespoons (30ml) water. Add 6 drops Interference Blue, 1 drop Quinacridone/Nickel Azo Yellow, and 5 drops Iridescent Gold (Fine). This will replicate the yellowish appearance of unrefined wax. This formula is thick and should be applied with a knife.

Formula 2: Refined or Bleached Beeswax

Combine 2 oz. (59ml) Soft Gel (Gloss) with 0.5 oz. (15ml) Soft Gel (Matte). Add about 1.5 oz (44ml) water. Add 4 drops Interference Blue (Fine) and 1 drop Iridescent Gold (Fine). Apply by pouring a puddle onto the painting surface. Spread gently with a palette knife or spreading tool. This will replicate the white appearance of refined beeswax. This is a thin formula and can be poured.

faux encaustic

Encaustic, or painting with wax, is a wonderful art form dating back to ancient Egypt and still popular today. Using acrylic to replicate the appearance of encaustic has the advantage of archival durability and greater ease in care and maintenance. This technique produces a typical wax look that includes thick, slightly cloudy yet transparent layers with a subtle yellowish tint, melty or soft-edged forms and a deep, luminescent sheen.

MATERIALS

Painting support

Acrylic paints

Regular Gel (Matte)

Soft Gel (Gloss)

Soft Gel (Matte)

Interference Blue fluid (Fine) acrylic paint

Fluid Iridescent Gold (Fine) acrylic paint

Quinacridone/Nickel Azo Gold fluid acrylic paint

Brush

Wide palette knife or spreading tool

Mixing container with lid

3 APPLY ANOTHER GEL LAYER

Another coat of encaustic Formula 1 was applied to the painting. Repeat paint and formula layers as many times as desired to create the effect and depth you prefer.

Magical Effects and Finishing Sheens

Use these techniques to add a contemporary edge to a traditional or nontraditional painting, or just play around with them for new ideas and processes.

93

holographic effects

Interference pigments reflect and refract light in various ways to create shifting color. As you walk past a painting with interference paints, the colors will change, creating a holographic effect. The paint refracts different portions of the available light's color spectrum. A variety of interference paints are available. Below are several ways to enhance their unique effects.

- **Take advantage of transparency.** Interference colors are very transparent, so their appearance will be strongly affected by the color over which they are applied. Interference colors act very differently over a light background than over a dark background. Over white, the colors will flip between complementary pairs when viewed at different

angles. For instance, Interference Green will flip to red from a different angle.

- **Enhance the color with black paint.** Adding a small amount of black paint to an interference color will make it more opaque, enhancing the color's appearance.
- **Create tints with modern paints.** Adding modern acrylic paints in small amounts to interference paints will create tints with an unusual effect. The transparent, modern pigments produce the best results. (See technique 80.)
- **Use interference paints in the top layer.** Interference paints need light to create their unusual effects. Their effectiveness will greatly decrease if they are covered with an opaque color or mixed with too much regular paint. On the other hand, adding gloss gels and mediums will increase the refraction and their effectiveness.

shifting interference pigments

Here is a portion of the same chart shown at different angles to the light. Notice how changing the angle at which interference colors are viewed changes their appearance.

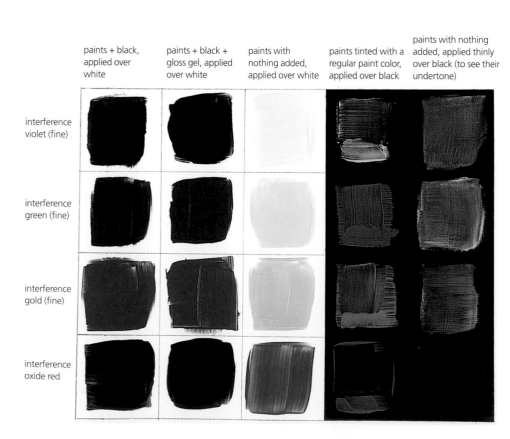

	paints + black, applied over white	paints + black + gloss gel, applied over white	paints with nothing added, applied over white	paints tinted with a regular paint color, applied over black	paints with nothing added, applied thinly over black (to see their undertone)
interference violet (fine)					
interference green (fine)					
interference gold (fine)					
interference oxide red					

faux metallic paints

There are many artist paints available that simulate metals. These paints need light to bring out their reflective qualities, so avoid mixing them with too much paint, overpainting them with opaque colors, or using them with matte acrylic products, which contain a fine white powder that inhibits light. One of my favorite things to do when working with faux metallics is to heavily dilute the paints with water and watch them separate into pigment and mica. This separation is most apparent when the paint is applied to an absorbent surface. When left to dry, these overdiluted paints create a great multicolored effect. For this technique, thick and fluid acrylic paints will work very well.

MATERIALS
Absorbent surface

Iridescent Bronze (Fine) acrylic paint

Brush

Water

1 ADD WATER TO THE PAINT
Dilute with enough water so the mixture is at least 1 part water to 1 part paint. You do not have to mix it very well, but make sure the paint is watery.

2 APPLY DILUTED PAINT TO AN ABSORBENT SURFACE
You can already see the green pigment used in making the bronze paint start to separate out on the mixing plate. Wet the watercolor paper before applying paint to create more of a bleed effect. Apply the diluted paint with a brush to an absorbent surface. Allow the paint to dry.

diluted metallic paint
The green color was not added, but appears as an unusual stain along with the reflective mica.

This painting is composed of two surfaces. One is a panel; the other was created with stretched, patterned fabric. Gold paint is applied in stencils. Opaque, hard edged areas contrast with softly hued backgrounds that were created with glazes and pours. A strip of pipestone and silver was inlaid on the bottom right. (See techniques 3, 4, 31, 56, 65, 67, 82, 83, 94 and 101.)

River
Acrylic and mixed media on canvas
31" × 17" (79cm × 43cm)
Nancy Reyner
Private collection

real metallic paints

Many acrylic paints are made from real metals. These can add a unique element to your color palette and are fun to play around with. Two of my favorites are Iridescent Stainless Steel and Micaceous Iron Oxide.

stainless steel paint, applied thickly to show its natural masstone with phthalo green with turquois (phthalo)

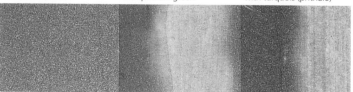

micaceous iron oxide paint, applied thickly to show its natural masstone with phthalo green with turquois (phthalo)

stainless steel paint, applied thinly to show its natural undertone with quinacridone burnt orange with dioxazine purple

micaceous iron oxide paint, applied thinly to show its natural undertone with quinacridone burnt orange with dioxazine purple

with quinacridone crimson with phthalo blue with nickel azo yellow

with quinacridone crimson with phthalo blue with nickel azo yellow

iridescent stainless steel paint and its variations

micaceous iron oxide paint and its variations

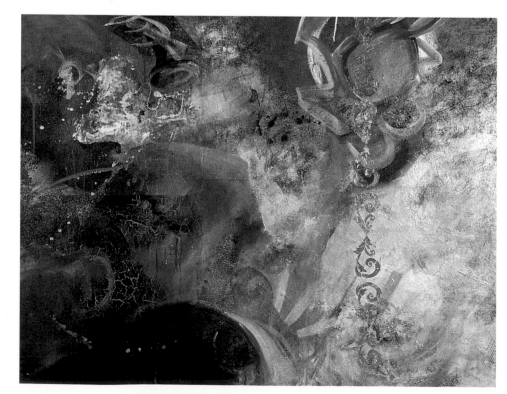

A combination of many pastes and gels were used to create a textured surface. Micaceous Iron Oxide and interference paints were applied freely with a brush and through stencils to create a textured, reflective surface.

A Brief Glimpse
Acrylic on panel
48" × 60" (122cm × 152cm)
Nancy Reyner

Mixing Color Into Metal Paint
You can add small amounts of modern acrylic paints to metal paints without decreasing their reflective quality. Avoid using opaque colors such as mineral pigments because they will decrease the metal paints' effects. See technique 80 for more about modern and mineral pigments.

marbleized skins

This technique takes advantage of a unique product by Golden called Clear Tar Gel to create a marble pattern suspended in a clear acrylic patch or "skin." This marble skin can then be stored for later use in a collage. Clear Tar Gel can be used in a variety of ways. It can be added to acrylic color to change its consistency to a stringy, tarlike paint (see technique 78), as a drip resist (see technique 25) or used as a marbleized painting layer (see technique 97).

(see technique 78), (see technique 25), (see technique 97).

MATERIALS

Nonstick surface (such as HDPE plastic, freezer paper or inexpensive plastic wrap)

Golden's Clear Tar Gel

Palette knife, nail or other pointed tool

Fluid acrylic paints

1 POUR THE GEL

Pour a puddle of Clear Tar Gel onto a non-stick surface. If you're using plastic wrap, test it first, because some won't release the paint once it's dry. Spread the pool of gel by picking up your surface and tilting it slightly to each side. Let the gel rest on a flat, even surface, but continue to step 2 before it dries.

2 ADD DROPS OF COLOR TO THE GEL

Using fluid acrylic paints, drop several colors onto the gel soon after pouring it out. The more colors you add, the more complex and opaque the marble skin will become. Use a maximum of 12 to 15 drops of color for every 2 oz. (59ml) of Clear Tar Gel. You can overlap colors or keep them separate.

Tips for Using Clear Tar Gel

- Don't dilute the gel with more than 15% water.
- Do not use the gel right after stirring, or it will get bubbles, stiffen and will not marbleize properly. If you stir it by accident, let it sit in a closed container for at least 2 hours.
- The more you mess with the gel, the more bubbles will appear in the finished skin.

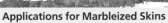

Applications for Marbleized Skins

- Cut the skin into shapes with scissors or a knife and glue them onto a painting, a book cover, a collage or any other surface using any acrylic medium or gel. My favorite gluing gel is Golden's Soft Gel (Gloss).
- When my son was younger, he loved making these skins and sticking them on our car window, where they adhered by themselves in warm weather without any glue.

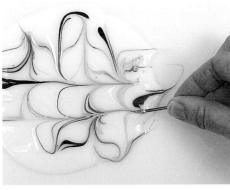

3 SWIRL THE COLORS TO CREATE YOUR DESIGN

Using a palette knife or other sharp tool, create a pattern by dragging through the colors. Here I am using a nail to run through the colors in a grid or crisscross pattern.

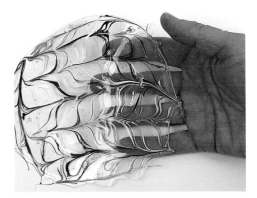

4 LET THE GEL DRY

When your design is finished, let the gel dry thoroughly. It is dry when the gel turns from white to clear. Remove the skin from the surface and store it between sheets of plastic wrap or freezer paper for later use.

marbleized painting layers

Using Golden's Clear Tar Gel, you can create a clear patterned or marbleized layer directly on your painting. This is a great way to add textural details to a realistic painting, add decorative patterning to an abstract design, produce a unique background or create an abstract painting all by itself.

MATERIALS
Painting support
Fluid acrylic paints
Golden's Clear Tar Gel

Palette knife, nail or other pointed tool
Squeegee, spatula or other spreading tool

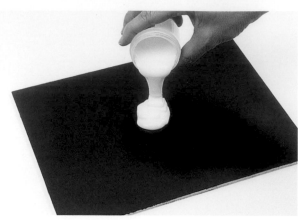

1 POUR THE GEL DIRECTLY ON YOUR PAINTING
Use the gel undiluted for maximum marbleing effects, or mix it with water 4:1 or 3:1 for a smoother layer. Experiment to see which look you prefer. Pour the gel in a large puddle in the middle of your painting support.

2 SPREAD THE GEL
Use a squeegee, spatula, knife or other spreading tool to spread the gel into an even layer across your surface. Do this carefully, as too much moving around will increase bubbles.

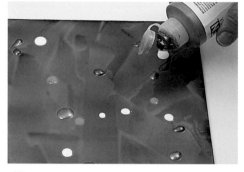

3 ADD DROPS OF COLOR
Using fluid acrylic paints, drop several colors onto the gel soon after spreading it out and while it is still wet. The more color you add, the more complex and opaque the pattern will become.

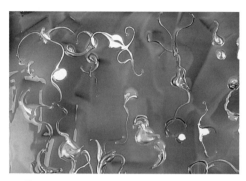

4 CREATE YOUR DESIGN
Using a nail, palette knife or other pointed tool, drag through the colors to create a pattern. The gel will continue to spread in feathery lines and to marbleize for an hour or two afterward, so keep the pattern simpler than you may want in the end. You can always repeat the entire process on another layer after the first layer has dried, if desired.

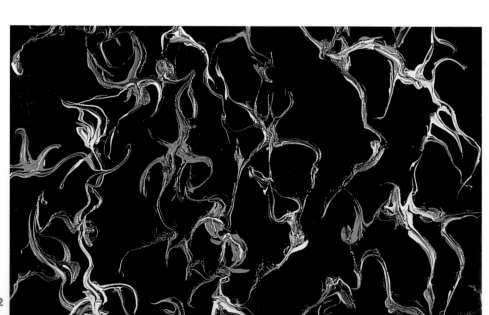

5 LET THE GEL DRY
When your design is finished, let the gel dry thoroughly. This may take 1 to 3 days, depending on the thickness of the gel and the weather. Make sure that your painting support lies flat during the drying process or the result may be an uneven surface, wrinkling and cracks.

surface finishes: glossy, satin or matte

When using a variety of paints and products, you will produce a painting with a multisheen surface. Use this technique to create an even, consistent finish for your artwork.

MEDIUM VS. VARNISH

By using a medium or varnish as a top coat, you can create a uniform finish. Mediums come in glossy or matte. By mixing gloss and matte products together, you can create a semigloss, also called satin. Varnishes also come in glossy and matte; some brands also offer a semigloss. Mediums are waterproof when dry and become a permanent nonremovable coating or layer. Mediums can be used at any stage of your painting. Varnishes, however, are generally used only as a final protective coat. Archival or artist's varnishes are different from those found in home improvement stores. They are made to be removable with solvents for cleaning purposes. The newer ones on the market have UV protection. Both mediums and varnishes will create a uniform finish.

SELECT A SHEEN LEVEL

Once you have chosen either a medium or varnish, select the sheen level you prefer to use on your artwork. Gloss, satin or matte finishes produce different effects and viewing experiences. I tend to choose a glossy sheen to make the colors look more intense, a satin sheen for a soft reflection like wax, and a matte finish for a nonreflective surface that produces a more intimate, tactile viewing experience.

APPLY THE FINISH

If I do any mixing of the mediums or varnishes, I mix them a day ahead so the bubbles created during mixing can subside. Using a soft, flat brush, apply the medium or varnish to your work. After applying a small area, move on; try not to rework an area that is starting to dry or the coating will start to pull up and create surface defects. Let the coat dry for 3 to 7 days before letting it come into contact with storage or packing materials.

Additional Methods For Creating a Clear, Glossy Coat

- For a beautifully clear, glossy coat, try using 3 parts soft gloss gel mixed with 2 parts water. You can also use this mixture as an isolation coat (see technique 90).
- A clear acrylic poured over the surface will also create a clear gloss coat, while smoothing out any texture in the painting. Pouring techniques are described in techniques 100 and 101, but for this purpose do not add color to the gel.

coated with matte medium | coated with a satin medium | coated with gloss medium | pure paint with no top coat

black paint

gray paint

white paint

how the finish affects color value

Mediums and varnishes generally do not affect hues but they may affect a color's value. Glossy finishes tend to darken grays and blacks, but leave white unchanged. A matte finish, on the other hand, will lighten blacks and grays, but leave white unchanged. Semigloss or satin finishes affect blacks and grays in varying degrees.

making a print look like a painting

Here is a way to add some tactile, painterly qualities to the flat surface of a machine-made print. With acrylic gel, the print gains brushstrokes and texture, and a handmade original with a bit more personality is created.

MATERIALS

Ink-jet, laser or offset print mounted on a sturdy support

Golden's Specialty Acrylic Polymer GAC 500 or other acrylic gloss medium

Soft, flat brush

Acrylic gloss gel

Palette knife

Rubber shaping tool (optional)

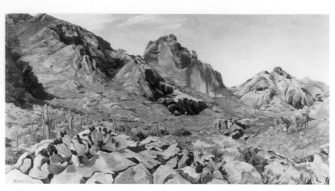

1 PREPARE YOUR PRINT

Use the gluing technique described in technique 55 to mount your paper print onto a sturdy support.

Print of original painting by Nancy Reyner, from the collection of Edythe and Larry Hecht

2 SEAL THE TOP SURFACE

Apply any glossy medium over your entire print using delicate handling and a soft, flat brush. Do not add any water to the medium, and avoid adding any water to the print with your brush, so the print's ink will not smear. Avoid reworking an area that is partially wet, or the ink may come off the print and onto your brush. Let this coat dry for a few hours.

3 APPLY GLOSS GEL

Use a gel instead of a medium for this step and apply it with a palette knife. The gel will shrink in volume by about 30%, so apply it thicker than you want. Experiment with various gels to find one or a combination you prefer. Gloss gel will intensify the colors, while a matte gel will lighten and add a soft haze to the print.

4 ADD TEXTURAL EFFECTS

Working quickly while the gel is still wet, use a variety of tools such as palette knives, brushes or rubber shaping tools to create different textural effects. Let the forms and lines in the print inspire your strokes so the texture seems integrated with the image.

finished print turned into a painting

Add Color to the Gel for an Interesting Effect
For an additional effect, try adding a small amount of color to the gel to tint or alter areas of the print. For example, adding a small amount of transparent blue paint to the gel you apply to the sky area will make it look even more convincing.

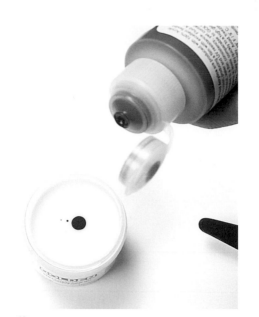

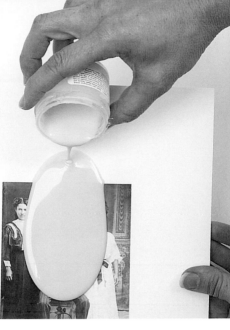

1 PREPARE YOUR BLACK-AND-WHITE IMAGE

Using the gluing method described in technique 55, mount your image on a rigid support.

Photo courtesy of Bonnie Teitelbaum

2 ADD COLOR TO THE ACRYLIC

Mix 4 parts acrylic gel or medium with 1 part water. Add more water to make if desired. Add a tiny amount of a gold acrylic paint. Stir well with a palette knife. Let the mixture sit tightly covered for at least a few hours to let the bubbles settle before proceeding to the next step.

3 POUR THE MEDIUM

Hold the mounted image vertically. Starting at the top of the image, pour a small amount of the prepared medium down the surface, letting the medium get thin as it works its way down. Add more medium if necessary, pouring from another side, and allowing the medium to join the previously poured area. You can also manipulate the pour with a palette knife, but keep this to a minimum.

4 LET IT DRY

Leave the image on a level surface to dry. It will take 1 or 2 days to dry enough to handle. Allow it to dry for 7 days before shipping or storing.

100

antique pour

This acrylic pour technique creates an antique, sepia toned finish for any black-and-white image, whether it be a photograph, print, photocopy or drawing. Tint pourable gloss medium with gold-colored paint for a richly colored, glossy, smooth finish. The thicker poured medium enhances luster better than a thin glaze or other coloring method, brings more intensity to the gold color, and adds a contemporary twist. For additional pouring ideas, see technique 101. Don't use any valuable originals for this project since the pour will be permanent. Test your image's ink first. If it is water soluble, follow the instructions in technique 99 for sealing the ink before pouring, or make a photocopy of the image.

MATERIALS

Black-and-white image mounted on foamcore board or another rigid support

Pourable acrylic gloss medium

Gold-colored acrylic paint such as Quinacridone/Nickel Azo Gold

Palette knife

glassy gloss look with poured acrylic

Pouring can be accomplished in several ways and can serve multiple purposes. Over a finished painting, a pour can create a beautiful gloss sheen and intensify colors. A gold-colored pour can antique a black-and-white photograph (see technique 100). Isolation coats and more layers can be created with pours (see technique 90). Try this technique with only one coating and no added color to create a beautiful gloss finish on your artwork or add color to the acrylic and create a painting using several poured colored shapes. Experiment on your own with different colors, shapes and layers.

MATERIALS

Primed painting support
Pourable acrylic gloss medium or gel
Fluid acrylic paints
Palette knife
Containers with lids
Spatula, squeegee or other spreading tool

Mixing Color Into Acrylic Gel or Medium
Any acrylic medium or gel will work for this technique as long as it has a pourable consistency, like syrup or heavy cream. Add about 1 part water to 4 parts medium along with a very small amount of color. Avoid adding too much color at first. You can always pour a second layer over the first after it has dried if you need more color. Mix color into the acrylic ahead of time and let it sit in covered containers overnight to eliminate the bubbles created as you stir.

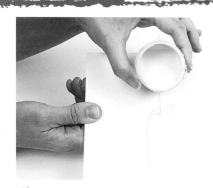

1 POUR THE MEDIUM
Prepare your pourable acrylic medium, adding color if desired. Use a surface that is sturdy enough to handle the heavier weights of multiple pours. If your support is absorbent, prime it with acrylic gesso or a gloss medium. Pour a puddle of medium in the middle of your support, or in the area you want colored if you're using a tinted medium.

2 SPREAD EVENLY OR FORM SHAPES
Use a spreading tool, squeegee, spatula or wide, flat knife to spread the acrylic outward to form a thin layer. Spread colored medium into your desired shape, or tilt the support slowly in different directions. Don't overlap shapes until the first shape dries if you want crisp colors and edges.

3 POUR MORE COLORED SHAPES
After the initial shape dries, pour additional shapes, letting each layer dry between applications. Pour several colored shapes to create a multicolored glossy painting.

glossy, multicolored painting that mimics the appearance of stained glass

102

cleaning up

Here are some helpful tips for cleaning up, as well as for preserving and caring for your finished acrylic artwork.

BRUSH CLEAN UP

Rinse your brush in your water container and blot it on paper towels or a rag. Push the brush hard into a bar of plain soap so that the bristles spread apart and move it around in the soap. Push the brush into the palm of your hand and move it in circular motions to loosen the paint. Rinse it well. Repeat this process a few times. Lay the brush flat to dry. To keep your brushes in top shape, apply a small amount of hair conditioner to the bristles and leave it on until you are ready to use the brushes again.

use soap
Acrylic paint can only be fully removed from brushes with soap. The bristles should be spread apart so the soap can get under the ferrule (the metal band that secures a brush's bristles to the handle).

REMOVING DRIED PAINT FROM BRUSHES

You can use a commercial cleaner for removing dried acrylic or latex paint from your brushes, but I prefer this safer, cheaper alternative: Heat water in a pot. Just before the water goes into a full boil, dip your brush into the hot water for 1 to 2 seconds. Dip a few times, then immediately clean the brush with soap. Leave the brush soaking overnight in a strong liquid soap.

Brush Care Tips
- Slightly dampen the brush with water, then blot dry before starting to paint. This will make cleanup easier.
- Do not let the brush dry with the bristles upright. Excess water will drip into the ferrule, weakening the glue.
- Avoid leaving a paint-covered brush either out of use or out of water for more than a few minutes or the paint will dry on the bristles. This will eventually cause the bristles to lose their shape. (If a brush does get to this point, try using it for some interesting new brushstrokes.)

The next day, repeat this entire process, starting with the hot water dip, until the old paint is fully removed from the brush.

CLEANING PALETTES

My favorite palette and clean up system uses the HDPE palette with technique 54. When I am ready to clean the palette, I just peel the whole thing off in one easy gesture. This peeled off acrylic sheet can be saved and used for future collages. Clean glass palettes after each painting session by heavily wetting it with a sponge or spray bottle. Let it sit for a minute or two, then wipe the paint off with a rag, or scrape it off using a single-edged razor blade or scraping tool.

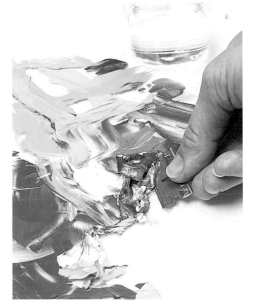

scraping paint off a glass palette

CLEANING HANDS

Just use warm water and soap to remove acrylic paint from your hands. If your hands are sensitive, consider using a barrier cream before starting to paint, which can be found in hardware and art stores. When you're finished, rinse your hands with water. The cream and paint easily wash off together.

CLEANING CLOTHES AND OTHER SURFACES

Remove acrylic paint from clothing and other surfaces immediately by dousing it with plenty of water and blotting with a rag. Keep the area wet until you can remove the article of clothing and put it in the washer. Once the paint has dried, it is more difficult to remove. If the paint has dried for only an hour or two, try using isopropyl alcohol on a rag to remove it. If the paint has dried for a day or longer, it may be impossible to remove from clothing.

preserving your artwork

The term *archival* can describe any method or material that will extend the life of your artwork in its original state (or the state in which it is meant to be seen) by increasing its ability to withstand damaging environmental factors. Preserving your artwork involves choosing good-quality materials to begin with, as well as employing archival procedures such as stain sealing, priming, varnishing, and allowing acrylic products to cure properly.

ARCHIVAL CHOICES IN MATERIALS

A rigid support such as wood or composite panel is a more durable choice than a flexible one such as canvas or paper. To avoid fading colors, select paints with a higher lightfastness rating. The lightfastness rating for each paint often is listed on the product label or is available from the paint company. If the rating is I (Excellent), this paint will be a great choice for outdoor murals and other permanent applications. A lightfastness rating of II (Very Good) means this paint should last for over 100 years and is therefore well suited for archival-quality needs. Paints with a lightfast rating of III or more should be avoided unless longevity is not an issue.

STAIN SEALING

When acrylic is applied thickly, it may draw impurities from the substrate into the paint, causing a yellow stain. This occurrence, referred to as Stain Induced Discoloration (SID) frequently happens with wood substrates. SID can be avoided by sealing the substrate before priming. There are two types of products available for stain sealing. Commercial stain blockers are good for walls and other rigid supports but should not be used on any flexible artist's support, such as canvas or paper. Golden makes a stain blocker called Specialty Acrylic Polymer GAC 100 that is specially formulated for fine artwork and can be used on canvas and other flexible surfaces. Acrylic gesso should be applied over GAC 100 before starting to paint (see technique 3).

Priming
Priming will increase adhesion to make your painting last longer and ensure its stability. Refer to Section 1, which focuses on priming various supports.

stain sealing products
Select a sealing product according to the type of surface used for your artwork.

varnishing and care

Varnishing is one of the best ways to protect a painting. When applied as a final layer over a painting, varnish will keep dust from damaging your painting. It is also the only way to ensure that the painting can be cleaned later. This is true for both oil and acrylic paintings. An archival varnish, one that is appropriate for fine art paintings, is nonyellowing and removable. Once the old varnish is removed, you can apply a new coat.

archival varnishing products for paintings

Damar varnish is a traditional varnish for oil and acrylic paintings. Damar tends to yellow slightly and is available only with a gloss sheen. I prefer to use Golden's varnishes, either the polymer varnish, which is water soluble and removable with ammonia, or the MSA varnish, which is both soluble and removable with mineral spirits.

Varnishing Tips

- Varnishing can be very easy, but it can also get quite complex. Test varnish by experimenting on scrap work before trying it out on an important finished painting.
- Apply varnish only over a nonabsorbent surface. Be sure the surface is nonabsorbent by applying an isolation coat (see techniques 59 and 90).
- Spraying varnish is recommended if you want to obtain an even matte or satin finish (see technique 69).

SELECTING A VARNISH

Avoid using a varnish from a commercial paint store. This type is not removable and will yellow over time. Varnishes appropriate for artwork can be found at quality art stores. Even then, be wary of acrylic products labeled "varnish and medium" on the same container because it is impossible for one product to be both. Check the label to see if there are any instructions for removing the varnish. If there are none, that product is not an archival varnish. Varnishes are available with varying finishes such as gloss, satin and matte.

Use archival painting varnishes that offer UV protection. Polymer varnishes cannot be applied over oil paints. MSA varnish may be applied over either oil or acrylic, but requires proper ventilation or a protective mask.

WRAPPING, SHIPPING AND STORAGE

Once your acrylic painting is completed, wait at least two weeks to be sure the acrylic has fully cured before wrapping, shipping or storing it. Do not wrap it up too tightly or store the work in a closed environment. In addition, especially during the curing phase, do not expose the painting to temperatures below 35°F (2°C). If your painting freezes during the curing phase, it may never properly cure.

Even after curing, your painting still must be handled with care. When wrapping your artwork, be sure that the painted surface does not come in contact with any textured items such as bubblewrap. If the painting should get hot, it will soften and may stick or take on the impression of other surfaces with which it comes into contact. A glossy surface has more of a tendency to get tacky in hot weather and stick than a matte one. Use a nonstick, smooth plastic such as HDPE to wrap your work. Be kind to your paintings; they are worth it. Occasionally wipe the painting off with a damp cloth to remove dust and any other substances that may come through to the upper surface long after the painting has cured.

Beautiful realism is achieved in this painting with glazing and layering. The surface texture was created with molding paste. (See techniques 22, 34, 38, 39, 40, 88 and 89.)

Green Bowl Still Life
Acrylic on canvas
30" × 24" (76cm × 61cm)
Sherry Loehr

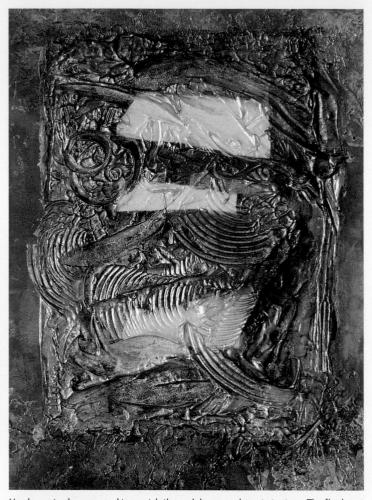

Hardware tools were used to scratch through layers and create texture. The final coat uses interference and iridescent paints to add sheen and more depth. (See techniques 2, 46, 47, 93 and 94.)

Look Through My Window
Acrylic on illustration board
15" × 11" (38cm × 28cm)
Teyjah K. McAren

For this piece, fluid acrylics were applied to fabricated aluminum. A variety of brushstrokes, painted lines and taped stenciling add interest. Soft gradations and multiple glazing layers form the antiqued background surface. (See techniques 6, 9, 67, 73, 88 and 89.)

I Can Hear You
Acrylic and graphite on aluminum
30" × 36" × 2" (76cm × 91cm × 6cm)
Declan Halpin

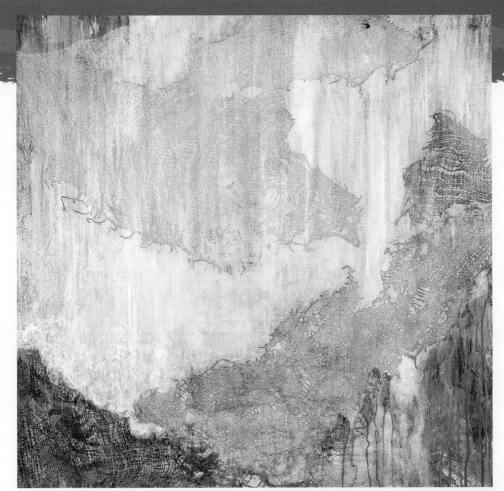

Dry brushing, glazes, pours, "Jackson Pollock" drips and drizzles with clear tar gel create unusual atmospheric effects in these paintings. Landscape motifs were created using spatial effects employing contrasting edges, hues, values and chromas. (See techniques 3, 34, 37, 38, 39, 78, 88 and 101.)

Spring Renews (left)
Acrylic on panel
24" × 24" (61cm × 61cm)
Bonnie Teitelbaum

Copper Line (below)
Acrylic on panel
16" × 12" (41cm × 30cm)
Bonnie Teitelbaum

Glazes, veiling with matte gels, drips with diluted paint and drawing mediums such as colored pencil were used over a surface of collaged paper. In some areas, the canvas was stitched with thread for additional texture and interest. (See techniques 24, 31, 39, 40, 41, 58 and 88.)

Raven
Acrylic and mixed media on canvas
32" × 32" (81cm × 81cm)
Diana Ingalls Leyba

The smaller landscape in the composition was painted on site, then later glued to a large wooden door panel. More collage elements were added, along with more paint. Drawing was done with Stabilo pencils and china markers. The palette used in the original plein air painting is also attached. (See techniques 3, 34, 38, 39, 40, 56, 58 and 70.)

All Those Duomos
Acrylic and mixed media on wood
48" × 72" (122cm × 183cm)
Ron Pokrasso
Private Collection

This colorful abstraction began with a composite wood support called MDF (medium-density fiber board). A textural surface was added by combing through and pressing various objects into wet molding paste. Various papers were glued on. Drawing elements were added with water-soluble crayons. Layers and glazes of metallic and interference paints add a vibrant, shimmering sheen to the finished surface. (See techniques 3, 34, 37, 38, 39, 40, 46, 47, 55, 70, 93 and 94.)

The City
Acrylic and mixed media on MDF board
30" × 42" (76cm × 107cm)
Patricia Forbes

Layers of textured grounds, color stains, gels, paint and drawing materials were used in this painting to achieve a depth similar to encaustic or deep resin pours. (See techniques 3, 23, 33, 58, 85, 91 and 100.)

Organically Based
Acrylic on wood
18" × 25" (46cm × 64cm)
Barbara De Pirro

This painting began with an underpainting of geometric designs. These designs are referenced in the textural patterns created with roofing sealant that was applied with an ice scraper. Additional painting techniques include glazing, washes, crackling and alcohol dissolves. (See techniques 23, 48, 52, 85 and 88.)

Organic Striations
Acrylic on canvas
48" × 36" (122cm × 91cm)
Jan Young

Glazes, veiling with matte gels, and paper collage were combined with colored pencil to create this combination of abstraction and realism. (See techniques 31, 55, 58, 88 and 89.)

Painted Lady
Acrylic and mixed media on canvas
25" × 16" (64cm × 41cm)
Diana Ingalls Leyba

Here, the artist employed a frescolike technique using transparent glazes and matte mediums in layers. Plexiglass and steel were also added to the piece. (See techniques 31, 56 and 88.)

Sacred R
Acrylic and mixed media on canvas
12" × 12" (30cm × 30cm)
Ron Picco

Crackle paste, pours and washes were used to create the background of this painting. The opaque paint that forms the birds and water contrasts with the softly hued, cracked surface. (See techniques 23, 28, 34, 36, 37, 38, 39, 40, 85 and 88.)

Aqua
Acrylic on canvas
48" × 36" (122cm × 91cm)
Nancy Reyner

Transfers, collage with Japanese paper, stenciling, staining, hand painting, brushwork, glazing and drawing were all used to create this abstract painting. (See techniques 19, 34, 38, 39, 40, 55, 58, 62, 85 and 88.)

Tinkerbell Z6
Acrylic and mixed media on paper
23" × 23" (58cm × 58cm)
Patricia Brady

This painting combines abstract and realistic elements using a photographic transfer technique. The images were photocopied before being transferred onto the painting surface with acrylic mediums and gels. Gels used with stencils create textural patterns. (See techniques 23, 62, 65 and 85.)

River's Bend
Acrylic on canvas
12" × 12" (30cm × 30cm)
Corrine Loomis-Dietz

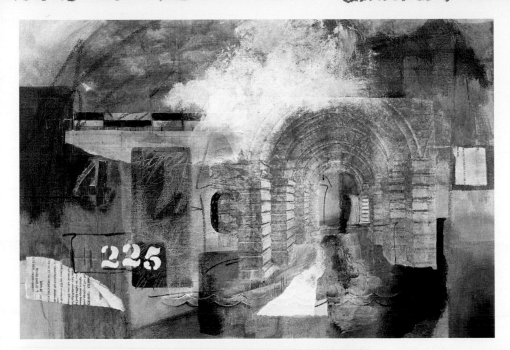

This painting began with a selection of objects, letters, photographs and other childhood memorabilia. These items were glued or transferred with acrylic onto the surface. Layers of clear gel were then applied on top to isolate these images. (See techniques 23, 55, 56 and 90.)

And Lot 225
Acrylic on canvas
18" × 24" (46cm × 61cm)
Jane Rosemont

Techniques such as blending and glazing were combined with washes to create this bold, contemporary work. Flat areas combine with gradations and shifting color to create contrasts in volume and depth. (See techniques 30, 85, 88 and 89.)

Poppies
Acrylic on canvas
42" × 54" (107cm × 137cm)
Bonnie Cutts

Textures add dimension to this composition, while patterns and color intensify the tactile surface. Layers of thinned acrylic paint and matte mediums add depth, while the charcoal line work emphasizes passages. (See techniques 10, 31, 34, 58 and 85.)

Just Passing Through
Acrylic on canvas
12" × 12" (30cm × 30cm)
Leah Dunaway

index

paint like the pros with these North Light Books

The *Artist's Muse* is for any artist who's struggled with creative block or who's looking for new and exciting ways to grow their work. This unique book and card game kit is packed with creative prompts and idea sparkers. By mixing and matching the cards and following the visual examples in the book, you'll find a realm of creative possibilities at your fingertips, leading to a more personal and confident artistic style.

ISBN-13: 978-1-58180-875-9, ISBN-10: 1-58180-875-5, paperback + kit with 3 card decks, 96 pages, #Z0345

Get up and make some art! *Kaleidoscope* delivers your creative muse directly to your workspace. Featuring interactive and energizing creativity prompts ranging from inspiring stories to personality tests, doodle exercises, paper dolls and cut-and-fold boxes, this is one-stop shopping for getting your creative juices flowing. The book showcases eye candy artwork and projects with instruction from some of the hottest collage, mixed media and altered artists on the Zine scene today.

ISBN-13: 978-1-58180-879-7, ISBN-10: 1-58180-879-8, paperback, 144 pages, #Z0346

No two artists think alike, and this book will help you discover your own individual style. *Finding Your Visual Voice* will direct you to recognize your visual preferences and focus your painting efforts with insights from accomplished painters, 8 step-by-step demonstrations, and many examples. A selection of paintings with questions and prompts at the end of each chapter will direct you to the style of art you want to create.

ISBN-13: 978-1-58180-807-0, ISBN-10: 1-58180-807-0, hardcover with concealed wire-o binding, 176 pages, #33486

Find instruction and ideas for using a variety of mediums and techniques to make artist trading cards to collect and swap. Whatever your background, you'll find innovative techniques for making cards, including collage, painting, metal working, stamping and more. These gorgeous miniature works of art are a great way to introduce yourself to a new medium—and to make friends along the way. The book even offers suggestions for starting your own artistic community to trade techniques and cards.

ISBN-13: 978-1-58180-848-3, ISBN-10: 1-58180-848-8, paperback, 128 pages, #Z0524

These books and other fine North Light titles are available at your local fine art retailer or bookstore or from online suppliers.